LAND ART

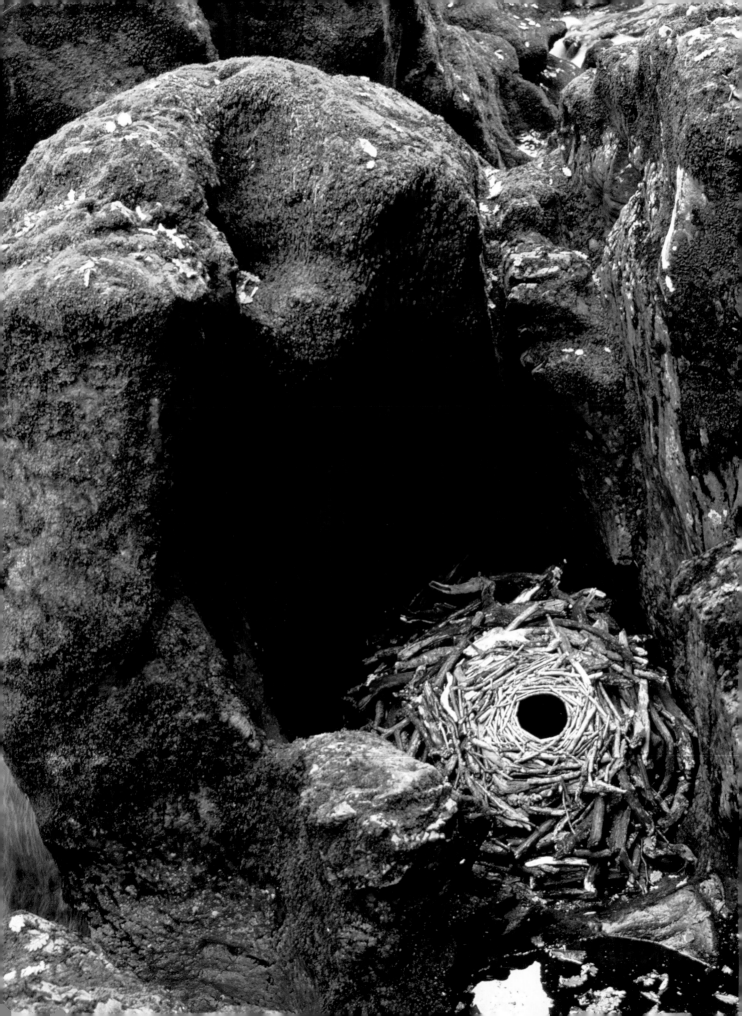

Ben Tufnell

LAND ART

Tate Publishing

ACKNOWLEDGEMENTS

First published 2006 by order
of the Tate Trustees
by Tate Publishing, a division
of Tate Enterprises Ltd,
Millbank, London SW1P 4RG
www.tate.org.uk/publishing

British Library Cataloguing in
Publication Data
A catalogue record for this book is
available from the British Library

ISBN-13 978-185437-604-6
ISBN-10 1-85437-604-7

Distributed in the United States
and Canada by Harry N. Abrams,
Inc., New York

Library of Congress Cataloging in
Publication Data
Library of Congress Control
Number: 2006931290

Designed by 01.02
Printed in Singapore

Front cover: Chris Drury, *Covered
Tumulus*, Firle Down, Sussex, 1997
Back cover: Robert Smithson,
Sprial Jetty 1970
(photographed in 2002)
Frontispiece: Andy Goldsworthy
*Stick Hole, Scaur Water,
Dumfriesshire, Scotland,
14 October 1991*, 1991

Where appropriate,
measurements of artworks
are given in centimetres,
height before width

Many people helped make this book and I would like to extend
my heartfelt thanks to them all: Nicholas Alfrey, James Attlee,
Adam Brown, Ann Coxon, Tina Fiske, John Haldane, Melissa
Larner, Jennifer Mackiewicz, Sally Nicholls, Judith Severne, Joy
Sleeman, Roger Thorp, Jon Wood, Emma Woodiwiss, and the staff
at the libraries and archives at Tate and the Henry Moore
Institute, Leeds. In addition The Henry Moore Institute provided
invaluable research support which was greatly appreciated.

Some of the material in chapter 4 was originally presented as a
paper at the 'Landscape Fictions' symposium at Plymouth
University in 2005. I would like to thank Liz Wells and the
Land/Water research group for the invitation to participate in
that event.

I would particularly like to thank the many artists who have
generously given of their time and responded to requests for
information: Roger Ackling, Walter De Maria, Agnes Dene, Chris
Drury, John Frankland, Anya Gallaccio, Andy Goldsworthy,
Antony Gormley, Michael Heizer, Richard Long, Ivan and Heather
Morison, David Nash, Herman Prigann, Louise Scullion, Charles
Simonds, David Tremlett, herman de vries, and Kate Whiteford. I
should also like to acknowledge a particular debt of gratitude to
Hamish Fulton, for his friendship, generosity and
encouragement.

Finally, this book could not have been written without the
support of Cecilia Gregory. It is dedicated to her.

Ben Tufnell

CONTENTS

INTRODUCTION
THE NEW LANDSCAPE ART

Early in 1968, Michael Heizer, a young American artist, travelled into the vast open expanses of the American south-west. He went not as a sightseer or tourist but to look for locations in which to make a new kind of art. At El Mirage, a dry lake in the Mojave Desert, about 250 miles north-east of Los Angeles, he found an appropriate site. The lake bed of El Mirage is three to four miles long and is absolutely flat. Ringed by the Adobe and the Shadow Mountains, stark, parched and bright, it is an empty space. For Heizer it represented, in effect, a blank canvas.

At El Mirage Heizer made a series of artworks using the lake bed itself. *Windows*, *Compression Line*, *Gesture*, *Collapse* and *Slot* (all 1968) consisted of open, box-like structures constructed from wood, which were inserted into holes dug into the lake bed – creating negative spaces – or which sat on the surface with dirt piled around them. The geometry of their structures recalled the forms of recent Minimalist sculpture but the context of their making and placing suggested something very different. Formally sculptural in their engagement with space and mass, solid and void, Heizer's works were sited far from sculpture's traditional contexts: the gallery or civic space. These works (modest by his later standards) were amongst Heizer's first to be made directly in the landscape.

A sixth work used a different approach. *Circular Surface Drawing* was also about mass and space but the mode of its creation was more performative. Heizer shovelled 'two three-quarter ton loads of backfill from a work in progress ... out of the back of a truck driven in a circular pattern at speed'.[1] The explosive, large-scale image he created echoed an icon of post-war American art, the flung shovel-loads of dirt recalling the skeins and loops of paint poured and dripped by Jackson Pollock.[2] With this group of works, Heizer assimilated and transformed the examples of two important immediate American artistic precursors; he took Minimalist forms and Abstract Expressionist gesture and transposed them to the desert on a greatly enlarged scale.

Shortly afterwards, at the beginning of April, Heizer returned to El Mirage with another young artist, Walter De Maria. Heizer's *Circular Surface Drawing* was big – about twenty-five metres across – but on this second visit, De Maria made two works on an altogether larger scale: *Cross* and *Two Parallel Lines*. *Cross* consisted of a pair of lines in white chalk, each three inches thick, forming a huge diagrammatic crucifix 500 feet wide and 1,000 feet long. *Two Parallel Lines*, also known as *Mile Long Drawing*, consisted of two shallow lines four inches wide etched into the lake bed, each half a mile in length (fig.1). Given the flatness of the terrain and the scale of the works, the only way in which they could be viewed in their entirety was from the air.

The gap between the parallel lines was roughly double the span of a human body, and Heizer photographed De Maria lying on the desert floor, pressed against the ground, his body stretched across this gap. This iconic image seems to assert the necessity of physical contact with the work. And indeed, on the ground it could only be fully experienced completely by walking its length. *Two Parallel Lines* was not a

fig.1
Walter De Maria
Two Parallel Lines
(Mile Long Drawing)
1968
El Mirage, Mojave
Desert, California

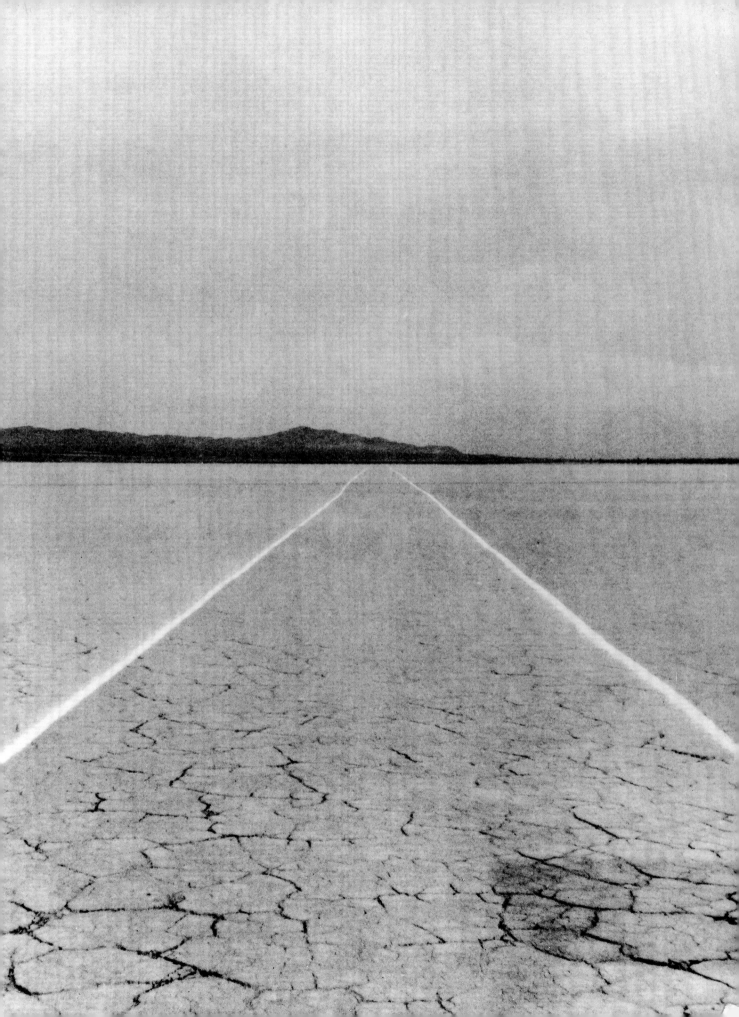

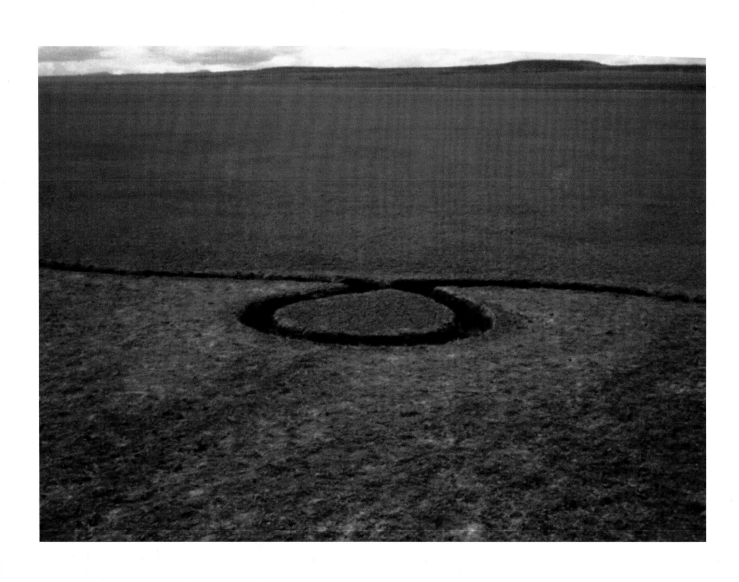

fig.2
Michael Heizer
Isolated Mass – Circumflex 1968
Massacre Dry Lake, Nevada

fig.3
Giuseppe Penone
*My height, the length of
my arms, my breadth,
in a brook* 1968
Garessio, Italy

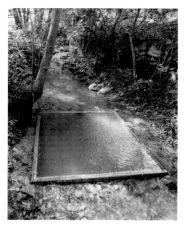

piece of art that, like a traditional painting, could be apprehended in a single glance. Not only did the viewer have to travel a huge distance in order to see it, but once there, considerable effort and time were required to discover its nature and meaning. De Maria designated his work a 'drawing', but the scale of it, its non-pictorial character and the physical and spatial reality of any potential viewer's engagement with it, were more akin to the experience of apprehending large-scale architecture, or even such elongated structures as roads.

On 6 April, from Williams, Arizona, Heizer and De Maria telegraphed the art dealer Richard Bellamy in New York: 'LAND PROJECT POSITIVE … DON'T UNDERESTIMATE DIRT.'[3]

Touching Nature

In the same year the young Italian artist Giuseppe Penone made the first of a series of experimental actions, poetic gestures, in the woods near his home in Garessio in Northern Italy. He wound together three young trees anticipating that they would continue to grow entwined together and thus continue to bear the sign of his intervention. Of another work he wrote:

> I placed my hand on a tree and marked the outline with nails. Later I attached 22 lead weights (representing my age) on the tree and tied them together with galvanized wire. I'll add a weight every year until I die. In my will I'll leave a disposition that a lightning rod be placed at the top of the tree – maybe the lightning will melt the lead on its way down.[4]

Penone's works in Garessio posited a continuity, an identification between artist and environment; the work a form of autobiography. One of his most explicit statements about this notion of connectedness was a work entitled *My height, the length of my arms, my breadth, in a brook* 1968 (fig.3). For this sculpture Penone constructed a rectangular frame from concrete that would enclose his prostrate body, bearing the imprint of his face, outstretched hands and face on its internal planes. The frame was then placed in a small stream, where water filled the space that the artist had occupied, flowing over, through and around it and thus creating a symbolic merging of the artist's body with the natural landscape.

Penone said: 'One of the problems of sculpture is contact, the idea alone isn't enough, it doesn't work, an action is necessary. This action is transmitted through contact.'[5] His Garessio works make this notion of contact and identification both perceivable as material fact, and understandable as symbolic action.

For a piece entitled *Maritime Alps. It will go on growing except at that point* 1968 (fig.4), Penone grasped a tree and marked the point of contact. He then attached to the tree in that place a bronze cast of his clutching hand. As the tree has continued to grow, it has reacted to the pressure from the bronze hand, causing a swelling of the trunk around that point. Penone's gesture, his touching of nature, is thus preserved and continues to make its impact visible. The work is a form of collaboration with nature.

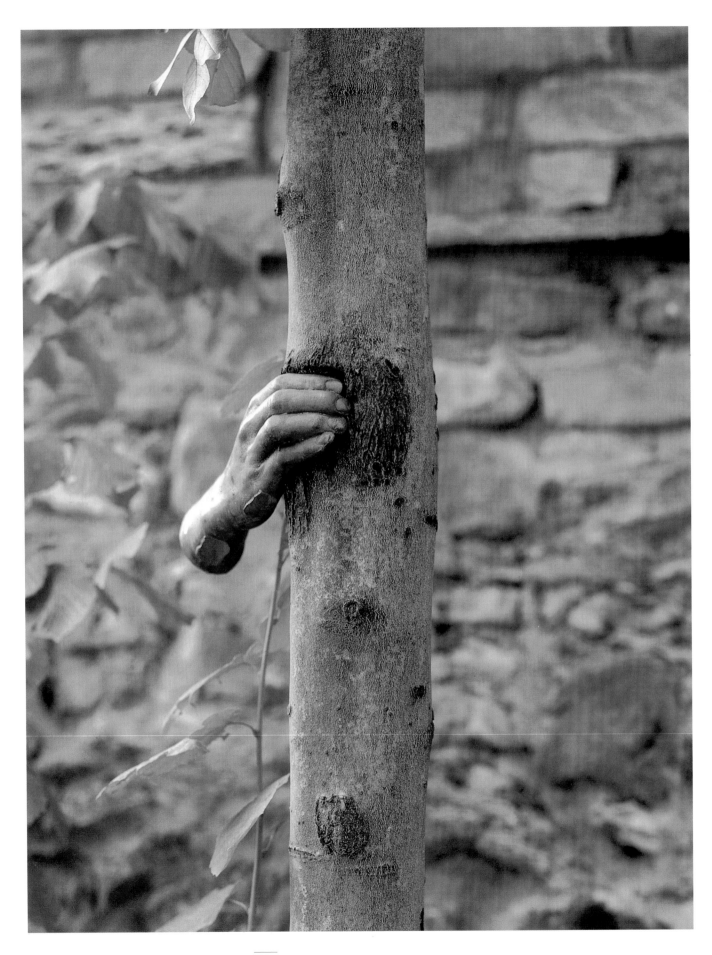

fig.4
Giuseppe Penone
*Maritime Alps. It will go
on growing except at that
point* 1968–78
Garressio, Italy

Walking a Line

These innovative works by Heizer, De Maria and Penone offered a new language and direction, as well as a new context, for contemporary art. But towards the end of 1968, in November, the British artist Richard Long made an audacious work that, with its radical simplicity, broke even more completely with traditions of landscape art. Long walked for ten miles in a straight line across the high moorland landscape of Exmoor in the south-west of England and designated this simple action a work of art. While superficially *A Ten Mile Walk, England* 1968 seems to offer an interesting parallel with De Maria's lines in the desert, it actually articulates a very different kind of engagement with the landscape (fig.5). Long's work was dematerialised, part action, part documentation, an actual event in a specific place at a precise point in time. Unlike De Maria, Heizer or Penone, Long did not mark the landscape through which he passed. While for the artist the walk was clearly a vivid reality, for the viewer the only trace of the work, our only way of accessing this reality, is through a map with the route of the walk ruled onto it. Certain information can be gained from this document: we can see that Long began at a track near Clovenrocks Bridge before climbing onto high ground, roughly following a ridge line, before passing several ancient sites – cumuli, barrows and standing stones – crossing several streams and rivers and two roads and eventually finishing in Cowley Wood. We can see that he didn't follow a track or path but that he must have walked his line following a compass bearing. We can guess at the terrain underfoot; heather, rocks, grass. But we know nothing of the weather, of Long's state of mind. For an audience, *A Ten Mile Walk, England* 1968 is a piece of Conceptual art. Nonetheless, it is also sculptural in its articulation of a passage through space, and distinctive in the radical simplicity of its approach to landscape.

Long's practice was a beguiling combination of visionary innovation and pragmatism: He said: 'My work is simple and practical. I may choose rolling moorland to make a straight ten mile walk because that is the best place to make

fig.5
Richard Long
A Ten Mile Walk, England
1968

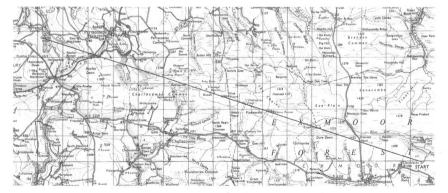

A TEN MILE WALK
ENGLAND 1968

such a work, and I know such places well.' Yet his ambition in making works such as this was nothing less than a revision of the scope and subjects of contemporary art. He said later:

> In the mid-sixties the language and ambition of art was due for renewal. I felt art had barely recognized the natural landscapes which cover this planet, or had used the experiences those places could offer. Starting on my own doorstep and later spreading, part of my work since has been to try to engage this potential. I see it as abstract art laid down in the real spaces of the world.[6]

Even today, to make such an imaginative leap and designate a walk in the landscape a work of art seems extraordinarily brave. Long's work, and Penone's, De Maria's, Heizers's and that of a number of their contemporaries, signalled a revolution in art and made possible a new range of responses to landscape and nature.

Trauma and Idealism

How are we to make sense of these diverse activities? How are we to connect them? Clearly they share a single key characteristic. They are actions, processes – the making of art – carried out in the landscape; not in the studio or the gallery.

These works were neither the earliest nor most important in the genre that can be described as 'Land art', but they do give some sense of the extraordinary breadth and variety of work that it encompasses. Nor was 1968 a definitive year zero. Long had been making works in the landscape since 1964, the same year in which De Maria had made an unrealised proposal for a sculpture in the desert, and other artists including Alan Sonfist and Robert Morris had also previously made pioneering works and proposals.[7] However, 1968 was a moment when artistic ideas and themes that had been developing for some time could begin to be characterised in this way. In this year, both Long and Penone held their first solo shows, in Germany and Italy respectively, and in October, the Dwan Gallery in New York opened an exhibition organised by Robert Smithson, entitled *Earthworks*.[8] The show included work by a group of American artists including Smithson, Heizer and De Maria, as well as Dennis Oppenheim, Robert Morris and others, and was perhaps the first exhibition to survey an emerging tendency to make work in and about the landscape.

The year 1968 was one of radical change, of reassessment, of revolution. It was a 'year that rocked the world'.[9] For many in America it represented a point when the idealism of the early 1960s gave way to a profound sense of discontent, encouraging a widespread questioning of civil codes and societal structures. The Cold War was at its height. American involvement in Vietnam had also peaked and 1968 witnessed the greatest annual number of American casualties – 14,589 – in the entire conflict.[10] The US was rocked by anti-war and civil-rights demonstrations, by race riots and the assassinations of both Martin Luther King Jr and Robert Kennedy. The troubled state of America in 1968 is reflected in the number of movies

depicting societies in crisis that appeared that year and the next, including *Night of the Living Dead* (1968), *Planet of the Apes* (1968), *Easy Rider* (1969) and *Zabriskie Point* (1969).[11] When the curator Alanna Heiss returned to New York in 1970 after a period living in London she described the landscape of America as consisting of 'the Manson murders, the moon landing and the Vietnam War.'[12]

In 1968 the discontent was not confined to the United States. In Europe there was also widespread unrest. In Czechoslovakia the so-called 'Prague Spring' saw Alexander Dubcek introduce liberal reforms – based on 'the conviction that man and mankind are capable not only of learning about the world, but also of changing it' – which were crushed just months later by an invasion force from five different Warsaw Pact countries. In France the insurrectionary activities of the Situationist Internationale (Guy Debord's revolutionary *La Societe du Spectacle* had been published in 1967) were one factor in the explosive combination of political outrage, nihilism and desire for revolutionary change that led to widespread rioting in Paris, Bordeaux, Nantes and Lyons in May.

In 1968 the threat of nuclear warfare – and global annihilation – was seen as a very real possibility. Rampant nuclear proliferation was a cause for concern. Ecological issues were also becoming more prominent, as the arguments first made at the beginning of the decade, in publications such as Rachel Carson's *Silent Spring* (1962) became more widely understood. In 1969 Friends of the Earth was founded.

1968 also saw the acceleration of the space race. In December, Apollo 8 successfully made the first manned orbit of the moon, the result of a push that would culminate in the moon landing the following year. As a result, the end of the year saw the widespread publication of the first images of the earth from space, changing the way in which we visualise our world for ever (fig.6).

Land art reflected the socio-cultural conditions of its time. It originated during a period of conflict, a time that embodied a paradox of idealism and trauma, and this is encoded within the genre.[13] The context from which Land art sprang also informed the way in which it was received and interpreted by its observers. It is simplistic to assume, as many did (and continue to do), that because the work was made out-of-doors, in the desert, on the land, about the experience of nature, this was an art form of environmental consciousness and protest. While a number of the artists were, and have continued to be, vocal in their support of environmental issues, others were deliberately and defiantly non-committal and apolitical. While Heizer proclaimed that the H-Bomb was 'the ultimate sculpture' and boasted to his patron Robert Scull that his massive *Complex One* 1972–6 could withstand a nuclear attack, Long pointedly said that he wanted 'to do away with nuclear weapons, not make art that can withstand them'.[14]

Land art betrays the conflicted attitudes of the time towards the earth and the environment. It encompasses the scarring of the landscape, the ecological reclamation of industrially devastated terrain, an impulse towards change and permanence and an attitude of respect, a desire to 'leave no trace'. It is both grossly

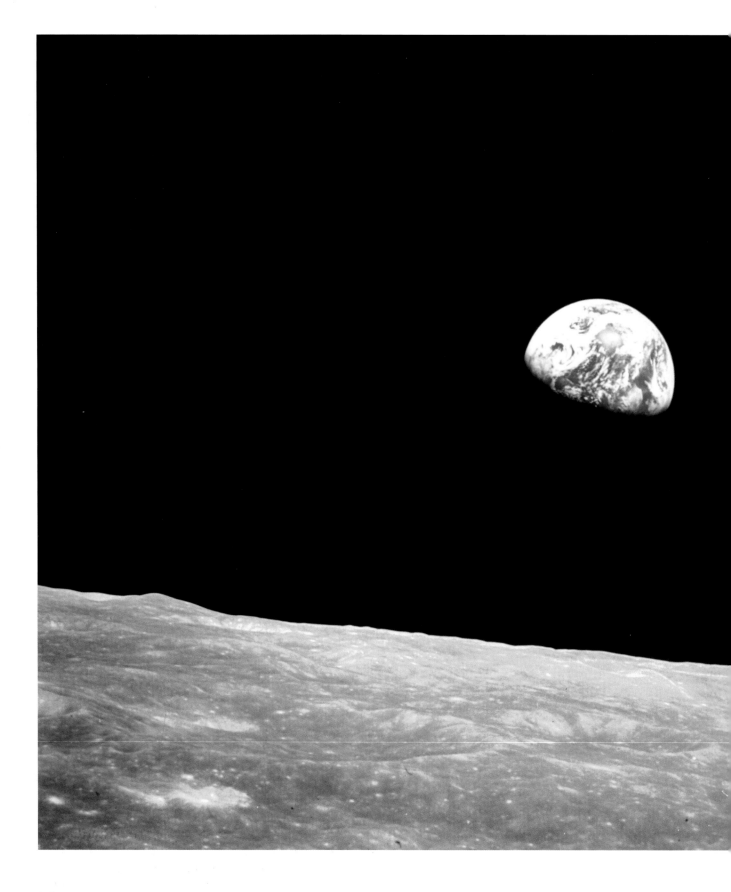

fig.6
The Earth viewed
from Apollo 8,
December 1968

material and intensely spiritual. It abounds with images of birth and burial, life and death. As such, it reflects the complexity of our relationships with landscape and nature at the end of the twentieth century and the beginning of a new millennium.

The Wreck of Former Boundaries

What then is Land art? It is clearly not a movement – an 'ism'– with defined aims, clear membership, a manifesto. The various works discussed in this book were not made by artists who banded together out of a commonality of purpose like, for example, the Surrealists (although it can be noted that many of them have worked together and have formed close artistic relationships). In this sense, there is no such thing as 'Land art'. There are rather a number of artists who have regularly and consistently been described as 'Land artists' (including most usually the Americans Heizer, De Maria, Smithson, Robert Morris, Nancy Holt, Helen Mayer Harrison and Newton Harrison, Peter Hutchison, Dennis Oppenheim, James Turrell, Charles Ross, Alan Sonfist and others, and Europeans such as Long, Penone, Hamish Fulton, David Nash, Christo, herman de vries and Andy Goldsworthy). However, almost all of these artists have been equally consistent and insistent in rejecting such a label. For many the term is historically specific, being used in the early 1970s to denote a very particular kind of work: American earthworks. However, compared to the other terms in use, such as Earth art, Environmental art or Eco-art, this seems to be the most useful, being appropriately open and non-specific, suggesting theme but not style. Nonetheless, there are conceptual grounds for examining the work of these diverse artists together, alongside a range of other artists including Keith Arnatt, Francis Alys, Joseph Beuys, Ana Mendieta, Andrea Zittel and others.

Such a broad grouping belies considerable ideological differences that are – as a generalization – most pronounced between European and American artists. For example, both Long and Fulton have been vocal in criticising the actions of many of the Americans. Stressing the distance between his work and that of De Maria and Heizer, Long has said:

> My interest was in a more thoughtful view of art and nature, making art both visible and invisible, using ideas, walking, stones, tracks, water, time, etc, in a flexible way ... It was the antithesis of so-called American Land Art, where the artist needed money to be an artist, to buy real estate, to claim possession of the land and wield machinery. True capitalist art.[15]

Nonetheless, taken together, the works of these artists do reveal certain thematic consistencies. They propose a cohesive argument, or rather arguments, a set of propositions about our relationships with the land and nature, about the way in which art can articulate the experience of landscape and nature. As a genre it addresses seismic changes in art, culture and society that continue to be of relevance today.

Broadly, Land art is characterised by an immediate and visceral interaction with landscape, nature and the environment. Of course, one can argue that a painting by

J.M.W. Turner represents just such a response to the landscape, but Land art is primarily physical and non-representational, unlike traditional Western forms of landscape art. It is not simply sculpture placed in the landscape but encompasses an attitude to site and experience that goes beyond the object, emphasising the landscape in which it is sited, often bringing it within the compass of the work and so rendering it an active component rather than merely a setting.

Above all else, the primary concern that links all the artists discussed in this book is the use of art to enact or articulate a direct, non-pictorial engagement with landscape and nature, or to re-order our response to place, landscape or nature. The form taken by this engagement varies enormously, of course. It can be destructive, reverent, ritualistic or constructive, conceptual and ephemeral. The actions involved in the making of such art – excavating, building, mapping, walking – are mirrored by the very physical actions – travelling, walking, crawling, climbing (as well as looking and thinking) – required of the viewer of much of the work. Given that the art event (the artist's action or the completed sculpture) often takes place in the landscape, away from the gallery, documentation is often a key aspect of the work and is how we, as viewers, access it. The revolutionary character of Land art is revealed when one considers that it is an essentially sculptural genre and yet there is no existing Western tradition of landscape sculpture.

Most importantly, Land art is about and is in the real world. This is a concern that has been attributed both to Pop art and to Minimalism – two of Land art's immediate (urban) precursors – but which, in retaining and respecting the sanctity of the art object and the gallery space, these earlier movements could only represent symbolically. Arising at the end of the 1960s, a decade dominated by reductive theoretical debates about abstraction, Land art stood for real life. It demanded actual contact: real experiences, as Long suggested, 'in the real spaces of the world'.[16]

In June 1968 Robert Smithson, his wife the artist Nancy Holt, the dealer Virginia Dwan and the artist Dan Graham visited the slate quarries in Bangor-Pen Angyl, Pennsylvania. Here, Smithson felt a giddy sense of human and geological relativity. He described the trip in an important essay, 'A Sedimentation of the Mind: Earth Projects', published in *Artforum* in September 1968:

> Banks of suspended slate hung over a greenish-blue pond at the bottom of a deep quarry. All boundaries and distinctions lost their meaning in this ocean of slate and collapsed all notions of gestalt unity. The present fell forward and backward into a tumult of 'dedifferentiation', to use Anton Ehrenzweig's word for entropy. It was as though one was at the bottom of a petrified sea and gazing on countless stratographic horizons that had fallen into endless directions of steepness. Syncline (downward) and anticline (upward) outcroppings and the asymmetrical cave-ins caused minor swoons and vertigos. The brittleness of the site seemed to swarm around one, causing a sense of displacement. I collected a canvas bag full of slate chips for a small *Non-Site*.[17]

Smithson's *Nonsite* was to be a new kind of sculpture that would relate an object in an art gallery to a specific location in the landscape (fig.7). A container resembling

a modular Minimalist sculpture, within which the slate chips were placed, would be exhibited alongside a map indicating their source, the 'site'; *Site* and *Nonsite* thus established a dialectic of presence and absence, past and present, object and idea.

In 'A Sedimentation of the Mind' Smithson went on to propose a new form of art that would engage with the kinds of experiences that the slate quarries had offered, and would break with existing modes of thinking about art. Referencing work by Heizer, De Maria, Robert Morris and others, he proposed the development of new 'earth projects' that would engage with the earth itself, its geology, and concepts of entropy and time. They would 'explore the pre- and post-historic mind' and 'go into places where remote futures meet remote pasts'.[18] Such notions of place and relativity, and site-specificity, would be developed as central themes running through the genre.

Land art occupies a key position within a series of pivotal artistic debates and developments originating in the mid-1960s. It is one aspect of a sea-change in art and thinking about art – away from the notion of art as a process dedicated to the production of a physical object or image, an artwork – that we might broadly characterise as 'Conceptualism'. As such, it is one of a number of 'post-studio' strategies that began to engage with what Rosalind Krauss called the 'expanded field' of sculpture, and which explored the 'dematerialisation' of the artwork, to use Lucy Lippard's formulation.[19] Idea, process and experience are prioritised above objecthood.

Land art also plays an extremely important role in the undoing or opening up of the relationship between the artist and the gallery and by implication the economic structures of the gallery and museum system. By working outside the gallery, in the landscape, by making works that could not (in theory) be sold or, in some cases, even exhibited, and by thus initiating a critique of the role of the gallery or museum institution, artists such as Smithson are said to have forged a new model for the artist, and in expanding the means and areas in which the artist might operate. While many of these revolutionary ideas proved unviable in practice – considerable finance is required to build a major earthwork, and the artist is forced to negotiate with funding bodies, dealers, patrons, collectors, and perhaps commissioning museums or government organisations, even before the practicalities of construction can begin – they are of continuing relevance for young artists today.[20] In terms of social and environmental responsibility, artists such as Beuys proposed new models for the relationship between man and nature in their work, and therefore a new role for the artist in society, which has also had far-reaching consequences.

Reading Land Art

This book examines some of the different manifestations of Land art from the mid-1960s to the present day. It is important to stress that it does not set out to construct a comprehensive or definitive account but rather to represent a personal and partial discussion of the subject. Due to the limitations of space, it has not been possible to include many admirable artists who would otherwise have warranted discussion.

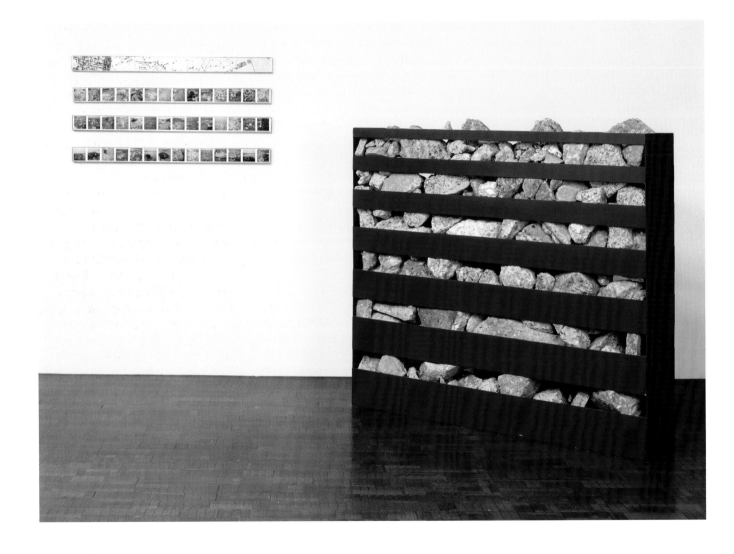

fig.7
Robert Smithson
Nonsite 'A Line of Wreckage',
Bayonne, New Jersey 1968
Painted aluminium container,
broken concrete, framed map
and panels with photographs
Container 149.9 × 177.8 × 31.7 cm;
each panel 9.5 × 124.4 cm
Milwaukee Art Museum

A number of important thematic concerns – for example, the connections with gardens and gardening that many of the works suggest – also had to be omitted. In addition, the focus here is on the manifestations of Land art in the West. While many of the actions and works of the Gutai and Mono-Ha groups in Japan – see for example Kazuo Shiraga's performance *Challenging Mud* 1955, in which the artist wrestled naked with mud until exhausted, or Nobuo Sekine's *Phase – Mother Earth* 1968, a huge cylinder of earth and corresponding excavation – and more recent projects such as Rikrit Tiravanija's *The Land* in Thailand echo the thematic concerns addressed here, they have not been included. Neither has it been possible to discuss the extraordinary response to the work of artists such as Long, Nash and Goldsworthy in Japan, where they have inspired a kind of 'school' of Land art.[21]

The book begins with detailed discussion of the work of two key artists, Richard Long and Robert Smithson, who are not only important innovators but whose work exemplifies and embodies the complications and contradictions of the genre, exposing the different attitudes and responses towards landscape found in the US and Europe. Consideration of their work is followed by a thematic reading of the genre, looking at the development of earthworks in the US, a corresponding development of more ephemeral and nature-based practices in Europe, issues around the placing the artist's body within the landscape, environmentally orientated work, notions of collaboration with natural processes and materials, and explorations of prehistory, astronomy and ritual. Where works of art in the landscape such as earthworks are described, first-hand accounts are employed to evoke the experience.

This publication also attempts to redress a historical imbalance in previous accounts, whereby American artists, particularly those working with earthworks, are prioritised over Europeans whose work is perhaps small-scale or ephemeral. The implication in these studies is that the impermanent, nature-based aspects of the genre produced in Europe represent a kind of watered-down response to the ground-breaking work being done in the US, something that is clearly not the case.

It should also be noted that Land art is not a historic phenomenon limited to a period from 1968 to approximately 1977, as is often implied. A number of the artists who came to prominence in the late 1960s and early 1970s continue to make fascinating and important work, and to forge significant developments in their work. In addition, a number of younger artists are now exploring and extending the legacy of that earlier generation of innovators. We end, therefore, with a review of these recent developments.

The art form that emerges from this extended analysis is an activity that is historically important, socially reflexive, politically engaged, metamorphic in its forms, both consistent and inconsistent, contradictory even, but which continues to be vital, exciting, innovative and relevant. Moreover, Land art is important because – even at its most formal or conceptual – it urges us to re-examine our relationship with the landscape and with nature. It is hard to think of any other recent form of art that engages with ideas of such contemporary relevance.

SIMPLE, PRACTICAL, EMOTIONAL, QUIET, VIGOROUS
THE ART OF RICHARD LONG

1

'My art is about working in the wide world, wherever on the surface of the earth. My art has the themes of materials, ideas, movement, time. The beauty of objects, thoughts, places and actions.' [1]

In published statements about his work, Richard Long has consistently emphasised the simplicity of what he does, stressing the ordinariness of his abilities and the materials with which he works. For example, in explaining his use of stones in his sculptures he has said: 'I use stones because I like stones or because they're easy to find, without being anything special, so common that you can find them anywhere. I don't have to have a special skill or talent for using them. I don't have to bring anything to them, I can just make a sculpture.' [2] 'I like', he has summarised, 'simple, practical, emotional, quiet, vigorous art'. [3] And indeed, at first glance Long's art does seem simple, disarmingly so. It consists only of walks made on roads and paths and across varied landscapes; arrangements of stones and sticks – usually in lines or circles – either made and photographed in the landscape or placed on the floor in the gallery; short but evocative texts; photographs of the marks made on rocks or the ground by water tipped from a bottle; wall works using poured or scrubbed mud. Long's emphasis is on fundamentals, essences, archetypes, both in the work itself and his positioning of it in texts and interviews. His is a hands-on, undemonstrative, non-theoretical approach. 'A good work is the right thing in the right place at the right time', he has said. [4]

Yet this emphasis on simplicity belies the conceptual and imaginative richness of Long's art, which explores complex ideas about time, space and experience. It plays down the audacity and originality of his early work, and the enduring authority and resonance of his vision of a new form of landscape art. Finally, it fails to allow for the striking wit and playfulness of his art, which also encompasses seemingly absurdist projects (such as the carrying of a stone from a beach on one side of England to a beach on the other, and then carrying another back again) and even misadventures such as the artist falling into a river. [5] Long's is a body of work that, over a period spanning forty years, has accumulated progressive richness and layers of meaning, constituting a web of references that increasingly interconnect across the surface of the planet. From its beginnings in Bristol and London, Long's art has expanded to encompass places as distant and varied as the remote Himalayan mountains of Ladakh and Zanskar and the Hoggar desert in Algeria. It proceeds conceptually (and, one might suggest, magically) from the modest premise that the action of walking can be understood as art, to encompass, in Anne Seymour's words 'the entire visible and invisible flux of the structure of life'. [6] At the same time it places the artist at the centre of his world, and stresses the physical nature of his engagement with it. It is, in Long's own words from 1971: 'From a mountain top in Africa / To a Tennessee riverbed, brushing through hoar frost / Magic signs, secret journeys / A portrait of the artist touching the earth.' [7]

It was striking, in researching this book, to note how often Long's

fig.8
Richard Long
Sahara Line 1988

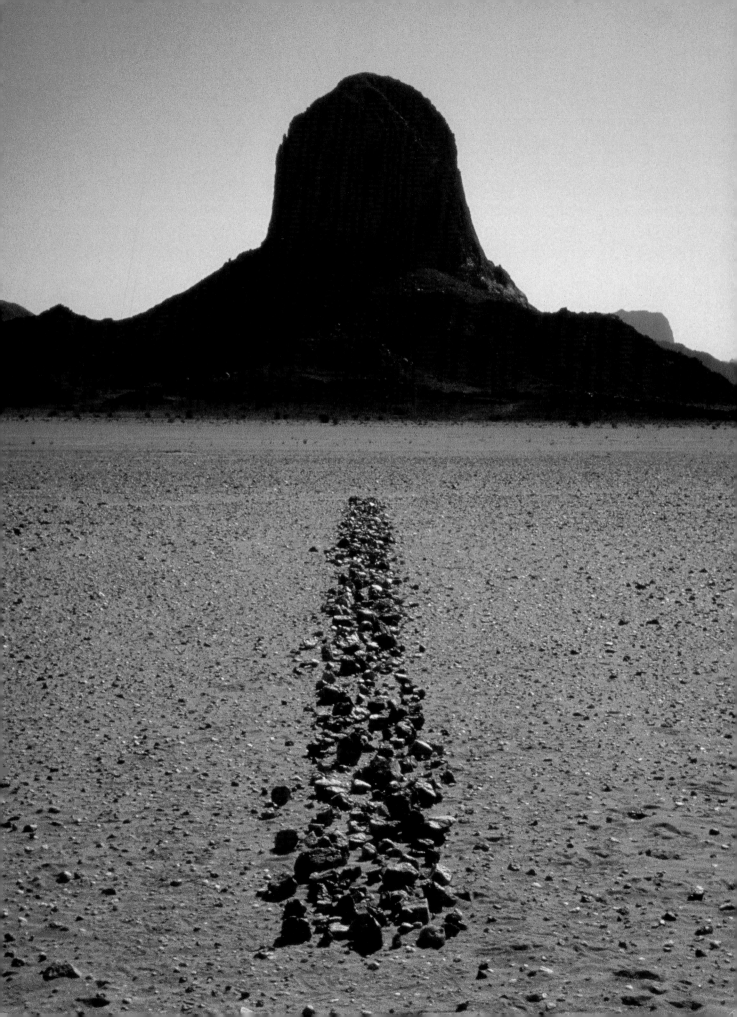

contemporaries compared him to Henry Moore. For generations of British artists who attained maturity between the 1930s and the 1950s, Moore was the leading figure of British modernism, a major international artist who broke down barriers and through his own innovations and successes enabled his contemporaries.

It is clear that for a generation of British, and subsequently international, artists Long is regarded in a similar way, as an exemplar. The sculptor David Nash recently suggested that 'Long liberated us, I respect him for liberating a lot of artists by just stepping over the boundaries of object-making.'[8]

Early Contexts

Long identified and began to explore his enduring themes from a remarkably early age. Growing up in Bristol, he attended the West of England College of Art there from 1962. His early exploration of the traditional (and then highly unfashionable) subject of landscape, and his attempts to find new ways to address it, such as *A Snowball Drawing* 1964 – in which Long made an abstract 'drawing' by creating a snowball – were so unconventional that he was eventually asked to leave. Undeterred he made work using turfs in his parent's garden and in the garden of a house in Bristol occupied by fellow students. As well as these outdoor pieces, he also used a derelict house to experiment with work utilising heaps of sand, leaves, blankets or poured plaster, which paralleled contemporaneous developments – of which Long had no knowledge – being made in New York and London by artists such as Robert Morris and Barry Flanagan.

In the mid-1960s the British art world was dominated by two tendencies: Pop art and the formalist sculpture of Anthony Caro and his followers. While there was widespread fascination with American culture, and work by American Pop artists such as Warhol and Lichtenstein was known to some, Minimalism had as yet received little or no exposure in the UK.[9]

In 1966 Long arrived in London to study on the 'Advanced' Sculpture Course set up by Frank Martin at St Martins School of Art. Martin aimed to 'create an open and exploratory environment'. Students were regarded as 'potential artists' and therefore encouraged to 'break new ground' rather than attempt to 'fit into an existing art situation'.[10] The course had quickly established a reputation for challenging accepted conventions and had been a forcing ground for 'New Generation' sculpture in the early-1960s. This highly formalised approach to sculpture, which dispensed with the plinth and placed the work directly on the floor in order to activate the surrounding space, was exemplified by the welded metal works of Anthony Caro and the use of brightly coloured plastics and other new materials by Philip King. Caro, King and William Tucker all taught at St Martins and by the mid-1960s this kind of work was much imitated by the regular students. However, Long's contemporaries on the Advanced course included a number of artists who were to be important to the development of Conceptualism, including Hamish Fulton, Gilbert & George, Barry Flanagan,

Jan Dibbets (on a British Council Scholarship 1967–8), Ger Van Elk, John Peck, Bruce McLean, David Lamelas, David Dye and John Hilliard. They set out to question the accepted notion of what might constitute sculpture. The course was taught by Peter Atkins 1966–9, and his emphasis on the analysis of wide-ranging creative processes as opposed to finished form led to the group making strongly conceptual and process-based work, much predicated upon personal, subjective experience.[11] In addition, Long's interest in the rehabilitation of landscape as a subject for contemporary art was shared by a number of his contemporaries, in particular Fulton (and also – at that time – Gilbert & George, Jan Dibbets and John Hilliard).

This period was a fertile one for Long. He said: 'I had a very strong feeling that art could embrace so many more things than it was at the time, that it could be about things like grass and clouds and water, natural phenomena, rather than just the slightly sterile academic, almost mannerism of welding bits of metal together, or using plaster, or the general kind of studio work at that time.'[12] The St Martins situation allowed for the free play of experiment and influence and gave Long the space to follow his instinct and develop a radical new way of dealing with landscape.

At St Martins Long began to make work that involved expanded notions of space and scale. His key work of this time, which the curator Rudi Fuchs later compared to Kasimir Malevich's *Black Square* in terms of its importance as a radical rupture with the art of the past, was *A Line Made by Walking* of 1967 (fig.9). Long has said that 'I like the simplicity of walking',[13] and this work was, in the words of Fuchs, of 'almost intolerable simplicity'.[14] The artist simply walked up and down along a line across a field, until his footprints had worn a visible path in the grass. The path was then photographed. It is thus as if the work were split into two parts: the making of the work – the walking of the line – being the primary element, and the black and white photograph and caption functioning as a kind of residue or souvenir of that particular action made in a particular place on a particular day in 1967.

The important breakthrough was the realisation that art could be made by as simple an action as walking in the landscape. Fuchs wrote:

> the fact that it used the real earth, without adding or subtracting other materials, hardly disturbing the ground that was walked on, opened up an enormous new range of content. In principle a walk could traverse different landscapes, at different times of day and night, in different conditions of weather and through different states of mind on the part of the walker – and thereby making all these aspects of the real world part of the sculpture.

For Fuchs this work suggested a new status for the artwork. 'The sculpture became a part of the world, an articulation of it – not an addition, not a stable object.'[15] Crucially, it also foregrounded the active presence of the artist in the landscape, 'touching the earth'.

A Line Made by Walking opened up an extraordinarily wide field of conceptual play for Long, not least in terms of scale. This was something he explored in his *Bicycle Sculpture* 1967[16] – which covered an area of 'approximately 2,400 square

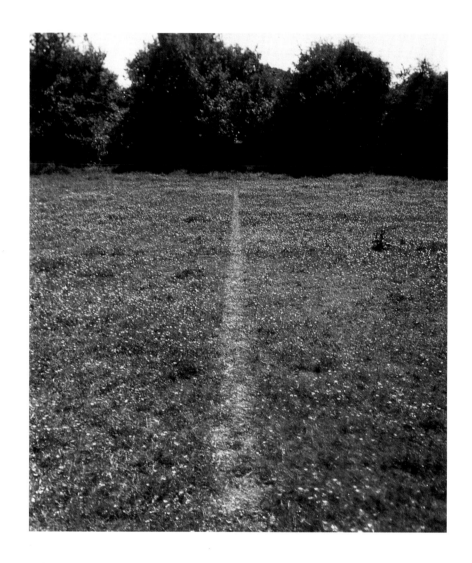

A LINE MADE BY WALKING

ENGLAND 1967

miles' – and *A Ten Mile Walk, England* 1968 (fig.5). Without moving any earth or stone, nor building anything, Long was making sculptures that – conceptually at least – were the biggest ever created.

Clearly it was impossible for such works to be brought into the gallery, or for a viewer to retrace Long's steps, so he began to use texts, maps and photographs to represent the sculptures in exhibitions and publications, and to establish a distinction between the works he made in the landscape and the sculptures he created specifically for display in galleries. His use of documentary materials such as photographs and maps was similar to contemporary practices in Conceptual art – see, for example, work by Joseph Kosuth, Douglas Huebler or Jan Dibbets – and have remained cornerstones of his practice ever since. However, Long has distinguished his work from Conceptual art, saying: 'My work is real, not illusory or conceptual. It is about real stones, real time, real actions.'[17] We might qualify this by suggesting that while the experiences are never anything other than 'real' for the artist, for the audience such works require an imaginative engagement; they are therefore conceptual, possibly even illusory.

International Contexts

While the St Martins situation was clearly important for his development, it is difficult to limit Long's work to a British context, even at this initial stage. From very early on he exhibited internationally and made contact with a wide range of both European and American artists. Within a year of his first solo show (which was offered following a recommendation by Jan Dibbets) at the newly established Konrad Fischer Gallery, Düsseldorf, in 1968, he had held solo exhibitions at John Gibson Gallery, New York; Museum Haus Lange, Krefeld; Yvon Lambert Gallery, Paris and the Gallery Lambert, Milan. He showed at the Dwan Gallery, New York – a key space in the development of American Land art – in 1970. Group shows in which he took part included *19:45-21:55*, Galerie Loehr, Frankfurt, in 1966, and *A3: Arte e Azione Povera*, Amalfi in 1968. In 1969 he participated in the important show *Earth Art*, at the Andrew Dickson White Art Gallery, Cornell University, Ithaca, New York; *Op Losse Schroeven*, Stedelijk Museum, Amsterdam; *Ecologic Art*, John Gibson Gallery, New York; *When Attitudes Become Form*, Kunsthalle Bern and Institute of Contemporary Arts, London; *Prospect 69* at the Städtische Kunsthalle, Düsseldorf; and the pioneering television/video project *Land Art*, Fernsehgalerie Gerry Schum, Dusseldorf.[18]

It is clear then, that from a very early stage, Long was in touch with the artists, dealers and collectors who were instrumental in the development of the Arte Povera movement in Italy, Conceptual art in both Europe and America and what would come to be identified as Land art. Of particular importance for Long were contacts with the Arte Povera group and with artists exhibiting in Prospect 1968, which was on at the same time as his first solo show, including Carl Andre, Beuys, Panamarenko and Buren, amongst others.[19]

fig.9
Richard Long
A Line Made by Walking
1967

Of the various avant-gardes emerging at the end of the 1960s Long's work perhaps has the greatest sympathy with Arte Povera. This term, literally meaning 'poor' or 'impoverished' art, was coined by the Milanese critic and curator Germano Celant in 1967 and was used to describe the work of a diverse group of artists whom Celant promoted in a series of exhibitions and publications. Including Penone, Jannis Kounellis, Giovanni Anselmo, Michelangelo Pistoletto and Mario Merz, the group used commonplace materials to evoke complex and poetic ideas. A number of the artists, including Penone and Anselmo, were much preoccupied with natural and organic processes such as growth and decay. Like Long, they made work in the landscape and created gallery installations using found materials such as plants and stones. At its inception Arte Povera was promoted as presenting a radical socio-political agenda. The Swiss curator Christophe Amman wrote in 1970: '*Ars Povera* means art that aspires to a poetic message in opposition to the technological world, and expresses that message by the simplest means. This return to the simplest and most natural laws and processes, with materials deriving from the power of the imagination, is equivalent to a re-evaluation of one's behaviour in industrialised society.'[20] It may not have been Long's principal intention to make work that was politicised in this way, but nonetheless such readings can and have certainly been applied to his work.

Objects, Thoughts, Places

Long has always insisted upon a clear distinction between the works made in the landscape and in galleries, saying that: 'the maps and the texts and the photos feed the imagination, and the sculptures in the gallery feed the senses'.[21] This is an essential distinction, yet Long's oeuvre has a remarkable unity because central to both kinds of work is the singular and personal experience of the landscape, which he accesses through his walks.

The walk is the ideological starting point and can take many forms. Planned, logical, a walk might follow a geological feature such as a river or coastline, or might be structured by geometrical forms such as grids (for example, *Eight Walks, Dartmoor, England* 1974) or circles (for example, *A Six Day Walk Over All Roads, Lanes and Double Tracks Inside a Six Mile Wide Circle Centred on The Giant of Cerne Abbas, Dorset* 1975). It might be conceived in order to enact a Beckettian premise such as keeping a different song in mind each day on a six day walk across Ireland (*Walking Music, Ireland* 2004). Long may travel with the intention of making a sculpture in a particular place, as he did in 1969 when he went to Kenya and climbed Mount Kilimanjaro in order to make a sculpture on the summit. However, within predefined walks there might arise unexpected opportunities for works – a line made in the dirt with a boot heel or a circle made with stones and boulders, such as *Arizona* 1970 or *A Circle in the Andes* 1972 (fig.10) – which the artist seizes in the spirit of opportunism and preserves with the camera. The experiences of the walks, the structure of the walks, their guiding principles, are then made public

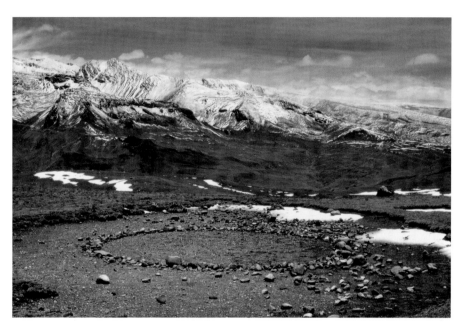

A CIRCLE IN THE ANDES 1972

in different ways. As well as photographs, there are maps, texts and sculptures.

Long's sculptures – the physical, three-dimensional objects that he makes, as opposed to the physical and three-dimensional experiences that the walks represent – fall into two distinct categories: sculptures made on the walks, in the landscape, and documented by photography; and sculptures made in the gallery as a response to space and locality. However, it is interesting to note that many of his early gallery installations were also made by walking. For exhibitions at the Dwan Gallery, New York, in 1970 and Whitechapel Art Gallery in 1971, when he showed *A Line the Length of a Straight Walk from the Bottom to the Top of Silbury Hill* 1971, and at the Stedelijk Museum, Amsterdam, in 1973, when he showed *A Line the Length of a Straight Walk from the Bottom to the Top of Glastonbury Tor*, Long walked with muddy bare feet across the gallery, thereby inscribing spirals onto the floor. While this is a strategy that he has continued to employ, he has more usually created lines and circles of stone or wood using materials gathered or quarried locally, thus evoking the specific area in which the exhibition takes place.

Above all, Long's work is determined by his experience, his response to particular places. He has said: 'I choose circles and lines because they do the job.' Yet he has also stressed that 'the creation in my art is not in the common forms – circles, lines – I use, but the places I choose to put them in', thus foregrounding the notion of site-specificity (the right thing in the right place at the right time) and the experience of place (both in the gallery and outside).[22]

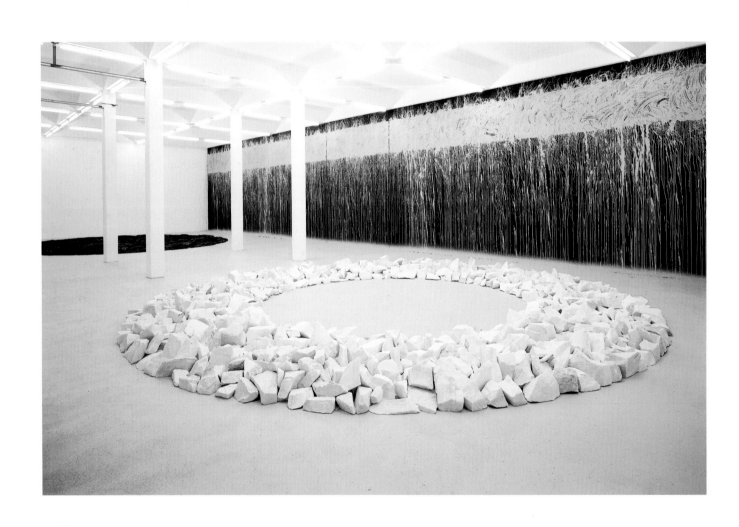

fig.11
Richard Long
Installation at Galerie
Tschudi, Glarus, 1993
showing *Ring of White
Marble* 1993 and *Muddy
Water Wall* 1993

fig.12
Richard Long
Engadine Walk 2004

ENGADINE WALK

ONE NEW MOON TWO THUNDERSTORMS
THREE PLACES OF STANDING STONES WALKING FOR FOURTEEN DAYS
OVER SEVENTEEN MOUNTAIN PASSES FORTY ONE RIVER CROSSINGS
A HUNDRED AND EIGHT STONES ADDED TO A SUMMIT CAIRN
WHILE THE EARTH TRAVELS 22,260,000 MILES IN ITS ORBIT
COUNTLESS STARS THE INFINITY OF SPACE

FROM ZUOZ TO ZUOZ SWITZERLAND SUMMER 2004

Long's separation of work made *in* the landscape and work made *for* the gallery space also suggests an interesting parallel with a key concept of his American contemporary, Robert Smithson. Smithson's theoretical framework of *Site* and *Nonsite* (a relationship equivalent to the linguistic formulation of signifier and signified), articulates a similar division in the structuring of the work. The *Site* is the original and unique place in the landscape, while the *Nonsite* is Smithson's presentation of a form of analogue or equivalent, often comprising actual geological material, maps, mirrors and texts, in the gallery space. Long's stone lines and circles in the gallery function in a similar way to Smithson's *Nonsites* in that they act primarily on the senses in an immediate and visceral way, but they ultimately refer to something that is elsewhere; another place and a past experience.

Smithson was critical of this aspect of Long's practice, suggesting that it actually failed to establish a meaningful dialectic between the two locations, being instead mired in 'vagueness'.[23] This may be a valid criticism but it is also possible that Smithson misunderstood the relationship that Long's work articulates, which, as much as it is about material facts – those of gallery and landscape location, as well as the specific properties of different kinds of materials used for sculpture – is also about ordering different kinds of experience: walking in the landscape, looking at a sculpture; imaginative engagement. Smithson's critique also suggests a subtle but crucial distinction between the two artists' approaches. Long's 'vagueness' is perhaps a form of openness; Smithson's art was more concerned with definitive statements.

The Infinity of Space

Long has persistently stressed the simplicity of what he does. He has also been remarkably consistent, both in his approach to the making of art and in the forms and means that he has employed. However, there has been a steady development within his work and in the last decade he has embraced what might be described as a kind of cosmic expansion. Long's interest in mathematics, physics and cosmology, and the unfathomable distances, numbers and proportions in which they deal, has increasingly led him to introduce a sense of the ineffable to his work.

Engadine Walk 2004 is a text work that describes a walk beginning and ending at Zuoz in Switzerland, made in the summer of 2004 (fig.12). The short text gives us the information that Long walked for 'fourteen days', crossing 'seventeen mountain passes' and made 'forty one river crossings' before zooming out, so to speak, and introducing a giddy degree of relativity by noting that the earth has travelled '22,260,000 miles in its orbit'. At this point, Long's frame of reference expands at a frightening rate, to encompass 'Countless stars' and finally, 'The infinity of space.'

This makes explicit what has been implicit in Long's work from the very beginning: a preoccupation with ideas of relativity and the evocation of what Robert MacFarlane, in his book *Mountains of the Mind* (2003), has characterised as 'deep time'. As a student, Long studied Bertrand Russell's *ABC of Relativity* (1925) and was

DARTMOOR TIME

A CONTINUOUS WALK OF 24 HOURS ON DARTMOOR

1½ HOURS OF EARLY MORNING MIST
THE SPLIT SECOND CHIRRUP OF A SKYLARK
SKIRTING THE BRONZE AGE GRIMSPOUND
FORDING THE WEST DART RIVER IN TWO MINUTES
PASSING A PILE OF STONES PLACED SIXTEEN YEARS AGO
A CROW PERCHED ON GREAT GNATS HEAD CAIRN FOR FIVE MINUTES
HOLDING A BUTTERFLY WITH A LIFESPAN OF ONE MONTH
CLIMBING OVER GRANITE 350 MILLION YEARS OLD ON GREAT MIS TOR
THINKING OF A FUTURE WALK
EIGHT HOURS OF MOONLIGHT

55 MILES

ENGLAND AUTUMN 1995

deeply impressed by the ideas he found there. His work has often used notions of relativity to reinforce a very human sense of frailty and fragility in, and in contrast to, nature. In *Dartmoor Time 1995* (fig.13), for example, Long contrasts 'a butterfly with a lifespan of one month' with 'granite 350 million years old'. Macfarlane has written:

> Contemplating the immensities of deep time, you face, in a way that is both exquisite and horrifying, the total collapse of your present, compacted to nothingness by the pressures of pasts and futures too extensive to envisage. And it is a physical as well as a cerebral horror, for to acknowledge that the hard rock of a mountain is vulnerable to the attrition of time is of necessity to reflect on the appalling transience of the human body.[24]

Yet Macfarlane also stresses that there is something 'curiously exhilarating' about this contemplation of deep time, and this exhilaration is something that Long's work produces.[25]

'Real stones, real time, real actions'

Long has said: 'I think all my works, my actions, have no meaning outside what they are. So if you think it's significant, then it's significant.'[26] Hamish Fulton, who also takes walking as the basis of his art, has asked the question: 'Why walk in nature?' His answer (one of many) is: 'To attempt a balance of influences.'[27] This suggests not only a balance of artistic influences but of the forces that bear upon the individual, and the environment in which the individual exists.

Long does not offer answers; his work points to facts, real experiences, definite places. His explanation as to the meaning of his art is straightforward:

> My work has become a simple metaphor of life. A figure walking down his road, making his mark. It is an affirmation of my human scale and senses: how far I walk, what stones I pick up, my particular experiences. Nature has more effect on me than I on it. I am content with the vocabulary of universal and common means; walking, placing, stones, sticks, water, circles, lines, days, nights, roads.[28]

Long's work constitutes a 'portrait of the artist touching the earth' but it is with a very light touch that he travels. The marks that he leaves are mostly ephemeral. He passes more or less unnoticed. His work occupies a position, he says, somewhere between the making monuments and the leaving of nothing but footprints. It is fertile territory. While Long disclaims that his work carries any particular message or meaning, his recent 'cosmic' walks are very particular in the complex ideas they articulate, as well as creating powerful metaphors with rich human implications. At the same time it is possible to read some aspects of his work, as many have done, as proposing a kind of ideal relationship with the landscape, one of respect, wonder, curiosity. In truth the great strength of his work is perhaps the way it can suggest so many possible meanings, its extraordinary combination of rigour and openness.

Many of the ideas that Long has addressed in his work are central to Land art. For this reason his work is referred to again and again throughout the pages of this book; a key influence, a constant presence and a recurrent point of reference.

fig.13
Richard Long
Dartmoor Time 1995

ENTROPY AND THE NEW MONUMENTS
THE ART OF ROBERT SMITHSON

When five successive years of drought caused the water level of the Great Salt Lake, Utah, to recede in 1999, it revealed a quasi-mythic structure: Robert Smithson's *Spiral Jetty*, now encrusted in brilliant white salt crystals. Smithson had built his most famous work in 1970. However, by 1972 the level of water in the lake had risen and the jetty was submerged, making a work that had always been difficult to see totally inaccessible. This inaccessibility, coupled with the evocative photographs taken in 1970 by Gianfranco Gorgoni, and the extraordinary essay and allusive film that Smithson made about the construction of the work, have contributed to the legendary status of the piece. When the water receded and the jetty re-emerged, the true extent of its iconic status was also revealed. The event was widely reported not only in the art press but also in the mainstream press around the world. For many observers, the *Spiral Jetty* remains the work that, more than any other, exemplifies Land art (figs.14, 15).

Richard Long first met Smithson in 1969, when they took part in the exhibition *Earth Art* at the Andrew Dickson White Museum, Cornell University, New York. Long subsequently stayed with Smithson in New York and even went on a rock-hunting trip to New Jersey with him. When Smithson travelled to the UK to take part in *When Attitudes Become Form* at the ICA, London, he visited Long in Bristol.

In many ways, Long and Smithson represent opposing positions. Long's work is practical and non-theoretical, although it sometimes addresses complex scientific ideas. Smithson's art is highly theorised, layered in its references and sources, wide-ranging in its employment of different media and complex modes of presentation.[1] Despite the siting of his most famous work in the emptiness of Utah, most of Smithson's work demonstrates a fascination with cities, or more precisely the margins of urban experience, suburbs such as Passaic, New Jersey, where he was born. Conversely, the characteristic (but not exclusive) locus of Long's walks is the rural landscape or natural wilderness.

Long and Smithson also diverge over the degree of intervention they are willing to use in the landscape. Long has endeavoured to keep the traces of his passing to a minimum. Often, he has laid the stones back down after standing them to make a stone circle and photographing it. The materials for his gallery sculptures are either stone quarried in the locality of the exhibition, materials – such as driftwood – gathered in the landscape, or mud drawn from river banks. Smithson also used quarried materials in the creation of a number of works; his motivation in doing so, however, was not primarily to minimise negative environmental impact but because he was fascinated by and drawn to industrial sites. Quarries were important to him because in them the strata of the rock is laid bare – thus revealing the intoxicating passage of time – but also for their cultural implications. Smithson was fascinated by the way in which the landscape is marked by man's use of it, seeing this as a wholly natural process. For him, such sites embodied the sense of collapse – of entropy – that he felt was a guiding principle of existence.[2]

It has been argued that Long's work – through his use of ideal forms such as

fig.14
Robert Smithson
Spiral Jetty 1970
photographed in 2002
Rozel Point,
Great Salt Lake, Utah

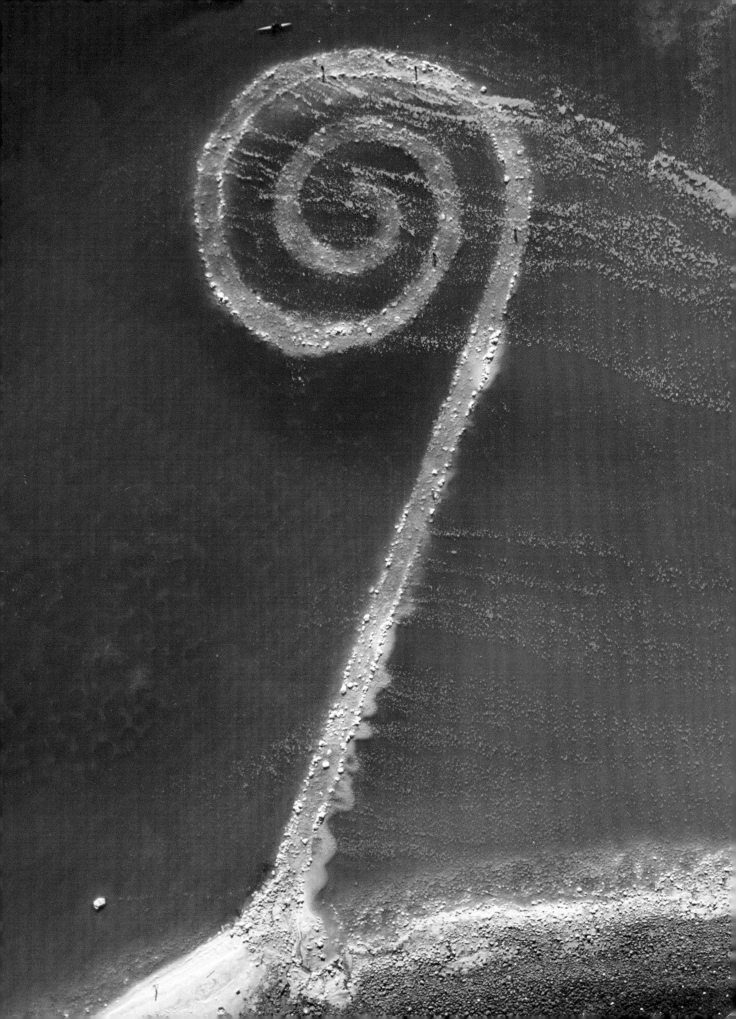

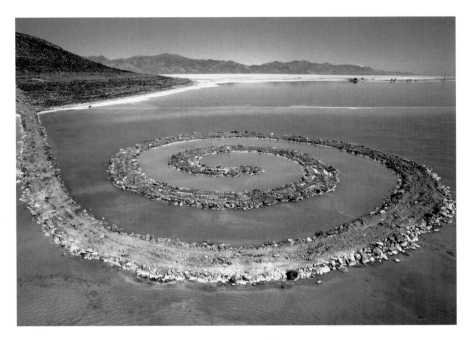

lines and circles – extends the modernist project.[3] Smithson however, is deeply sceptical about the optimism inherent in modernism, exchanging that idealism for an obsession with 'fragmentation, corrosion, decomposition, disintegration'. This, and his refusal to conform to a signature 'style', the critical stance he adopted towards art and language, has suggested to many that Smithson was a postmodern artist.

Nonetheless, despite their divergent positions, there are numerous points of contact between Long and Smithson. Primarily there is a shared interest in the notion of places and their equivalents, the dialectic that Smithson formulated as *Site* and *Nonsite*. Both artists are also interested in the related concept of mapping, meaning not only the use of cartographic documentation within their work, but the use of the work to locate a specific place and a specific time in relation to other spaces and times. Additionally, their work is deeply informed by scientific as well as cultural and artistic concerns, its forms and meanings directed by their reading and understanding of complex scientific concepts such as relativity and entropy. And both artists share an over-riding preoccupation with time. Indeed, one might go so far as to say that this is the presiding theme of their respective oeuvres.

Inverse Meanings

It is striking to remember, given Smithson's reputation, that he only actually completed two major earthworks in his short lifetime, the *Spiral Jetty* and *Broken Circle/Spiral Hill* 1971 at Emmen, Netherlands. Nonetheless, he was extremely

prolific in the five years up to his early death in 1973, exhibiting and publishing widely. His work of this period, which included sculptures using rocks, earth, broken glass, sea shells and mirrors, the *Nonsites*, photographic pieces, site works such as *Asphalt Rundown* 1969 and *Partially Buried Woodshed* 1970, and numerous proposals for earthworks and other large-scale projects, remains extremely influential. Smithson was also a writer and theorist (the *Collected Writings* is an indispensable guide to his interests and concerns).[4] He forged a highly idiosyncratic style of writing that combines art criticism, cultural theory, natural history, travelogue and philosophical mediation, and which maintains a critical relationship to his own work, both clarifying his intentions and further enriching it. He also played a key role in creating a critical context for the work of colleagues such as Heizer, De Maria, Robert Morris, Dennis Oppenheim and Carl Andre, promoting this group of artists as successors to the mid-1960s hegemony of post-Pop, hard-edge abstraction and Minimalism.

Smithson's themes and preoccupations were extraordinary wide ranging, encompassing everything from aesthetics to natural history and time travel. Robert A. Sobieszek has suggested that his sources included 'Science and mathematics, glaciology and crystallography, palaeontology and astronomy, geology and cartography, teratology and language, and philosophy and science fiction, to name just a few'. He goes on to stress that Smithson's writings and artworks abound with:

> what he called "inverse meanings", reversals and contradictions: fiction is reality; science fiction becomes scientific fact; the centre is found at the circumference; margins are at the centre; mirrors and their reflections change places; ruins are built in reverse; the future is prehistoric; order begets disorder; and negatives can be positive ... In short; 'It is always back and forth, to and fro.' [5]

Beginnings

Smithson was interested in natural history from an early age. He made repeated visits to the American Museum of Natural History in New York (which was later to feature in the *Spiral Jetty* film) and was encouraged by his parents to research and plan family holidays to Yellowstone Park, the Oregon Caves, the California Redwoods, the Grand Canyon, the Mojave Desert, Sanibel Island and other attractions in the US. However, despite his early plans to pursue a career as a naturalist, from the age of sixteen he began to study with the Arts Students League in New York. In 1959 he held his first exhibition of paintings at the Artists Gallery, New York, and in 1961 he showed at the Galleria George Lester, Rome. In the following year he had a solo show of assemblages at Richard Castellane Gallery, New York.

Smithson's earliest paintings, such as *Quicksand* 1959, were clearly indebted to Abstract Expressionism. However, he quickly became distrustful of the notion of 'expressive' art, working through a series of stylistic phases between the late-1950s and the mid-1960s. These encompassed an intensely poetic and religious symbolism

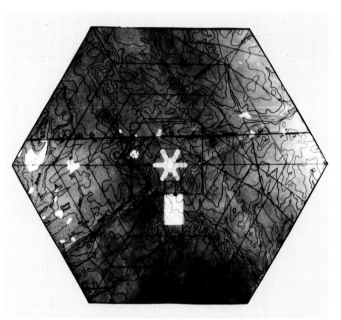

<u>A NONSITE</u> (an indoor earthwork)

31 sub-divisions based on a hexagonal
"airfield" in the Woodmansie Quadrangle –
New Jersey (Topographic) map. Each sub-
division on the <u>Nonsite</u> contains sand
from the <u>site</u> shown on the map. Tours
between the <u>Nonsite</u> and the <u>site</u> are possible.
The red dot on the map is the place where
the sand was collected.

(for example, *Feet of Christ* 1961), a form of painting-assemblage-collage indebted to Surrealism and the combine paintings of Robert Rauschenberg (for example, *Blue Chemical* 1962 or *Honeymoon Machine* 1964) and a response to Pop and hard-edge abstraction (for example *Malibu* 1964 or *Homage a Carmen Miranda* 1964). Smithson began to make what he considered to be his mature work in 1964. Nonetheless, this preparatory period was fundamental to his career, allowing for the development of his enduring themes and interests. Certainly in the paintings and constructions of this period one can see emergent preoccupations that recur in his later work: blood, decay and ruination, geological strata, speculations about time and history, exploration of notions of sight and seeing, and the recurring use of the spiral motif.

Beginning in 1964 Smithson produced a series of 'crystalline' sculptures in steel and coloured reflective plastic, such as *The Eliminator* 1964. At this time he became friendly with Donald Judd, Dan Flavin and Sol LeWitt, artists associated with Minimalism. He began to exhibit with them from 1965 and write about them from 1966 onwards.

The sculptures that Smithson showed in exhibitions such as *Primary Structures* (The Jewish Museum, New York, 1966) and *Art of the Real* (Aldrich Museum of Contemporary Art, Ridgefield, Connecticut, and Tate Gallery, London, 1968) were received as Minimalist, primarily because he was known to associate with those artists and wrote about them for magazines such as *Artforum*.[6] His work also seemed to demonstrate the Minimalist's concern with modular structures and new industrial materials such as Plexiglas, steel, mirrored plastic, and he too had his sculptures made by professional fabricators to his specifications. But for all their superficial similarities Smithson's sculptures from this period are in fact addressing a different set of preoccupations.

Unlike Minimalism, in which the objects are themselves only, symbolising nothing external, Smithson's work addresses and embodies complex conceptual ideas including crystalline growth and decay and the problematisation of perspective. His work denies Frank Stella's famous assessment of Minimalism that 'what you see is what you see'. For Smithson the physical object is a starting point for an investigation of layered ideas. It posits an expansion. It rejects clarity and unlike Minimalism for which clarity and logic are guiding principles, toys with logic (becomes 'alogical'). The curator and artist John Coplans wrote that when exhibited in *Primary Structures* in 1966, Smithson's sculpture 'looked eccentric compared to the prevalent notion of the Minimalist style'.[7] Lawrence Alloway identified in Smithson's work a 'sense of collapsing systems'.[8]

Smithson's work of 1964–6 was much informed by his interest in crystallography, and through that, processes and patterns of growth and decay within the natural world. The implications of this and the distance between his work and that of Judd at this time is illustrated by Smithson's account of a rock-hunting trip that the two artists took together. 'The Crystal Land' (1966) is one of Smithson's earliest published texts. He begins by likening a 'pink plexiglass box'

fig.16
Robert Smithson
A Nonsite
(an indoor earthwork) 1968
Painted aluminium container, sand, map and text
Container 167.6 cm diameter; map 26 cm diameter

by Judd to 'a giant crystal from another planet', before describing a visit to the Great Notch Quarry in New Jersey. What at first seems to be a conventional examination of Judd's sculpture quickly becomes something very different, and indeed Judd's work is not mentioned again after the first paragraph. Instead, Smithson evokes a world transformed by his attentive gaze into one of geological properties and material strangeness, governed by the principle of entropy. He comments that 'the entire landscape has a mineral presence' and in describing the quarry, dwells on the entropic qualities of the scene: 'Fragmentation, corrosion, decomposition, disintegration, rock creep, debris slides, mud flow, avalanche were everywhere in evidence.'[9] This is the reality that Smithson's work addresses. He thus highlights how far his concerns are from those of Judd, whose work is, by comparison, inert and disengaged from the complex processes that govern the world in which it is situated. In comparison, Smithson is engaging with a natural landscape and thus highlighting the complex relationship between man and natural forces, the most powerful of which is entropy. Entropy – the principle of energy loss – is much cited in Smithson's writings and is a notion that underlines much of his work. It is a concept that defines not only the natural world but mankind too. Moreover, it provides a powerful metaphor for a contemporary situation. Critic Lucy Lippard observed that 'Smithson saw entropy as "a mask for a lot of other issues, a mask that conceals a whole set of complete breakdowns and fractures," including those besetting America in the late 60s.'[10]

Dialectics

In 1966 Smithson was hired as an artist consultant to the architectural firm of Tippetts, Abbett, McCarthy and Stratton, which was then working on plans for a regional airport for Dallas-Fort Worth. He made various proposals, and invited a number of other artists, including LeWitt, Robert Morris and Carl Andre to come up with different ideas, some of which were for putative 'earthworks'. Unfortunately the firm lost the contract and nothing came of the project. However, it was an important formative opportunity for Smithson, which forced him to think in new ways. In particular, he had to consider questions of scale and of how artworks might be situated in the landscape, and consequently how they could be viewed. He began to think in terms of the site as material for the work. The consideration of how to make works on the airfield available to viewers in the terminal suggested to Smithson a relationship between two aspects of a single work (one proposal was to have a live feed from a video camera focused on the artworks out of the airfield, to monitors in the terminal building), which he went on to explore in a series of works relating *Site* and *Nonsite*.[11]

In the winter of 1968 Smithson made the first of these works, *A Nonsite*, which he described as 'an indoor earthwork'. The sculpture is a low, hexagonal, aluminium structure with thirty-one sub-divisions, each consisting of a shallow bin. The bins are filled with sand taken from the landscape at an airfield at Pine

Barrens in southern New Jersey. An integral part of the work is the accompanying map, itself a hexagon with divisions that correspond to the sculptural object. A short text accompanies the sculpture and specifies the location of the 'site', confirming that the sand in the bins was taken from corresponding locations there.[12] The work thus evokes the landscape to which it is a correlative. However, it is more than simply a representation of the site since it actually contains material drawn from it. By configuring the work in this way, Smithson established a dialectic between locations. The gallery became not simply a container for pre-existing objects or artworks but was brought into a complex allusive relationship to a specific place, which is elsewhere. Smithson meant that the 'weighty absence' of the site itself would be felt when the *Nonsite* was exhibited.[13]

Smithson went on to make a number of *Nonsites* including *Nonsite "A Line of Wreckage", Bayonne, New Jersey* 1968, *Mono Lake Nonsite (Cinders near Black Point)* 1968 and *Nonsite (Essen Soil and Mirrors)* 1969. For each work he varied the mode of presentation – some include photographs as well as maps and texts – and configured the containers in different ways, using an open structure of mirrors for the Essen *Nonsite*, for example.

Mirrors

From making art that explored a dialectic of present interior and distant exterior locations, Smithson proceeded to move out of the gallery and make work that focused on the site itself, often dispensing with the need to create an interior analogue. In this sense the *Nonsites* enabled and activated Smithson's interest in making art outdoors, in the landscape, away from the gallery, and from 1968 onwards he carried out a number of process-led projects and actions including *Asphalt Rundown* 1969, *Glue Pour* 1970 and *Partially Buried Woodshed* 1970, as well as photographic works using mirrors.

For Smithson, mirrors were agents of complexity. An image of an image doubled is twice removed from reality; the mirror produces a rupture in the surface of space and time, the documentation of that rupture producing a secondary dislocation. In a series of works including *Ithaca Mirror Trail, New York* 1969 and a piece made on the Yucatan Peninsula, Mexico, *Nine Mirror Displacements* 1969 (fig.17), he placed mirrors in the landscape so that they reflected back their surroundings. The placements were photographed, producing images of images of images. These works, or 'trails' suggest a narrative of movement through the landscape, and the Yucatan work was accompanied by one of Smithson's complex and allusive essays, 'Incidents of Mirror-Travel in the Yucatan' (1969).

Reading Smithson

'Incidents of Mirror-Travel in the Yucatan' was just one of a series of essays that Smithson published in the late-1960s and early 1970s, and indeed his writing was one of the most influential aspects of his short career.[14] It is characterised by what

Eugenie Tsai has described as 'cool irony'.[15] This, coupled with a extraordinary range of reference, as well as a willingness to question assumptions and challenge orthodoxies, make it a dizzying read.

One might argue that Smithson's writings constitute an integral part of his work as an artist, not a separate category of production, and that they should be assessed as such – as art – rather than as criticism or theory (a notion analogous with the activities of artists such as Art and Language and John Stezaker, whose work at this time consisted only of text). Robert Hobbs, writing of 'A Tour of the Monuments of Passaic' in 1967, identified a new kind of writing that was neither art criticism, fiction nor philosophy, but something he described as 'narrative art'.[16]

Smithson writes as if he is dreaming, improvising, feeling his way, seemingly hallucinating realities and theories. He typically starts with an apparently firm premise or argument, for instance the comparison of a Judd sculpture with a crystal, and then spirals off. There is a direct correlative between his approach

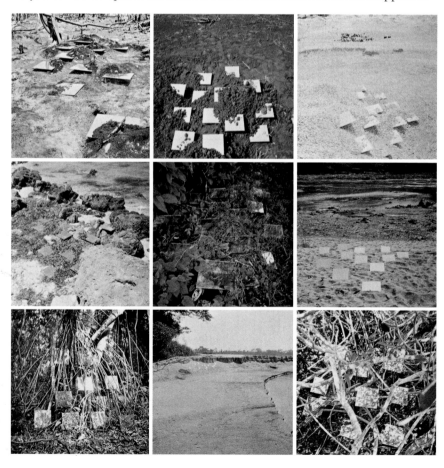

fig.17
Robert Smithson
Nine Mirror Displacements, from 'Incidents of Mirror-Travel in the Yucatan', Published in *Artforum*, September 1969

to his writing and his art. Both aspects of his practice use layering. Many of his texts are assembled from several discrete, sometimes unrelated sections, added together to produce a collage from which emerges a complete piece. Smithson's writings are perhaps closer to Jorges Luis Borges or Italo Calvino or even Arthur C. Clarke than to conventional art criticism or theory. He shares with Borges a fascination with labyrinths and labyrinthine thinking (pursuing an idea through a maze of digressions and dead ends), 'inconceivable systems' and 'symmetrical perplexities'.[17] With Calvino he shares a predilection for mind-blowing cosmic concepts and spans of time; with Clarke and other sci-fi writers a desire to speculate upon possibilities.

Spiral Jetty

In April 1970 Smithson began construction of his first earthwork, the *Spiral Jetty*, at Rozel Point on the Great Salt Lake, Utah. The jetty is a 1,500 foot long promontory, just fifteen feet wide, which whirls out from the shore of the lake, and is built from mud and rocks from the site.[18] It is located on land held under lease (now administered by the Dia Foundation, New York). The construction was funded by Smithson's dealer, Virginia Dwan, while Douglas Christmas of Ace Gallery, Vancouver, provided funding for the film that Smithson made to document the creation of the sculpture. The film is a complex piece of work that evokes the location of the jetty and introduces many of the ideas that fed the sculpture.

Smithson's thinking about the piece was complex, poetic and allusive. His starting point was an interest in the symbolic potential of a red saline lake. He had heard of such lakes in Bolivia, but when he learnt that the Great Salt Lake in Utah carried micro bacteria that coloured the water red, he decided to visit it. Inspired by the location he originally considered constructing an island in the lake, but the natural characteristics of the site and the historical contexts he found there led him to the spiral form. A local legend has it that the lake is connected to the sea via underground channels, which produce a vast whirlpool in its depths. With its abandoned oil derricks, machinery and old piers – which, for Smithson, evoked 'a world of modern prehistory'[19] – and its proximity to the Golden Spike monument (which embodies a now-defunct concept of progress), the entropic and mythic landscape of Rozel Point was thus historically and culturally charged. Smithson likened the red salt water to blood. He noted that like blood it was chemically analogous to the 'primordial seas'.[20] In addition, the specific crystal properties of the salt in the lake took on symbolic significance for the sculpture: 'each cubic salt crystal echoes the *Spiral Jetty* in terms of the crystal's molecular lattice. Growth in a crystal advances around a dislocation point, in the manner of a screw. The *Spiral Jetty* could be considered one layer within the spiralling crystal lattice, magnified trillions of times.'[21] As Jennifer L. Roberts has observed, Smithson underlined a passage in one of his crystallography books, which transformed this kind of crystal growth into an explicitly temporal metaphor: 'when growth takes place the step can advance only by rotating round the dislocation point somewhat like the hands

of a clock.'[22] In Smithson's conception, therefore, the *Spiral Jetty* not only provides a model of its own structure but functions like a time machine, focusing the distant past, recent past and entropic present into a single point, the centre of the spiral.

But what was the experience of the work? Most of us know the *Spiral Jetty* only from photographs by Gorgoni and others. It is therefore worth considering some first-hand accounts of it. Smithson published his own account in 1972. He described the approach to the site:

> We followed roads that glided away into dead ends. Sandy slopes turned into viscous masses of perception. Slowly, we drew near to the lake, which resembled an impassive faint violet sheet held captive in a stony matrix, upon which the sun poured down its crushing light. An expanse of salt flats bordered the lake, and caught in its sediments were countless bits of wreckage.[23]

He offers an intensely poetic and mythic vision of the site, emphasising its entropic qualities, as if the location itself has generated the artwork, rather than the artist in response to it:

> As I looked at the site, it reverberated out to the horizons only to suggest an immobile cyclone while flickering light made the entire landscape appear to quake. A dormant earthquake spread into the fluttering stillness, into a spinning sensation without movement. This site was a rotary that enclosed itself in an immense roundness. From that gyrating space emerged the possibility of the Spiral Jetty.'[24]

Lawrence Alloway's account of walking onto the jetty evokes the power of the work and he, too, stresses the symbolic power of the location:

> Walking along the spiral lifts one out into the water into a breathless experience of horizontality. The lake stretches away, until finally there is a ripple of distant mountains and close around one the shore crumbles down into the water, echoing the mountains ... The landscape is openly geologic, evoking past time with placid insistence.[25]

John Coplans suggested that Smithson didn't choose his sites 'according to what might be described as norms of beauty':

> The Great Salt Lake is a sombre, moody, dead lake that supports no life within its waters except for the algae giving it its red hue. I think I saw the *Spiral Jetty* under the very best of circumstances, under romantically sublime conditions. On the day I was there the vast stretch of lake water that filled the horizon for 180 degrees was shot through with the widest range of colouration, from bright pink and blue to gray and black. On the left, near the abandoned drilling wharf, and for some ten or twelve miles out, a storm was raging, with black clouds massed high into the sky, claps of thunder and flashes of lightning, and the surface of the lake in turmoil. Toward the centre the storm eased off, but with lower clouds and sheets of rain scudding across the lake surface, almost obliterating from view some islands lying offshore. To the right, a blue sky almost clear of clouds with a high moon and stars, and on the extreme right, the sun going down in a mass of almost blinding orange. Where I stood, in the centre of the spiral, a warm wind blew offshore, carrying the smell of the flora, and rustling through it, the cries of birds. Then scrubby, low hills behind began to flatten and darken against the twilight.

Coplans's conclusion is that 'the site is a terribly lonely place, cut off and remote, conveying the feeling of being completely shunned by man.'[26] Like Alloway, he compared walking the jetty to travelling in time: 'A spiral vectors outward and simultaneously shrinks inward – a shape that circuitously defines itself by entwining space without sealing it off. One enters the *Spiral Jetty* backward in time, bearing to the left, counter-clockwise, and comes out forward in time, bearing right, clockwise.'[27]

Then, as now, writers seem to stress the demanding, disorientating aspects of the *Spiral Jetty* experience. A more recent visitor has written: 'As you start to walk the spiral, you enter a kaleidoscope of moaning wind, relentless light, and mercurial water colours. The surface is rocky and uneven, but not that difficult to walk. It merely requires your attention, on all levels.'[28] Such accounts, which highlight the difficulty of the approach, the remoteness of the setting and the sublimity of the landscape, have only enhanced the mystique of the work. It is a typical response to suggest that the view down onto the jetty and out over the expanse of the lake from the hillside above it, is 'both spectacular and humbling'.[29]

But for many visitors the first experience of seeing the work is underwhelming: 'Is that it?'[30] While in photographs the earthwork can appear huge, monumental, iconic, the actuality is that in the vast landscape in which it sits it can seem smaller than expected. Nonetheless, 'the jetty's grandeur is something that creeps up on you ... and the longer you stay around it ... the larger it looms'.[31] The appearance of the work has perhaps been softened by time, the rough rocky structure now coated in brilliant white crystals, 'the once-virulent water ... now a benign shade of pinkish-blue'. In its current incarnation, according to one recent account, the jetty resembles a 'beached fossil'. Nonetheless, the location and the experience of the work in its place is still transcendent. It is, in the words of the same writer, in the 'starkest middle of nowhere that could be conceived'.[32]

Spiral Jetty: The Movie

In the thirty-five years since its construction, a host of possible interpretations have gathered about the *Spiral Jetty*. It has variously been read as a metaphor for the passage towards death, an ascent towards enlightenment, a representation of mythic forces (the whirlpool), an articulation of time, a visualisation of the principle of entropy (Smithson pointed out that it 'comes from nowhere and goes to nowhere'). It is perhaps evidence of his genius that he was able to create a work that could bear the pressure of so much critical discourse. Its openness means that this discourse continues; few other American artists have been the subject of such intense speculation as Smithson has been in recent years.[33]

It is interesting that most analyses of the jetty tend to focus on meanings derived from the appearance, rather than the experience of the jetty. This is surely because so few commentators have actually visited the site; the work is known

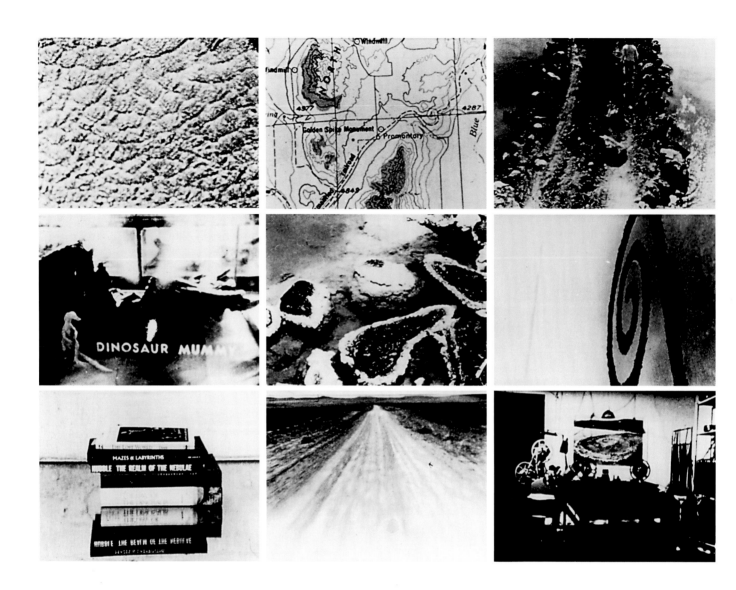

fig.18
Robert Smithson
Spiral Jetty, film stills,
1970

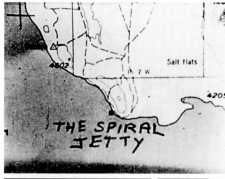

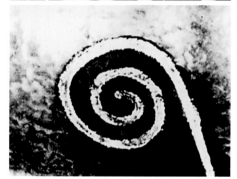

primarily through photographs of it. But Smithson's complex quasi-explicatory text (written in 1972) and particularly his film (fig.18), have also played an important role in directing our understanding of the work. He must have known that few people would actually travel to see it, and thus both text and film serve to make it accessible to a wider audience. However, they also enrich it, so that the work extends beyond the experience of the site:

> The movie began as a set of disconnections, a bramble of stabilized fragments taken from things obscure and fluid, ingredients trapped in a succession of frames, a stream of viscosities both still and moving. And the movie editor, bending over such a chaos of 'takes' resembles a palaeontologist sorting out glimpses of a world not yet together, a land that has yet to come to completion, a span of time unfinished, a spaceless limbo on some spiral reels.[34]

There are thus three layers, or three points of a triangular relationship: a *Site* and two *Nonsites*. There is the jetty itself, and then the film, which combines footage of its construction, images of dinosaurs, geological maps, a car racing along a track in the desert and an incantatory voiceover. The imagery and editing evoke vast spans of time and a complex network of ideas. And then there is the text, which details both the search for the site, the construction of the earthwork, and the making of the film. Smithson thus comments on his own actions, on the film of the earthwork and the origins of the earthwork, and adds another layer of allusion and reference to the potent mix already in place. Both film and text are like William Burroughs' cut-ups. They create a collage of disparate presents, returning again and again to the construction of the jetty itself, comparing the diggers and loaders with pre-historic creatures by juxtaposing construction footage with images of the Hall of Late Dinosaurs in the American Museum of Natural History filmed through an 'entropic red filter'.

In 1971 Smithson was invited to make work in an abandoned quarry near Emmen, in the Netherlands, as part of the *Sonsbeek 71* outdoor sculpture exhibition. The experience was to suggest a change of direction, or more precisely, of purpose, and make him reconsider the potential social role of Land art. Between 1971 and 1973 he made a number of proposals to mining companies for earthwork projects as part of land-reclamation strategies (discussed further in Chapter 6).

In 1973 Smithson was commissioned to complete an earthwork at Tecovas Lake, a manmade body of water created for irrigation purposes, on a ranch near Amarillo, Texas. His work was to be a 150 foot long ramp curving out into the lake, suggesting the beginnings of a spiral as it gained in height. On 20 July 1973, having staked out the dimensions of the work, Smithson flew over the site to survey it from the air. Flying low, the small plane stalled and crashed into the ground, killing Smithson, the pilot and the photographer. Smithson's final work, the *Amarillo Ramp* was completed later that year by his widow, Nancy Holt, helped by Richard Serra and Tony Shafrazi.

CONSTRUCTION AND EXPERIENCE

'Instead of using a paintbrush to make his art, Robert Morris would like to use a bulldozer.'[1]

Earthworks, large-scale artworks made in the landscape, often remotely located, frequently on a huge scale and employing techniques and materials more readily associated with the mining or construction industries – the kind of work exemplified by Smithson's *Spiral Jetty* (figs.14, 15) or *Amarillo Ramp* – have often been characterised as a quintessentially American artform. They have been positioned as an extension of a lineage of American landscape art stretching back via Georgia O'Keefe, Edward Weston and Ansel Adams to the paintings of Thomas Cole and the Hudson River School: Albert Bierstadt, Frederic Church and the 'American sublime'. The Hudson River School was active during a period when America 'began to identify itself with the intractable West, considering its distances and demanding mountains to be both test and symbol of American character', and many commentators have perceived a similar ideological approach in earthworks.[2] In 1983 the artist Alan Sonfist claimed: 'Art in the land is an American movement.'[3]

The earthworks movement of the late 1960s and early 1970s used the open spaces of the American deserts (primarily in the south-west, where almost all of the major works were located),[4] and did indeed seem to embody a particularly American attitude towards that landscape. For many critics, this attitude was unduly aggressive – even colonial – seemingly proposing the triumph of American culture and technology over nature.[5] As a result, the artists were (and continue to be) accused of being environmentally insensitive, unduly macho and ever arrogant, their actions recalling frontier attitudes wherein the American way of life is imposed upon unyielding landscapes and cultures. Such readings are only reinforced by published images of Heizer, De Maria, Smithson and others in the Californian desert, wearing denim, cowboy boots and stetsons. Even though horses are replaced by pick-up trucks and the focus of their activity is the creation of art rather than the husbandry of cattle, they appear to be consciously recapitulating 'America's national myth' of the Western. In film critic Edward Buscombe's prescient analysis, 'The basic conflict' embodied in the classic Western, 'develops from a struggle between the forces of civilisation and savagery, and the narrative features lawless acts by those who, because of the frontier location, are beyond the pale of civilisation.'[6]

The scale of many earthworks is also typically American. The statistics are telling. *Spiral Jetty* is made up of 6,650 tons of rock and soil; Heizer's *Double Negative* 1969 (figs.19, 20) required the excavation of 240,000 tons of rock and debris; De Maria's *The Lightning Field* 1977 (fig.22) covers an area one mile by one kilometre. Such works seem to reflect an American obsession with size. In addition, they reject the historic fine-art traditions of Europe in favour of forms referencing historic Native American idioms: the lines at Nazca, Mesoamerican temples, Indian burial mounds. For Heizer: 'It was a question of an American sensibility, things were being

fig.19
Michael Heizer
Double Negative 1969
Mormon Mesa,
Las Vegas, Nevada

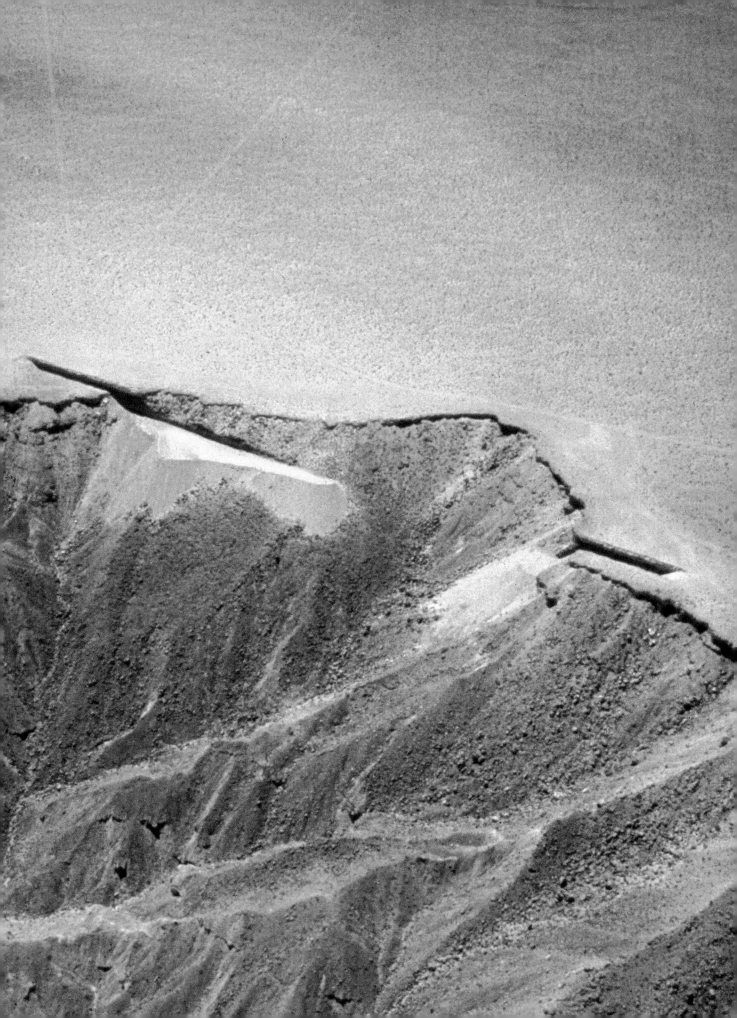

done that felt uniquely American – a lot of them had to do with size – size and measurement.' He was determined to be 'a contributor to the development of American Art, to not simply continue European art ... I was intentionally trying to develop an American art, and the only sources I felt were allowable were American; South American, Mesoamerican, or North American'.[7] This is a notion to which Heizer has returned again and again. In 1985 he said: 'My idea was to make American art ... As long as you're going to make a sculpture, why not make one that competes with a 747, or the Empire State Building, or the Golden Gate Bridge?'[8]

Yet at the same time Heizer has distanced himself from the poetics and history of the West and the symbolic dimensions that such ideas might bring to his work. He has always emphasised the practical decisions that led to his work being constructed where it was: 'It had nothing to do with landscape or the romanticism of the West, I was looking for material. The West isn't romantic to me, I'm from there.'[9] Or again, 'I didn't come here for the context. I came here for materials, for gravel and for sand and water, which you need to make concrete, and because the land was cheap'.[10] This paradox – of form versus location – is one that has defined many readings of this aspect of Land art.

In 1967 Smithson published an essay, 'Towards the Development of an Air Terminal Site', in *Artforum*, detailing the proposals that he, Andre, Morris and Sol LeWitt had come up with for the Dallas-Fort Worth airport project. The following year he organised a show at the Dwan Gallery in New York, which, while initially intended to present the airport scheme, expanded to become a putative survey of a fledgling movement and gave it a label by which critics might recognise it. *Earth Works* included a number of the artists who were to become central to the development of Land art, including Smithson himself, Morris, Andre, Heizer, Oppenheim and De Maria.[11] Smithson's long essay, 'A Sedimentation of the Mind: Earth Projects', was published in *Artforum* at the same time as the show, and it serves as a kind of manifesto and summary of some of the concerns of the artists involved.[12]

Earth Works and other early exhibitions highlighted two of the problems associated with large-scale art works constructed in remote locations: problems of access and dissemination. One of the principal themes embodied in works such as *Double Negative* and *Spiral Jetty* is that of site-specificity. One must travel long distances to see and experience these works; they cannot be transported and such experiences cannot readily be translated into other media. Location and sculpture are thus absolutely and irrevocably intertwined. In Heizer's formulation, the work is not in the place; it *is* the place.

In response to this, a number of artists developed two strategies: the use of photographic (and textual) documentation – presented both as artworks in their own right and as archival documents – and projects developed specifically for the gallery context (such as Smithson's *Nonsites*) which establish a relationship with the landscape work. In addition, magazines such as *Artforum, Avalanche* and

Interfuncktion began to offer alternative ways by which to disseminate work, in the form of specially commissioned artist's pages.

Earthworks were soon critically assimilated into the range of post-Minimalist methodologies springing up in New York in the late 1960s. For many observers the phenomenon was associated with Conceptualism. It was included in group exhibitions such as Harald Szeeman's survey of new developments, *When Attitudes Become Form*, shown in Berne and London in 1969, and publications like Germano Celant's *Arte Povera: Conceptual, Actual or Impossible Art* (1969). While the identification with Conceptual art initially seemed particularly apposite, since for most viewers the works were only present conceptually, accessed through documentation, such readings in fact directed attention away from important formal, sculptural considerations that, for many of the artists, were as, if not more, important; concept was prioritised over physical experience.

By the early 1970s a number of artists had been able to realise major projects: Heizer's *Displaced/Replaced Mass* 1969, *Munich Depression* 1969 and *Double Negative* 1969; De Maria's *Las Vegas Piece* 1969; Richard Serra's *Shift* 1970; Smithson's *Spiral Jetty* 1970 and *Broken Circle/Spiral Hill* 1971. These works were immediately recognised as representing an innovative extension of art's engagement with landscape, as well as carrying forward formal debates around the sculptural object. However, as we shall see, there was also initial confusion as to their purpose and meaning.

Smithson and Morris were catalytic figures in the development of the earthworks genre. Both had made proposals for earthwork projects in the mid-1960s but were not oferred the chance to complete projects until 1970–1. In addition, while Smithson's role as an artist and writer has already been discussed, essays such as 'Entropy and the New Monuments', 'Towards the Development of an Air Terminal Site' and 'A Sedimentation of the Mind: Earth Projects', his role on the airport project and as curator of Dwan's *Earth Works* exhibition make it clear that he also played a crucial role as an activist and promoter of this new kind of work.

Morris had first made a proposal for an earthwork – an observatory-like structure – in 1965. A year later, his proposal for the airport scheme was *Project in Earth and Sod*. This comprised a ring of packed earth, 6 feet wide and 3 feet high, with a variable radius depending on the site, to be covered in grass sods. Designed to be seen from the air rather than experienced on the ground, the work nonetheless anticipates much Land art in its adoption of an archetypal, simple form. In *Earth Works* Morris showed *Earthwork* 1968 (which he later retitled *Dirt*, adding a timely suggestion of dysfunctionality). In its formlessness (anti-form) and insistence on raw, unrefined matter, this large pile of earth and industrial waste engaged with contemporary critical debates about form and process in sculpture.

Morris's writings were also important. His series of essays on sculpture, 'Notes on Sculpture, Parts 1–4', 'Anti-Form' and 'Aligned with Nazca' were published in

Artforum between 1966 and 1975, and questioned the perceived limits of sculpture, focusing attention on the ways in which it is experienced, as well as the significance of the framing contexts within which it is situated.[13] In 'Notes on Sculpture part 2' (1966), which deals mainly with scale, he discusses the interior – the room – as a structuring factor for sculptural objects. He proposes widening the parameters of such frameworks:

> Why not put the work outside and further change the terms? A real need exists to allow this step to become practical. Architecturally designed sculpture courts are not the answer, nor is the placement of work outside cubic architectural forms. Ideally, it is a space without architecture as background and reference, which would give different terms to work with.[14]

Morris later realised a series of major projects – including *Observatory* 1971 (fig.54) and *Grand Rapids Project* 1974 – that engage with these 'different terms' and place the emphasis on participation. His projects are unusual within this genre in the sense that they are accessible; most are located in or close by to urban areas. This, and their focus on participation, suggests the possibility of a social art (in opposition to most earthworks, for which the ideal viewing conditions are solitary). As Morris suggested, his *Grand Rapids Project*, a system of paths and terraces built into the face of a hillside in Grand Rapids, Michigan, is a site for different experiences and different kinds of behaviour: 'runnings, walkings, viewings, crossings, waitings, meetings, coolings, heatings'.[15] Like all earthworks, these are sculptures to be experienced, although they are also to be *used*.

Sculpture in Reverse

The artist who perhaps best exemplifies the earthworks genre, and the complexities and contradictions that it embodies, is Michael Heizer.[16] His first landscape works, made in 1967, *North* and *South*, consisted of a double stepped cube and an open cone sunk into snow-covered ground in the Sierra Nevada, thus proclaiming from an early stage his interest in voids and negative spaces. Heizer made his first exploratory trips to the deserts of the south-west in 1967 and played an important role in identifying such spaces as a potential location for art, going on to make journeys with De Maria, Smithson and Nancy Holt the following year.

In 1968 Heizer rejected what he saw as the complacency of current art. He wanted to make art that was 'American' and purged of dependence on European traditions. He was also concerned that artworks had been reduced to the status of commodities, what he called 'a malleable barter-exchange item' in a glutted system.[17] Heizer turned to the deserts of the West because there he could find, as he expressed it: 'that kind of unraped, peaceful, religious space artists have always tried to put in their work'.[18] His comments about the art market, taken in tandem with the works he made away from the city context, provoked much comment and discussion at the time; and perhaps produced in future readings of Land art an over-

emphasis on the rejection of a commodified, art-market system and the projection of a utopian, anti-capitalist ideal for art. In fact, Heizer's exploration of desert spaces was practical. He used the desert as a laboratory, a kind of studio without walls, abundant with materials.

In the summer of 1968, he was working on *Nine Nevada Depressions* (fig. 2), a series of negative sculptures – a 520-mile line of loops, cuts, trenches and slots – cut into the surface of dry lakes and deserts across Nevada, which had been commissioned by the collector Robert Scull. It was an enlarged colour transparency of one of these works, *Dissipate*, presented as a light box, that Heizer showed in *Earth Works*. Virginia Dwan offered him a solo show after that exhibition and funded the construction of *Double Negative*, Heizer's best-known and most controversial work, built on sixty acres of purchased land in 1969. Documentation of that monumental sculpture was shown in a solo exhibition at Dwan Gallery in 1970.

Double Negative consists of two deep cuts, huge trenches, made into the edge of the sandstone escarpment at the Mormon Mesa, near Overton, Nevada. The dimensions of the work are given as $9 \times 15 \times 457$ metres.[19] 240,000 tons of sandstone were blasted with dynamite and bulldozed to make it, a process that Grace Glueck called 'sculpture in reverse'. The cuts are made on either side of a indentation in the mesa edge so that they face each other across a space where the land falls away to the river valley below. Their insistence and alignment implies a presence that straddles the void, a presence that is absent. Heizer explained:

> In *Double Negative*, there is the implication of an object or form that is actually not there. In order to create this sculpture, material was removed rather than accumulated. The sculpture is not traditional object sculpture. The two cuts are so large that there is an implication that they are joined as one single form. The title *Double Negative* is a literal description of the two cuts but has metaphysical implications because a double negative is impossible. There is nothing there, yet there is still a sculpture.[20]

The writer John Beardsley has suggested that in such works Heizer proposed an 'entirely new syntax' for sculpture. He argues: 'Rather than being a form that occupies space, with a surface delineating the limits of an internal volume, *Double Negative* is composed of space itself: it is a void.'[21]

Germano Celant described the experience of entering the work:

> Once properly positioned, the gaze ventures along the edges and the descent and discovers, from the other side of the valley, a similar or equivalent cut or hollow. The descent into the hollow is almost immediate, with the result that one begins to feel the majesty of the walls and the void. The path towards the bottom allows one to enter an interior that is exterior, or vice versa. On its inside there is nothing, or rather, nothingness is its logic, its appeal and majesty. As one begins to descend, the spatial vertigo shifts one's perception of the self. One is continually displaced and replaced by the immensity of a void. *Double Negative* is an internalised desert, or a desert folded over onto itself.

fig.20
Michael Heizer
Double Negative 1969
Mormon Mesa,
Las Vegas, Nevada

Its presence is absence. It gives form to nothingness without adding anything. Having arrived at the bottom of the descent, one feels oneself immersed in a plain that comes to a sheer end in the valley. On the other side, letting one's gaze pass over the void that separates the two sides of the mesa, thus including this absence in the work as well, one single intervention reveals a spectacular cut that reflects yet another conquest of emptiness.[22]

Formalism in the Desert

Heizer has said: 'To me the subject matter of sculpture is primarily the object itself; sculpture is the study of objects.'[23] However, while he has stressed the practical considerations that led him to make *Double Negative* in that particular location, and emphasised the formal concerns that the sculpture addresses, the sublimity of the setting is unavoidable, and the way in which this informs any understanding of the sculpture recurs again and again in analysis of it. In curator Diane Waldman's account of the work both the setting and the difficulty of reaching it are discussed:

> The vast expanse of the desert was matched by its stillness, the arid heat and the wind. There were no signs of life except for the occasional cloud of dust raised by an automobile off in the distance. It took two days to reach Michael Heizer's *Double Negative*. Our first attempt failed when the only road became impassable, the cars bogged down, tyres spinning, and the spectre of getting stuck or miscalculating a turn and going off the road over the edge of the precipice was all too real ...
>
> In contrast to the monotony of the parched, cracked earth of the mesa – a flat landscape of rocks, tumbleweed and scrub brush – the drop off the escarpment unfolded a vista of harsh beauty, with the work itself cut below the shelf of the mesa, overlooking the snaking ribbon of the Virgin River far below ... From the shelter of the walls, one can begin to sense the enormity of the work, but because of the chasm that separates east and west faces, it is impossible to view the work in its entirety from any one direction.

Waldman's conclusion was that the setting is integral to the work:

> It is the land, of course, that unifies *Double Negative*. A hard landscape, the site neither enhances nor detracts from the work itself. As a result, *Double Negative* is not only free of gratuitous decoration, a characteristic that unfortunately obtains in much other recent environmental work, but the grandeur and simplicity of its form convey a sense of its inevitability – of its being part of the land.[24]

For Waldman, as for other visitors, the work becomes not only the sculpture itself, but the experience of the location. Thus *Double Negative* exemplifies the difficulty of interpretation met by many earthworks: it is a formal sculpture about mass, space and scale that has been repeatedly discussed in terms of the impact and meaning of its location, the poetry of the desert setting, and the symbolism that such isolation and remoteness suggests. One way in which Heizer has resisted this is by repeatedly quoting the statistics of its construction, which return us to the physical, practical aspects of the work. Nonetheless, the landscape setting is clearly

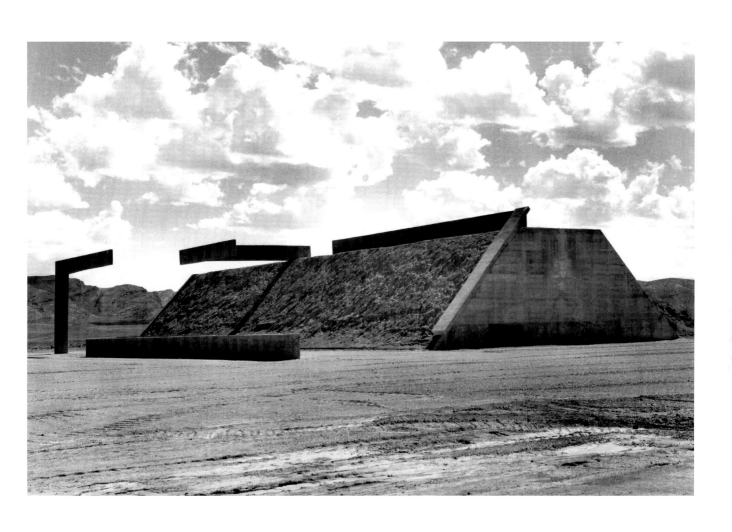

fig.21
Michael Heizer
Complex One
from *City* 1970–ongoing
Nevada

an important determinant in our experience of this work and others, even if that experience extends no further than the photographic image.

Heizer's formalism, his concern with purely sculptural issues as opposed to the poetics of site and landscape, is even more apparent in a massive ongoing project in the Nevada desert. *City* (fig.21) a group of huge abstract structures, inspired by the forms of Egyptian mastabas as well as the ball court at Chichen Itza in Yucatan. Four enormous geometrical sculptures form an enclosed complex, gathered around a central plaza. Heizer began work on *City* in 1972 and is only now nearing completion.[25] Robert Hughes has noted that *City* recalls 'the enigmatic structures left behind by America's various nuclear and space programmes, which by the 1970s were already beginning to seem an archaeology of the Age of Paranoia.'[26] Such a comment gains added resonance when we note that *City* is sited close to the Nevada nuclear testing site. However, as always, Heizer rejects the importance of location and setting. Of the setting he has said: 'I didn't come here for the context. I came here for materials, for gravel and for sand and water, which you need to make concrete, and because the land was cheap desert, a flat and totally theatrical space.' In this place, he suggests, 'There is no landscape.'[27] When the first part of the compound, *Complex One*, was completed in the 1974, photographs showed the structure in a remote desert setting, against a backdrop of the Nevada mountains. But when *City* is completed, a viewer in the central plaza will be unable to see this dramatic surrounding landscape; as a deliberate strategy it will be blocked out by Heizer's enormous structures. The point is, for Heizer, that the work is about the sculpture, not about the landscape within which it is set.

Contexts

Not all critics saw works such as *Double Negative* as having an 'inevitability' or of being at one with their landscape settings, as Diane Waldman did. The curator Michael Auping, who was vocal on the subject of the morality of Land art in the 1970s, wrote: 'Earth Art, with very few exceptions, not only doesn't improve upon the natural environment, it destroys it.'[28] At a time when environmentalism was a growing issue, Heizer's work in particular – due to the sheer scale of the alterations he wrought upon the land, as well as his outspoken attitudes – was controversial. Joseph Mashek commented in 1971 that *Double Negative* 'proceeds by marring the very land, which is what we have just learned to stop doing'.[29]

However, not all commentators took such a critical position, and current interpretations of earthworks are confused by the fact that many contemporary commentators understood the work in terms of a very specific social context. The development of earthworks as a genre coincided with a growing interest in ecology, an important factor in the transformation of traditional conservation into actively protectionist environmentalism. Within such a framework earthworks were widely understood as a manifestation of that ecological sensitivity and were even interpreted as evidence of the drive towards back-to-the-land pastoralism that

gained such ground during the 1960s. In addition, many commentators ignored the material crudeness of the works in favour of readings that stressed a perceived harmony with the environment. In fact, as Elizabeth Baker, who visited many of the key earthworks during the 1970s, has rightly observed, such works 'present art in a very clear polarity with nature'. She rightly suggests that the abstract, geometrical Minimalist mode in which many of these works were realised 'is the antithesis of the accidental, free, organic shapes of nature; it is the essence of the artificial – of art. As the mark of rational, arbitrary, man-made order interposed with nature, such forms take on a good deal of added resonance.'[30]

In addition, the stance that these artists adopted in relation to the art market was widely misunderstood. Dave Hickey saw this, and asked in 1971, 'why have the national art magazines both overrepresented and misrepresented the earthworks movement and its related disciplines, choosing to portray them as a kind of agrarian Children's Crusade against the art market and museum system, when this is obviously not the case?'[31] Rather than dissociating themselves from the commercial system, artists such as Heizer, Smithson, Morris and De Maria had shows in commercial galleries, courted the support of museums and collectors, and depended on the art-world system for the dissemination of their work. Anti-institutionalism was very much an aspect of the times, in all areas of cultural activity. Thus this misunderstanding is based on a contemporaneous reading of the work, encouraged by Heizer's comments on the art market and Smithson's condemnation of museums as dead spaces in essays such as 'Some Void Thoughts on Museums' (1967).[32] In fact the real limitations of the gallery system that artists such as Heizer sought to escape were the very real restrictions it placed upon the size of the work.

Such misreadings were prompted in part by the wider social context within which earthworks were originated. Suzaan Boettger has recently argued:

> It is no coincidence that the years of the antiwar movement, of the emergence of environmentalism, of a late-sixties social disorder, and of Earthworks paralleled one another. Earthworks embodied ambivalent responses to the anti-institutional position of so much of late-sixties culture and fused them with conflicted behaviour towards the natural environment. Earthworks materialise both the social fragmentation of the late sixties and the era's desire for regeneration through nature. The very 'demoralisation of America' manifested in Earthworks in turn stimulated viewers' reactive projections of the regenerative forces of nature onto these earthen creations.[33]

Isolation and Transcendence

Heizer aspires to deny any connection with nature and to emphasise his formal sculptural concerns, despite the sublime drama of the desert locations in which he has chosen to work. Walter De Maria is equally insistent upon formal issues, for example in his recurrent deployment of lines and grids, but his works seem permeable, as if designed to allow the participant the direct experience of nature (as well as art) that Heizer seems so anxious to deny.

fig.22
Walter De Maria
The Lightning Field 1977
Quemado, New Mexico

De Maria had made proposals for artworks in the landscape as early as 1964, but his first realised desert pieces, *Mile Long Drawing* (fig.1) and *Cross*, were executed during his 1968 trip to El Mirage (see Introduction). The following year he made *Las Vegas Piece* 1969 in Desert Valley near Las Vegas. The work consisted of four shallow cuts, two a mile long and two half a mile long, made with the blade of a bulldozer.[34] As with the works of the previous year, the work had to be walked to be understood. John Beardsley described the experience:

> This is a piece that yields its charms slowly. While one eventually comes to learn its configuration, it is never entirely visible. Instead it presents itself as a series of options ... As one walks the piece, its monotony is at first soothing and finally invigorating as one realizes the completeness with which one has experienced both the work and its surrounding landscape.[35]

For Baker, the work produced 'an intensified sense of self that seems to transcend visual apprehension alone':

> This piece requires that you walk it. At ground level (it is a clear form seen from the air) knee-high scrub growth hides it unless one is right on it – its track is shallower than all sorts of natural washes and holes. Ground level perception seems essential to its full meaning. It provides a four-mile walk and an experience of specific place, random apprehension of surroundings, and an intensified sense of self that seems to transcend visual apprehension alone. Its shape becomes known indelibly as a mental visual form, however, during the time it takes to pace it.[36]

De Maria's work thus created a 'dimensional, directional space' using 'understated, almost immaterial means', a strategy later also seen in his 1977 masterwork, *The Lightning Field* (fig.22).[37] In that piece, De Maria has said, 'The land is not the setting for the work but a part of the work.'[38]

The Lightning Field is De Maria's best-known work. While not actually an earthwork, it shares the characteristics of scale, remoteness and sublimity that define the genre. Located in New Mexico, it was commissioned and is now maintained by Dia Foundation. Prior to building the field, a smaller prototype field was completed in Northern Arizona in 1974.

The work consists of 400 highly polished, precision-engineered, stainless-steel poles, set in concrete foundations 3 feet deep with pointed tips and arranged in a grid measuring one mile by one kilometre. The poles are set 67 metres apart and are between 458 and 815 centimetres high; installed so that the tips form a level plane that would 'evenly support an imaginary sheet of glass'.[39] Responding to changing conditions, the poles are most visible at dawn and dusk, when they are lit by angled light, disappearing at midday. The open structure allows for the experience of work and setting simultaneously. The remote desert site was selected for its high incidence of lightning; May to September is the best season for viewing, but even then on average there are just three days per month during which lightning storms pass over the field. It is evident, then, that the likelihood of seeing lightning

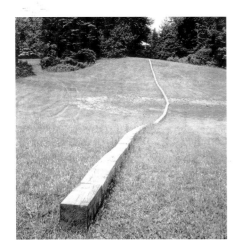

attracted down onto the field is extremely small. However, what is important is the *idea* of the coming lightning storm, the potential unleashing of terrifyingly powerful natural forces.

The viewing conditions at *The Lightning Field* are carefully controlled by the artist with the collaboration of Dia. De Maria has proclaimed that 'Isolation is the essence of Land Art' and the field is set up to allow for the work to be encountered in (near) solitude.[40] Having made arrangements with Dia's representatives, visitors are dropped at the site and spend twenty-four hours there, staying in a small cabin, thus allowing for an immersive experience in the changing light throughout the day and night, which marks the passage of time.

After her visit, Elizabeth Baker wrote: 'one feels oneself in a transparent structure that measures out a certain portion of otherwise indeterminate space; one also feels perceptually stretched'. She concluded that: 'Simultaneously cold/precise/industrial and fragile/lyrical/meditation-inducing, De Maria's un-emphatic, psychologically loaded landworks are ultimately intensely compelling to the imagination.'[41] Of the demands of such works Lawrence Alloway commented:

> Solitude characterises the *Spiral Jetty* and the *Double Negative* and *Las Vegas Piece*. Although the works are big, they are in no sense social. They are best experienced singly by spectators; only in that way can there be a proper acknowledgement of the sense of being alone that these works induce. The remoteness of the sites as well as the scale of the landscape contribute to this effect. Earthworks communicate a cisatlantic sense of the resonantly empty.'[42]

Alternative Strategies

Not all American artists working in the landscape at this time adopted such monumental and permanent methods. A number developed less intrusive strategies. Peter Hutchinson's *Parcutin Volcano Project* 1970 tracked mould growth on a line of white bread placed on the rim of a volcano in Mexico. George Trakas created a number of works such as *Union Station* 1975, a series of constructed paths through the landscape, raised bridges made of wood and metal, which choreographed the viewer's experience of nature.[43] Christo and Jeanne-Claude's projects such as *Valley Curtain* 1970–2 and *Running Fence* 1972–6 matched and exceeded many earthworks in terms of scale but were temporary interventions, in place for a short period of time but leaving no permanent mark or trace of their presence but for photographs and memories.

Carl Andre's proposal for the Dallas–Fort Worth airport project was 'A crater formed by a one-ton bomb dropped from 10,000 feet or an acre of bluebonnets (state flower of Texas).' In 1968 he realised a number of works in the landscape. His first outdoor work was *Joint* which consisted of a line of 186 bales of hay, about 140 feet long, connecting the edge of a forest with a neat lawn through an area of rough ground. The punning title evoked not only drugs and sex, but the way in

PARALLEL STRESS - A ten minute performance piece - May 1970

Photo taken at greatest stress position prior to collapse. Location:
Masonry block wall and collapsed concrete pier between Brooklyn and
Manhattan bridges. Bottom photo: Stress position reassumed Location:
Abandoned sump, Long Island

which the piece connected disparate types of terrain. *Log Piece* 1968, made in Aspen, Colorado, also consisted of a line, about thirty metres long, this time of rough-hewn and uneven logs, placed in woodland. Like De Maria's lines in the desert, the sculpture needed to be paced out for the relationship of work and setting to be fully revealed. Andre exhibited photographic documentation of this work in both *Earth Works* and *When Attitudes Become Form*. It was reprised in 1977 as *Secant*, a much cleaner and more ordered line of wood across undulating grassy ground, over ninety metres long (fig.23).

Andre's attention to 'place' in his sculptures, meaning the specifics of the spatial context for the sculpture, was a powerful influence on Land art. The importance of this new emphasis within the sculptural process is suggested by Andre's succinct summary of the development of modern sculpture:

> Sculpture as form
> Sculpture as structure
> Sculpture as place.[44]

However, despite overlapping concerns, Andre consciously sought to distance himself from Land art. He explained:

> By 1968, it was clear to me that my mission was to bring the Neolithic, abstract, earth-changing sensibility into the gallery. The land-artists were, more or less, bringing the modernist sensibility into the countryside. I wanted, for clarity's sake, to distinguish myself very much from both the earth-artists & the conceptualists. I am very much a solitary animal.[45]

Richard Fleischner is probably best known for his low-lying earthwork *Sod Maze*, made for *Monumenta* at Newport, Rhode Island, in 1974. However, like Andre, Fleischner had previously made a series of works using hay. Working in two fields at Rehoboth, Massachusetts in 1971–2, he produced a series of works, using hay bales because they were 'cheap modular blocks', but also because they enabled him to work easily and quickly on a large scale. Unlike Andre's open arrangements, works such as *Hay Line* 1971, *Hay Corridor* 1971 and *Hay Maze* 1971 were enclosing structures, directing the viewer's experience of a clearly defined space. In 1972, working in sudan grass, which grows thickly and very quickly, Fleischner again created a series of works that were to be entered into and explored, but in which the artist was able to control the viewer's experience of space; *Bluff* (fig.25) and *Zig Zag* are examples.

In contrast, Dennis Oppenheim's work of the period is fascinating both for its amazing variety, and for its positioning of the artist's own body as a primary vehicle of meaning. While works such as *Time Line* 1968 and *Gallery Transplant* 1969 inscribed ephemeral marks onto the landscape – the line of an international border or the ground plan of a gallery – in snow and ice, works such as *Vertical Penetration*, *Ground Mutations* 1969 and *Parallel Stress* 1970 (fig.24) place the artist himself in a

direct physical relationship with the landscape. Oppenheim recalled this development, in terms reminiscent of Long's activities:

> the sense of physically spanning land, activating a surface by walking on it, began to interest me. When you compare a piece of sculpture, an object on a pedestal, to walking outdoors for ten minutes and still being on top of your work, you find an incredible difference in the degree of physicality and sensory immersion. The idea of the artist literally being in the material, after spending decades manipulating it, appealed to me.

As such, a number of his works of this period anticipate an extraordinary aspect of Land art that developed alongside earthworks.

fig.25
Richard Fleischner
Bluff 1972
Rehoboth, Massachusetts

BODY AND LANDSCAPE

At the end of the 1960s a new kind of landscape art emerged alongside earthworks, one that was intimate, personal, and individual in conception. Alongside the walking art of Richard Long and Dennis Oppenheim's performative strategies, a number of artists built on recent trends in performance and body art to articulate an engagement with landscape and nature in which the body of the artist was explicitly placed within, subjected to, identified with and even merged with the earth.

Two works exemplify this approach. In Keith Arnatt's *Self-Burial (Television Interference Project)* 1969, a figure (the artist) stands on an open patch of earth, against a background of trees and hills (fig.26). Over a series of nine black and white images he gradually sinks into the earth. By the eighth image, only his head is visible and the rest of his body is beneath the ground. In the final picture the landscape is empty; the implication is that Arnatt is still there, but has been absorbed into the ground. The sequence recalls the stop-motion special effects of early cinematic animation – in particular the deadpan comedy of Buster Keaton – yet it also carries disturbing overtones.

Conversely, Charles Simonds's film *Birth* 1970 (fig.27) presents a raw, primal landscape of mud and earth. Something seems to move under the surface and then a figure (again, the artist) gradually emerges, naked and covered from head to foot in clay. Golem-like, a creature born out of the land itself, the artist is thus explicitly identified with its materials and meanings.[1]

It is extraordinary to note how such images of burial and birth reverberate through the art of the late 1960s and early 1970s, reflecting the paradoxical combination of anxiety, pessimism and idealism embodied by the period.

Birth and Burial

In the late 1960s and early 1970s, the British artist Keith Arnatt frequently deployed text and image to question the identity and status of the artist in relation to the artwork. One of his best-known works is *Trouser-Word Piece* 1972, in which a quotation from a philosophical text by John Austin is paired with a photograph of the artist wearing a sandwich board announcing: 'I'm a Real Artist'. *Self-Burial* represents an ironic take on Conceptualism. Arnatt wrote of this work: 'the continual reference to the disappearance of the art object [in the rhetoric surrounding Conceptualism] suggested to me the eventual disappearance of the artist himself'.[2] Commissioned by Gerry Schum's TV Gallery for the programme *Land Art*, the sequence of images was first broadcast on German television in October 1969 as a subtle disruption of regular programming. Each image in the sequence was shown daily and consecutively for only about two seconds, and was neither announced nor explained. The work reflects Arnatt's interest in the influence that context exerts on the artwork and vice versa.

Self-Burial is one of a number of works made by Arnatt towards the end of the 1960s that use the ground and earth as a key element and which were documented with photographs. Arnatt's *Earth Plug* 1967 was a hollow metal tube, sunk into the

fig.26
Keith Arnatt
Self-Burial 1969
Photographs on board
46.7 × 46.7 cm
Tate

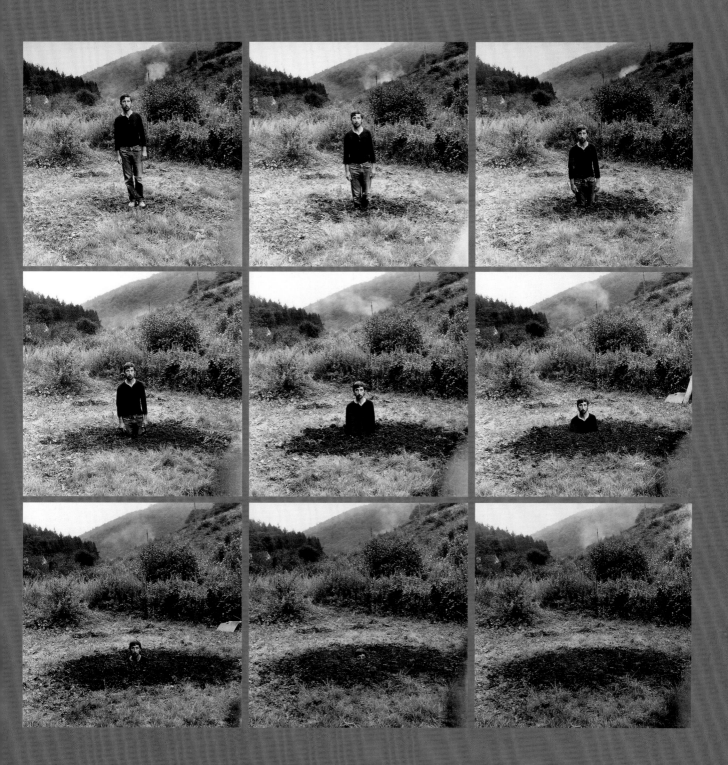

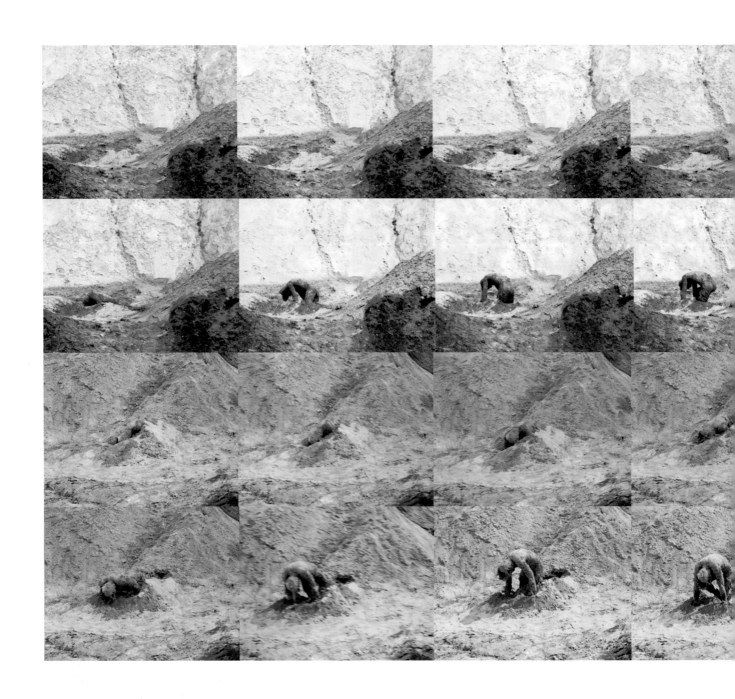

fig.27
Charles Simonds
Birth 1970

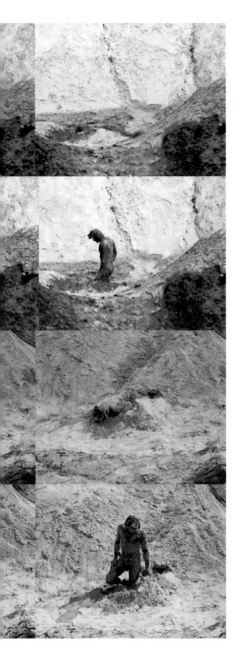

ground and filled with earth, but visible only by the handle with which it could be extracted. This work was Arnatt's response to a review of Claes Oldenburg's *Placid Civil Monument*, a work executed for the exhibition *Sculpture in the Environment* in New York. Oldenburg had a team of gravediggers excavate a hole in Central Park, just behind the Metropolitan Museum of Art, and then fill it in again. Another work, *Invisible Hole Revealed by the Shadow of the Artist*, consisted of a shallow square hole dug into the earth, with a turf-lined bottom and mirrored interior sides. The mirrors reflect the turf at the bottom of the hole and render it congruent with the surrounding grass, effectively invisible. The hole is revealed only by the artist's shadow, cast across the depression at an angle as he takes the photograph that documents the work.

While Arnatt's work in general addresses ideas about the nature of art, these early pieces can also be interpreted as conveying a darker undercurrent of meaning to do with man and nature. They are meditations on presence and absence, visibility and invisibility, truth and deception, involvement and identification. They posit a fragility, an ephemerality, with regard to man's position within a natural context. The figure of the artist is contingent, disappearing, is only present as a shadow, or is completely absent. The artist's interventions – the 'invisible' hole, the earth plug, each suggestive of a kind of grave – are barely there. Despite the deadpan humour of *Self-Burial*, it seems to function almost as a form of conceptual *memento mori*, playing on notions of mortality and what might be characterised as the fatal relationship of earth and culture.

Simonds's *Birth* suggests a polar opposite to Arnatt's work. Instead of Arnatt's cool humour, Simonds's work is characterised by seriousness and sincerity. The artist's simple explanation of the piece – 'I buried myself in the earth and was reborn from it' – belies the complexity of his action and its implications, its metaphorical possibilities, yet it also carries a sense of Simonds's conviction, his committed identification with his self-mythologising action.[3] *Birth* has the quality of ritual; a mythic ceremonial action undertaken by the artist on behalf of the audience. In Simonds's fantasy of integration and immersion, the figure of the artist becomes an archetype; streaked with mud, he is literally at one with the landscape, and almost indistinguishable from it.

Birth is one of a group of intensely symbolic and poetic films made early in Simonds's career that equate the artist's body with the landscape and the raw materials of which it is made. It was followed in 1971 by *Landscape – Body – Dwelling* (remade in 1973) in which the artist lay down nude on the earth, covered himself with clay, and then 'remodel[led] and transform[ed] my body into a landscape with clay, and then [built] a fantasy dwelling-place on my body on the earth'.[4] He explained:

> I'm interested in the earth and myself, or my body and the earth, what happens when they become entangled with each other and all the things they include emblematically or metaphorically; like my body being everyone's body and the earth being where

everybody lives. The complexities work out from this juncture. One of the original connections between the earth and my body is sexual. This infuses everything I do, both the forms and the activities. In my own personal mythology I was born from the earth, and many of the things I do are arrived at by refreshing and articulating that awareness for myself and others.[5]

Simond's conviction that he was 'born from the earth' carries a powerful environmental implication. It posits man and nature as part of a continuum.

Birth also represents a beginning for Simonds's own identity as an artist exploring mythic themes that articulate the relationship between man and earth. It is no accident that it was filmed in the clay pit in Sayreville, New Jersey, that he has subsequently used as a source of materials for his sculptures and constructions.

John Beardsley has suggested that Simonds' work 'hypothesises an identity between the landscape, the structures we build on it, and our bodies.' He explains:

> Peripatetic, Simonds wanders the urban and natural landscapes of the world, musing, recording, testing his hypotheses. He observes the varying modes of our lives in different landscape and the ways in which our social conventions, our architecture, and the evolution of our thought correspond to where we live. His works are a physical expression of these observations.[6]

Simonds's films have been followed by an expanding body of works in clay, in which he has constructed habitations and dwellings for 'the little people', an invented civilisation for which he has also developed societal myths and histories. The constructions of the 'little people' have been made both in marginal spaces in streets and on waste ground, and in the more formal surroundings of art galleries around the world. Through his actions and installations Simonds has sought to restore a social function to art: he explores the way in which culture – manifested through the architecture and behaviour of a society – interacts with its environment.

The Authentic Self
Works such as *Birth* and *Self-Burial* were made possible by the development in the 1960s of performance art and Body art – in which the artist's own body was the primary medium – by artists such as Chris Burden and Vito Acconci. This aspect of 1960s art was ultimately derived from the Existentialist and individualist rhetoric of the 1950s (as articulated by writers such as Jean-Paul Sartre, Albert Camus and the Beat poets), a decade in which the Cold War, the arms race, and revelations about the atrocities of the Second World War produced acute anxiety regarding the place of the individual within the body politic and a corresponding sense of the fragility of the self. It was a decade in which ideas about individuality, conformity and the self became increasingly politicised. In the 1960s and 1970s artists responded by forging art forms that dramatised the self as a contested site by placing the emphasis on the artist's own body (or that of the participatory

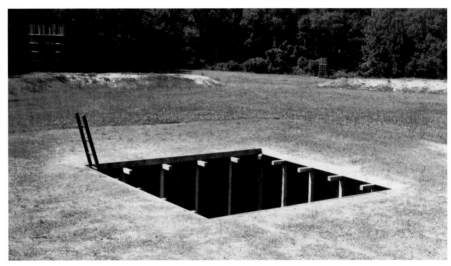

audience) as bearer and signifier of meaning. Such work legitimised trangressive or dangerous behaviour as a medium for the exploration of the self and its relation to society. It also represented a response to a present socio-political context and, particularly in America, the trauma associated with conflicted society. As Amelia Jones has suggested, the widespread use of masochism in 1970s Body art was 'a means of countering the broken social contract evidenced by the tragedies of the Vietnam War'.[7]

Body art also purported to represent real experience in opposition to the commodified and mediated experience of institutionalised culture (a division also dramatised by Land art's partial rejection of the museum or gallery). Within the visual arts, performance and body work were important and influential for pushing artists into what Ronald J. Onorato has characterised as 'real-time and real-space scenarios'.[8] In these terms, the use of the body was a means of securing 'authenticity' and immediacy. Authenticity was achieved by breaking down the barriers between artist and audience. This might be through visceral performance or participatory actions. Such thinking extends to the activities of a number of Land artists, who through the use of their own bodies in the landscape direct our attention not only to the landscape itself, but also to how it is experienced. Immediacy is achieved on two levels: a) through the actual actions of the artist, and b) through the audience's projection of personal experience onto the recorded experience of the artist.

The Body Threatened
It is interesting to note that while earthworks constituted a male-dominated genre, in the field of body and landscape art a number of female artists were prominent, including Alice Aycock, Mary Miss and Ana Mendieta.

Both Miss and Aycock attempted to create 'real-time and real-space scenarios' through sculptural and architectural works that the audience might enter and interact with, thus creating a kind of stage for participation and experience. Miss once said: 'I guess the combination of a battlefield and a garden would be my ideal space'. Works such as *Perimeters/Pavilions/Decoys* 1977 (fig.28), a series of structures including a tower and a kind of chamber set below ground level and accessed by a ladder, set in an open area bordered by woods, go some way to producing the surreal mix of the pastoral and the dangerous that this statement suggests by evoking watchtowers, pits and prison compounds.[9]

Many of Aycock's early works play upon fears and fantasies of burial. *Masonry Enclosure: Project for a Doorway (proposal)* 1976, is an unrealised structure with an inaccessible doorway halfway up one of the exterior walls. There is no other means of accessing the interior. From the door, a set of steps leads down into the structure, which is excavated below the ground so as to have a much deeper interior volume than is apparent from outside. The steps increase in size so that while they can be descended it would be impossible to climb up them again back to the doorway. Thus, 'anyone moving down the stairway would gradually entomb him/herself'.[10] Aycock's intention was that each individual would bring their own memories, fears and desires to such works and thus create the possibility of a unique experience.

Aycock's best-known work, *A Simple Network of Underground Wells and Tunnels*, was constructed for the exhibition *Projects in Nature* in an open meadow at Merriewold West, Far Hills, New Jersey in 1975. She had made proposals for earthworks from 1972 onwards but they differed radically from the works of artists such as Heizer and De Maria in that they are emphatically body-sized or body-related, rather than monumental; her constructions are designed to accommodate and affect the human physique in intimate terms, rather than by invoking the sublime. She sought to create a situation in which 'an event takes place and it is structured in terms of your body and your entire perceptual system'.[11]

A Simple Network consists of an area approximately 6 × 12 m, within which are sunk six concrete wells, connected by tunnels. Three of the wells have open access from the surface, but the remainder are closed off by covers and earth. The tunnels are only 81 centimetres wide and 71 centimetres high, and thus passable by crawling, but nonetheless constricted. Aycock's explicatory text on the work invokes a host of associations and influences from literature, philosophy and history including the French philosopher Gaston Bachelard, 'childhood fears of the cellar and attic', the underground dwellings and storage of the Matmatis people of Tunisia, the Hopi and Anasazi Indians, 'the Caves of Kor which were a "honeycomb of sepulchres"', and Monatgue Summers's book on vampires. She cites Bachelard's identification of the cellar with feelings of 'exaggerated fear' and 'buried madness' and quotes from the sequence in which the narrator discovers the pit in Edgar Allan Poe's *The Pit and the Pendulum*: 'my chin rested upon the floor of the prison, but my lips, and the upper portion of my head, although seemingly at a less

elevation than the chin, touched nothing ... I put forward my arm, and shuddered'.[12]

In *A Simple Network* the body is buried, enclosed, but the situation is active; it is not a passive experience.[13] Viewers place themselves in this threatening situation by voluntarily descending into the work. Aycock has spoken to of how in such works she deliberately sought to create a sense of menace, which one might characterise as 'authentic' (as opposed to the passive, mediated, 'inauthentic' experience of painting or conventional sculpture). Of another work, *Low Building with Dirt Roof for Mary* 1973, another structure that can only be entered by crawling, she wrote that: 'The sense of claustrophobia inside is increased by the knowledge that the exterior surface of the roof is covered by a mound of earth ([weighing] approximately 7 tons).'[14]

Aycock has positioned her work as a space in which private and personal memories and mythologies might be accessed. But equally it is a place in which a present experience could be enacted or encountered. One's understanding of such an experience might be mediated by memory but the work creates a space for action, for a 'live' experience. That such works were located in open countryside (instead of an urban or gallery context) was an important consideration, producing an extreme contrast of openness and constriction that in turn returned the participant to an acute awareness of bodily scale and their physical surroundings.

The Body in Exile

In the Cuban artist Ana Mendieta's work, especially in her *Silhueta* series, the seemingly opposing conditions of birth and burial are symbolically conjoined. Two performative actions demonstrate this. In *Untitled (Burial Pyramid)* 1974 Mendieta was buried by colleagues beneath a pile of stones at a temple structure in Yagul, Mexico. As she inhaled and exhaled deeply the stones were gradually displaced and the slow revelation of her body was documented on film and in photographs. *Untitled (Genesis Buried in Mud)* 1975, also recorded on film, shows the artist buried in mud on the banks of the river and, again, the form of her body only becomes apparent through her breathing movements, as if the ground itself were drawing breath; the title makes specific the identification of artist, earth and creativity.

Mendieta called her work 'earth body art', thus making explicit the hybrid nature of her activities. In her work she borrowed from different cultural traditions to invoke cross-cultural archetypes and address themes including – primarily and repeatedly – the identification of the earth with the female body.

Curator Olga M. Viso has suggested that Mendieta:

> longed to access the primal beginnings of civilisation: a time that ostensibly preceded identifications of difference based on nationality, ideology, race and ethnicity. While knowledge of such primordial impulses (which she saw as an abiding respect and wonder for the equalising forces of nature and an awareness of the individual's place in time and history) might be latent in contemporary Western society, she was determined to decipher them.

Viso suggests that Mendieta used the body – specifically her own body – as the conduit for this process: 'It was through the shared language of the body that Mendieta sought to understand not only her own identity and life experience but, more importantly, society's perception and understanding of itself.'[15]

Mendieta was born in Cuba in 1948. In 1961, because her father was involved in counter-revolutionary activities, she and her sister Raquelin were sent to the US. The two sisters were placed in a home for disturbed or neglected children in Dubuque, Iowa, and were subsequently moved between different foster families and boarding schools. For Mendieta this childhood experience of exile gave her an acute consciousness of difference. 'It wasn't that being different was bad, it's just that I had never realised that people were different. So trying to find a place in the earth and trying to define myself came from that experience of discovering differences.'[16] Such questions of identity, problems of differentiation and integration, would eventually become the keystones of her art.

In 1967–9 Mendieta studied at the University of Iowa. At the end of 1969 she met the German artist Hans Breder there and began to study on his Intermedia programme, which embraced a multiplicity of media, including film and performance, and which was grounded in Breder's knowledge of European Fluxus, Conceptual and Performance art. Breder was also interested in, and introduced Mendieta to, Viennese Actionism which, with its mythologising, quasi-religious rituals, use of blood, theatre and spectacle, was to prove a powerful influence. She also took courses in 'primitive' art and was deeply impressed by both the magical power and the attitudes to nature expressed in non-Western cultural traditions – its 'authenticity'.

In 1971 Mendieta made her first visit to Mexico, which, with its powerful integration of religion and everyday life, was to remain an important place for her. In 1972 she stopped painting and began to concentrate on performance. Two works of that year illustrate how she attempted to assimilate ritual structures and religious imagery into her work, alongside a powerful exploration of identity and sexuality. For *Untitled (Death of a Chicken)* 1972 she stood, naked, clutching a chicken which, with its throat cut and in its death throes, spattered her breasts and stomach with blood. With *Untitled (Facial Hair Transplants)* 1972 she addressed gender stereotypes by attaching the shaved facial hair of a classmate to her face to form a moustache and beard, giving her a superficially and patently artificial male appearance.

In 1973 Mendieta began to work in the landscape. For her, the land was a source of mystical energy that might enrich her art: 'I wanted my images to have power, to be magic. I decided that for the images to have magic qualities I had to work directly with nature. I had to go to the source of life, to mother earth.'[17] That year she took another trip to Mexico and at Yagul she made the first of the *silhuetas*, works in which the form of the artist's body is somehow imprinted onto the landscape. *Imagen de Yagul* (Image from Yagul) 1973 (fig.29) shows her lying naked

in an open, pre-Hispanic tomb, covered in sprays of delicate white flowers that appear to be sprouting from between her legs and under her arms, and which completely obscure her torso and head. With her identity concealed, she becomes – like an old English Green Man – a kind of mythic archetype, or a representation of nature. Yet by locating the piece within a tomb, and adopting the pose of a body prepared for burial, Mendieta conjoined ideas of life and death. Such works address the opposition and conjunction of body and nature, as well as nature and culture.

The *silhuetas* became Mendieta's defining works, and their forms and methods vary enormously, although the defining characteristic is always of a female body merged or inscribed into the earth. For *Untitled (Silhueta Series, Mexico)* 1976 (fig.30), a figure was excavated into the grey sand of a beach in Mexico and then filled with red tempera pigment, like a stain of blood. The sculpture was then photographed. Later, when the tide slowly washed the form away, Mendieta photographed that too. In *Untitled (Silhueta Series, Iowa)* 1978, a silhouette is formed from mud, located in isolation with a stretch of muddy marsh, grass and leaves sprouting around it. In a second work of the same title Mendieta creates the figure by simply tramping down the vegetation and picking flower heads. She also made *silhuetas* with gunpowder, by burning, and by gathering together piles of materials such as sticks, cacti and seaweed.

In an unpublished statement Mendieta wrote:

> I have been carrying on a dialogue between the landscape and the female body (based on my own silhouette). I believe this to be a direct result of my having been torn away from my homeland during my adolescence. I am overwhelmed by the feeling of having been cast from the womb (nature). My art is the way I re-establish the bonds that tie me to the universe.[18]

In a later series made in Jaruco, Cuba in 1981, she used the traditional technique of carving to affirm her bond to her homeland. The *Esculturas Rupestres* (Rupestrian Sculptures) (fig.31) are permanent works in which archetypal female forms, referencing the goddess figures of many southern and central American cultures, are incised into caves and rock faces. They gained added resonance through being inscribed into the land from which the artist had been exiled.

The prominence of women artists in this area of Land art is perhaps representative of the resurgence in the 1960s and 1970s of thinking which positions the earth as essentially feminine, or as a female entity, the archetypal Great Goddess. The rise of feminism in the 1960s and the exploration of Goddess myths in the 1970s led a number of female artists to reassess the potential of this symbolism, and alongside Mendieta, artists such as Mary Beth Edelson and Donna Henes developed performative strategies to explore this kind of imagery. Such gendered readings of landscape produce interesting interpretations of the actions of some of the male artists active in the landscape.

The Experience of Nature

Since the early 1970s a different kind of bodily engagement with the landscape
has been the foundation for work by Hamish Fulton. Fulton studied at St Martins
School of Art in London with Richard Long (where they made a number of
collaborative works) and while their work shares a number of basic premises – for
example the notion that what Fulton calls the 'short walk in nature' can constitute
a work of art – it has subsequently developed in different ways to address
a divergent (if sometimes overlapping) set of concerns.

Fulton's early work used text and image to document journeys or trails through
the landscape, as well as to evoke intense moments of personal experience, but
often deployed them in ways that suggest the subjectivity and unreliability of
experience and memory. *Isle of Arran* 1970 is a collage which contrasts two
photographs – one of an empty ploughed field on a misty day, the other in which
a field, possibly the same one, contains a figure walking away through thick corn –
with an account of an extraordinary and seemingly unconnected coincidence on
the Isle of Arran.[19] In such works the landscape is depicted in terms of a passage
through time and space; implicit in that passage is the artist's presence.

In 1968 and 1969 Fulton visited the US, where he met Robert Smithson and
other artists in New York. The 1969 journey was of particular importance. Fulton
had a long-held and passionate interest in the lives of the plains Indians – inspired
by his readings of books such as *Wooden Leg* by T.B. Marquis (1931), *Black Elk Speaks:
Being the Life Story of a Holy Man of the Oglala Sioux* by John G. Neihardt (1932)
and *Land of the Spotted Bear* (1933) by Luther Standing Bear – which focused on

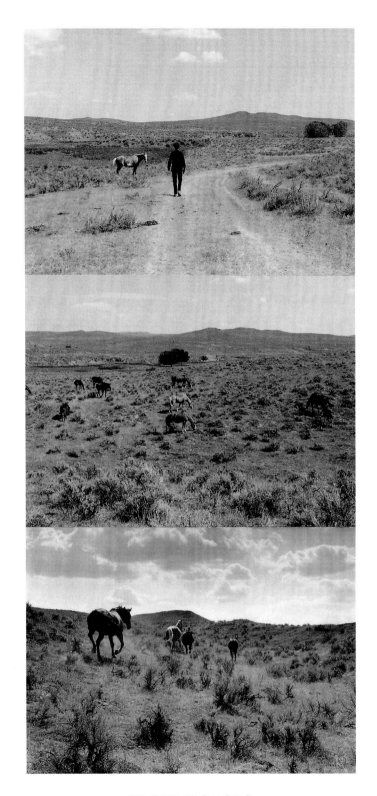

CROW HORSES

LITTLE BIG HORN BATTLEFIELD
MONTANA
SUMMER
1969

the ways in which Native American life embodied a spiritual and symbiotic relationship with nature, and stressed the importance of first-hand experience. In 1969 he travelled to Wyoming, South Dakota and Montana, visiting key places such as the site of the Battle of Little Big Horn, and making numerous short walks with a notebook and a camera. There, Fulton was so deeply impressed by the landscape that he 'began to consider making landscape art'.[20]

Many of the works made by Fulton during this trip are photographic collages that suggest a narrative development, or a movement through a landscape, as in *Crow Horses, Little Big Horn Battlefield, Montana, Summer 1969* (fig.32). Others are concerned with making explicit moments of time, as in *Mirror Flash, Badlands, South Dakota* 1969. Crucially, many of the photographs were taken by Fulton's partner, Nancy Wilson, and thus show the artist himself. It is Fulton we see walking into the landscape in *Crow Horses*. It is Fulton who recreates Sitting Bull's stance from a historic photograph in *Little Big Horn Battlefield, Montana, Summer 1969*. It is Fulton who stands on a rocky bluff in the Badlands and holds a mirror so that for an instant it catches the light of the sun and flashes it into the camera lens. The artist is *in* the landscape rather than presenting a view of it.

Fulton's early photographic works often evoke states of mind brought about by the experience of particular places, for example *Cloudy Listening Waiting* 1971. A single photographic image or short text might stand for a walk – an ongoing experience – lasting many days. Other works are meditations on place and time; often images are collaged together to establish connections, sometimes across continents and wide spans of time, or to suggest a changing viewpoint. Works such as *Ten Views of Brockman's Mount* 1973, which features a series of photographic views of the eponymous hill in Kent, England, suggesting a movement or progress around the feature, along with a commercial picture-postcard view, led commentators such as Rudi Fuchs to read Fulton's works as sculptural in that they articulated both spatial relationships and temporality.

Over the four years following his American trip, Fulton refined the conceptual parameters of his practice. In 1973, after making a walk of 1,022 miles from the northern coast to the southern tip of Great Britain, he codified his artistic methodology into a series of aphorisms, committing himself to make:

> Only art resulting from the experience of individual walks. (*Only* = not a generalised response to nature. *Art resulting from* = first the walk second the art work. *The experience of* = a walk must be experienced it cannot be imagined. *Individual walks* = each walk has a beginning and an end.).[21]

The basic premise of all Fulton's subsequent work is conveyed by the even more condensed statement: 'No Walk No Work.'[22]

Fulton's subsequent practice can be broken down into two aspects. Primarily there is the walk, which might be delineated, defined and carefully structured – for example a set number of paces or miles, timed to coincide with the advent of a full

moon or other natural phenomenon, or following an ancient pilgrim route – be it a 'wandering walk' through a wilderness area, just a few steps in the artist's garden or many thousands of miles long along roads. Secondly there is the artwork through which Fulton represents the experience of the walk. This can take many forms: a simple textual record giving location, length of walk and time of year, photograph and text or, more recently, large-scale text works on the walls of galleries, which appropriate the methods and impact of advertising hoardings.

Although both Long and Fulton have made walking the conceptual foundation of their work (and have undertaken many walks together over the years) the intention of their walking differs. Long's walks serve to make apparent an idea (for example, the amount of time taken to walk all the paths within an imaginary circle, or the relativity of human and geological time). Fulton's walks on roads and pilgrimage routes can do the same, but his emphasis has increasingly been upon his physical and mental experience. While Long has discounted the importance of physical challenge or hardship (while acknowledging the pleasures that a tough walk can offer), stressing instead the primacy of his conceptual intention, Fulton has been insistent on the transformative power of walking in nature, making ever longer walks, both on roads and in wilderness areas, and arduous ascents of high mountains in the Andes and Himalayas. In recent works, this emphasis on the actuality, the reality of the experience has led to a focus on the physiological aspects of the walk, made explicit in texts works such as *Mind Endorphin Body Adrenalin Walk, Kent 1998* and *Mind Heart Lungs, Cho Oyu, Tibet 2000*.[23] In Fulton's conception this goes hand in hand with mental and spiritual insight. He has said: 'The physical involvement of walking creates a receptiveness to the landscape. I walk on the land to be woven into nature.'

> Walking is not about recreation or nature study (or poetry – or 'stopping' to make 'outdoor sculptures'; or 'take' photographs). It is about an attempt at being 'broken down' mentally and physically – with the desire to 'flow' inside a rhythm of walking – to experience a temporary state of euphoria, a blending of my mind with the outside world of nature.[24]

Like Long, Fulton has been consistently positioned as an artist continuing an English landscape tradition (specifically a Romantic tradition), but in fact his influences are more wide-ranging than this would imply. The notion of counting and measuring time in the landscape, a prominent aspect of his work, is partly drawn from Native American navigation systems such as tally sticks. Another important precedent for him are the Japanese Haiku poets, who travelled light, recording their experiences in highly condensed but deeply evocative texts.[25]

Leave No Trace
Fulton differs from Long and the other artists examined in this chapter in another crucial way: he makes no mark on the landscape, preferring to abide by the wilderness ethic of 'Leave No Trace'. Despite his insistence on physical contact – for example, touching 100 rocks by hand on a seven-day walk through the mountains

of central Hokkaido in Japan,[26] or in *Touching Boulders by Hand, Portugal 1994* (fig.33) – Fulton's passage through the landscape is almost invisible. Only the artist's self is marked by the events of the walk: the physical strains and stresses, the euphoria of transcendence, the mental impressions. The only evidence is his own memories and thoughts, and the photographs and texts he presents in books and exhibitions.

Yet Fulton's work also attests to the impossibility of recovering these experiences. One strategy for exposing the unreliability of memory are conjunctions of text and image that seemingly refer to different things, but which actually somehow evoke the experience of a single walk, a single sequence of events. For example, a work representing seven one day walks on Hikkosan, *Raven, Japan 1999*, depicts an old stony path passing through and dense and tangled wood, yet the creature of the title is absent, nowhere to be seen.[27] In a series of recent group projects he has walked the same route each day for a week with the same group of people. As each day the weather conditions and disposition of the group are different it is thus always a unique experience, never the same walk even though the route is repeated. In this way Fulton's work insists on subjectivity whilst paradoxically dealing in facts; it insists that each contact with nature is personal and unique. While his work offers the possibility of recognition or even identification – a kind of surrogate experience of nature – at its heart is always Fulton himself, the artist in the landscape.

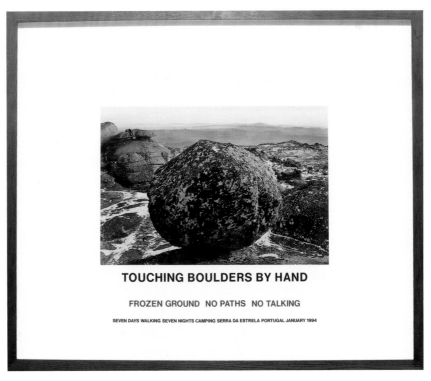

fig.33
Hamish Fulton
Touching Boulders by Hand, Portugal 1994
Photograph and text
116.5 × 139.5 cm

WORKING WITH NATURE

While Michael Heizer remains best known for monumental sculptures such as *Double Negative* and *City*, his early Mojave Desert works were small scale and temporary. Equally, British artist Andy Goldsworthy, renowned for his work with leaves, sticks, ice and snow, has also completed a number of permanent landscape works including the massive *Lambton Earthwork* 1988 in County Durham. Other European artists including Chris Drury, Charles Jencks, Hermann Prigann, and Nils-Udo have also completed large-scale permanent works. Nonetheless, such work remains rare within Europe. While the wide-open and undeveloped spaces of the American West have allowed artists to work on a greatly enlarged scale, the European landscape – a densely worked and layered human construct that is highly determined both historically and culturally – has tended to produce predominantly ephemeral conceptual strategies and small-scale sculptural practices indebted to folk traditions. As Guiseppe Penone has stated:

> In the US there is still nature that is real nature, you can tell that it is not a product of man, but in Europe every tree that you see has been planted by man and is part of an *organisation* of nature, so that it is not possible to think in the same way. Europeans need always to think in terms of history.[1]

Since the 1970s, an approach to making art in the landscape that we might characterise as 'working with nature' has developed. European artists such as Goldsworthy, Drury, Prigann, Nils-Udo (fig.34), Sjoerd Buisman, David Nash and herman de vries (and American and Canadian artists including Patrick Dougherty, Roy Staab and Michael Singer) work with their hands, with natural materials, and employ traditional skills including basket-weaving, wood-working, dry-stone walling and plant husbandry. Postmodern in that it offers an implicit critique of modernist sculptural practices and materials, such work is as much a part of the 'expanded field' of post-war sculpture as earthworks or Conceptualism.

The Experience of Making

> I'm not an artist born full of things I want to express. I'm empty, hungry, wanting to know more. That's my true self; and my art is a way of learning, in which instincts guide best. It is also very physical – I need the shock of touch, the resistance of place, materials and weather, the earth as my source. It is collaboration, a meeting point between my own and earth's nature.[2]

Andy Goldsworthy first came to prominence in the mid-1980s and while he has has since become one of the best known and popular artists working today, his art has been frequently misinterpreted and misunderstood. To many viewers his sculptures and the photographs that document them – in particular those works that use what seem to be the unnaturally intense colours of leaves and flower petals – represent a celebration of beauty in nature (fig.35). As a result he has been criticised for presenting a kind of populist decorativeness and a dewy-eyed

fig.34
Nils-Udo
Mirror 1999
Aachen, Germany

fig.35
Andy Goldsworthy
Maple Leaves,
Ouchiyama-mura, Japan,
19 November 1991

sentimentalisation of nature. However, this is a reading that ignores the fundamentally sculptural concerns with which Goldsworthy engages. Such critiques privilege art over craft and form over decoration but also devalue the formal explorations which are central to Goldsworthy's project. They partake of a long-standing tradition that suspects the use of colour, which the artist David Batchelor has recently analysed as 'chromophobia'.[3] Goldsworthy himself accepts that beauty is something with which he deals, but stresses that it is just one idea within a body of work that engages with many aspects of nature:

> Nature is intensely beautiful and at the same time very unnerving, and at times deeply frightening. You feel it as soon as you go out to the land, where everywhere you go things are dead, decaying, fallen down, growing, alive. There's this incredible vigour and energy and life. And it's sometimes very difficult to deal with. I would hope that I don't have a kind of romantic view of nature. I do feel the beauty of it, for sure. But it's a beauty that's underwritten by extreme feelings.[4]

The notion that Goldsworthy's work is decorative and somehow affirmative also ignores the fact that Goldsworthy is as obsessed with decay and disintegration as Smithson was. Integral to much of his work is an inbuilt obsolescence: the works are constructed to disintegrate and this phase of their existence is as important as their coming into being under the artist's hand. He has said: 'My sculpture can last for days or a few seconds – what is important for me is the experience of making. I leave all my work outside and often return to watch it decay.'[5] As such, Goldsworthy's work powerfully articulates a sense of mortality, and is concerned with the notion of entropy. Addressing a persistent misconception about nature he has said: 'We misread the landscape when we think of it as pastoral and pretty. There is a darker side than that.'[6]

Goldsworthy studied at Bradford School of Art and Preston Polytechnic from 1974 to 1978. During this period, unhappy with studio-based work, he began to work several days a week out-of-doors at Morecambe Bay, a vast, sandy tidal estuary a few miles to the north of Lancaster, where he was based. There he made exploratory work with sand, stones and his own body, sculptural work and actions that he documented photographically in order to show his tutors. At this point, Goldsworthy was essentially working without a context. Unaware of recent developments such as Minimalism and Conceptual art, his closest reference points were British artists such as Henry Moore and Barbara Hepworth. While in 1974–5 he saw photographs of Smithson's *Spiral Jetty* and Joseph Beuys's *Bog Action* 1971, he only became aware of a British context for his landscape works in 1976 when Long visited the college to lecture there. In the late 1970s he also received important support and encouragement from the sculptor David Nash.[7]

By 1977–8 Goldsworthy had developed a method that he has maintained ever since. He works in the landscape using the materials available in the location. He works with his hands and, when able to, uses only natural materials: spit or water

serves to bind leaves to stone or wood, thorns are used as pins, grass to wrap or tie. However, he is quick to point out that if tools are necessary to make a work, then he uses them. He does not work in this manner out of a kind of ecological purism, but because this is the best way to gain an understanding of the place and the things he is using. In this sense, he sees himself as a formalist, exploring the properties of different materials and engaging with sculptural concepts such as mass, balance, space and form. His work enacts an investigative process through which he seeks to understand both his materials and the landscape contexts from which they arise.

Goldsworthy's art also constitutes a response to place and time based on careful observation. He has been based for extended periods in just a few places, hilly, rural locations such as Penpont in Dumfriesshire, and has used his surroundings as a sort of expanded studio. His work is thus 'from and deeply rooted in the British landscape ... and the changes that occur there'.[8] He works with nature in order to try to understand the 'rhythms of change', the particular qualities of the landscape, its geology, climate, vegetation, and the way in which it changes from day to day and across the seasons. Over time, Goldsworthy has repeatedly addressed a series of motifs or themes, as if testing them against different conditions, different seasons, examining how they function in different locations. His forms are simple, abstract, archetypal, and although he plays down this aspect of his work, richly symbolic: holes and voids, cairns shaped like eggs or seeds, spirals, wandering lines.

For most people, Goldsworthy's sculptures are experienced as photographs, but he emphasises that the object itself is the focus of the work, and the image a kind of residue:

> Each work grows, stays, decays – integral parts of a cycle which the photograph shows at its height, marking the moment when the work is most alive ... Process and decay are implicit in that moment ... The photographs leave the reason and spirit of the work outside. They are not the purpose but the result of my art.'[9]

This process-led, temporal aspect of Goldsworthy's art is made explicit by his practice of exhibiting, alongside the main image of the work 'at its height', a secondary image of the decayed work, or of the landscape context of a sculpture. And since the process of making and the engagement with materials, together with the seasonal and climatic conditions of place, are key to the piece, his unlikely looking structures, precarious configurations of snow, ice, leaves, stones and sticks, are also explained in tersely poetic, evocative captions.

Alongside the ephemeral works are permanent ones such as a series of dry-stone walls, cairns and arches. Goldsworthy has also staged events. On midsummer's night, 2000, his *Midsummer Snowballs* (fig.43) appeared in locations around the City of London. These giant snowballs had been made in Scotland the previous winter and put into deep freeze. Each contained different materials – stones, berries, leaves – and as they melted disgorged their contents into the streets, offering passers-by a surprising confrontation with raw nature in the middle of the metropolis.

'Art in Nature'

Goldsworthy is the most visible of a group of artists working in Europe who are concerned with making sculptural work in the landscape and whose practice is characterised by the ephemeral and the handmade. Other artists working in this way – whose careers encompass a wide range of strategies and sensibilities – include Alfio Bonanno, Chris Drury, Nils-Udo, Giuliano Mauri, Hermann Prigann, Bruni & Babarit and Dominique Bailly, many of whom have been associated with, or have been promoted by, an organisation called Art in Nature. Founded in 1989, Art in Nature's purpose is to foster environmental awareness through the use of art. As a programme, it addresses two main questions: 'What is the position of the world of art with respect to nature?' and 'What is art's position with respect to the expansion of technology?'[10] These are surely valid questions but for many critics the group's response to the second question in particular has been to adopt a reactionary attitude to modernity and to fetishise the pastoral and the handmade.

Art in Nature is predominantly an Italian, German and Scandinavian movement, and its activities have been focused on sites such as TICKON (Tranekaer International Centre for Art and Nature) at Tranekaer Castle, Denmark, Arte Sella in Trentino, Italy, and to a lesser extent projects such as Crestet in France and Grizedale Forest in Britain. The organisation has been energetic in establishing a new agenda for exploring the dialectic of nature and culture, and has organised exhibitions, conferences and publications to this effect. Curator Dieter Ronte has defined the organisation's approach as one in which the artists:

> create their own works of art in natural spaces in the open air, in the countryside or else on the outskirts of large cities, using materials exclusively from the surrounding area, without the aid of substances or colours that, in this environment, might be perceived as incongruous, or as a violent and arbitrary intrusion. The aesthetic objective is characterised by interaction, by the oneness of art and nature, by the new art in nature and the cultural approach to the understanding of nature.[11]

For Ronte, the work both articulates formal aesthetic values and addresses a spiritual need. The treatment of materials is important for this: 'The artist intervenes in nature without causing irreversible damage. This statement is valid both on a visual plane and on a spiritual one. The artist is engaged in a spiritual, intellectual and aesthetic dialogue in favour of both nature and art.'[12] While most of the work made by artists associated with the group is abstract, and the notion of spirituality is implicit in the treatment of materials, this aspect of the group's programme is made literal by constructions such as Giuliano Mauri's *Cattedrale*, 1992, and *Tree Cathedral*, 2001 (fig.36), constructed for Arte Sella.

Art in Nature is just one of a number of European organisations that, in the 1980s and 1990s, helped create a context for a revival of folk traditions in contemporary art and craft. And in Central and Eastern Europe – regions where

fig.36
Giuliano Mauri
Tree Cathedral 2001
Sella Valley, Italy

traditional forms of rural life have remained current until very recently – artists have also developed conceptual and performance strategies articulating deep-seated roots in land and tradition.[13]

In the West such strategies can be seen as a revival of the questioning and sometimes implicit rejection of contemporary society and its structures that took place fifteen years earlier in the US and UK in works like Michael Heizer's appropriation of Mesoamerican forms in *City*; in Ana Mendieta's use of Goddess imagery; Charles Simonds's adoption of ritual; in Richard Long's stone circles or in Hamish Fulton's walks along ancient pilgrimage routes. As such it bespeaks a fundamental shift in society, a reordering of priorities.

Nature and Culture

An artist is a communicator, but to be an artist one must first be a human being: that is to say, whole, undivided, if that is possible. From such a position there is no division between man, art and nature. The world is perceived as it is. Personally I have nothing to communicate, consciously or unconsciously; the work simply reflects the moving from moment to moment in the world as it is, and so it is nature itself that communicates.[14]

One of the most prominent artists associated with Art in Nature is Chris Drury. Like Goldsworthy, Drury has worked predominantly with natural materials in the landscape. However, while Goldsworthy's work primarily addresses formal concerns, Drury has instead developed ideas about ritual, myths and archetypes, working with medicinal plants, cairns, baskets, maps, and constructing shelters and contemplative chambers in the landscape (fig.37). Recently he has also explored the correspondence between flow patterns in the human heart and in nature, completing a major earthwork on this theme, *Heart of Reeds* 2005 (fig.38), at Lewes in Sussex. Drury's work explores conceptual distinctions between nature and culture and frequently uses forms and methods derived from non-Western societies to explore the interdependence of these two philosophical conditions. In Kay Syrad's formulation, Drury is concerned with the 'insight' given to 'inner nature' by certain kinds of encounter with 'outer nature'.[15]

Drury began his career as a figurative artist. A meeting with Hamish Fulton in the early 1970s and a trip to Canada with him in 1974 – when they explored a wilderness region, camping wild with minimal equipment – led him to reassess the way in which he might address the subject of nature in his work. For Drury his breakthrough work (which he has said contains the seeds of everything he has done subsequently) was *Medicine Wheel* 1982–3. This sculpture (and accompanying text) organises natural objects – including seed pods, herbs, bird feathers, bones, berries, skulls and eggs – ritually gathered, one on every day of a year, into a large mandala-like construction. The objects accumulated within it reflect Drury's experience of the changing seasons, and the places through which he passed at that time. In this sense it is a way of organising his experience, a kind of diary. The form

of the work was suggested by the practices of certain Native American tribes:

> a medicine wheel was used in a Native American form of cosmology, giving a cultural meaning to the outer world. This, in itself, started me on a journey of making shelters and baskets as a way of linking cultural objects to the outer world of landscape and place and time. The finding of objects led me to link material and object to a found moment in time and space.[16]

Within Drury's work, ritual plays a key role. Having read of the cultural values ascribed to basket-weaving in certain Native American tribes, in which the practical and the spiritual are bound together, Drury adopted this as an aspect of his practice. Weaving is hypnotic, meditative and therefore transformative. Drury has said of this: 'The design, weave and mind-numbing repetitive nature of this painstaking work all play a part in looking inward, just as the act of walking does outside', an idea that connects to Fulton's notion of being 'broken down' and bound into the landscape through the physical activity of his walks. In this formulation any activity, if it is carried out as ritual, can offer a transcendental experience.[17]

Transformative experience is also offered by the shelters that Drury builds within the landscape. These are both practical and symbolic. 'Shelter is a basic human need and a manifestation of human presence. It is a dwelling place within the movement of a walk. It can be made simply and quickly with materials to hand, using minimal tools. Material and site are inseparable if a shelter is to sit comfortably.'[18]

Drury's shelters are sometimes permanent but equally they have been constructed, photographed and then dismantled. On occasion he has subsequently carried the materials used to make a shelter away from the site and then reconfigured them in a gallery space. In other works the artist has used the shelter and inscribed the experience into the resulting work made from its constituent materials. In *Four Days by a Lake: Canvas Lavo, Lapland* 1988, Drury constructed a simple canvas shelter by a lake and lived in it for four days. In the exhibited work the canvas is pinned to the gallery wall in a fan-shape. On it are shapes made with soot from the fire, and the star shapes with which Drury marked the hours, together with talismanic objects from the site: antlers, feather, bones.[19]

Drury's preoccupation with the nature-culture dialectic is made explicit in a sculptures such as *Tree Mountain Shelter*, made in the Sella Valley, Italy, 1994 (fig.39). This work is an igloo-like shelter constructed from stones, surrounded by a second, open-weave wooden structure. The shelter is set in a small clearing in a wood. Drury has said of it:

> In many cultures the mountain and the tree symbolise the journey of the human psyche ... Shaped like a mountain, its inner, woven hazel shell is clad in stone, which in turn is surrounded by an outer, open-weave cover of sticks. In the side facing the mountains is a window. From here there is a view of the actuality of nature, the mountain, which nevertheless acknowledges human separation from it: nature viewed from the shelter of

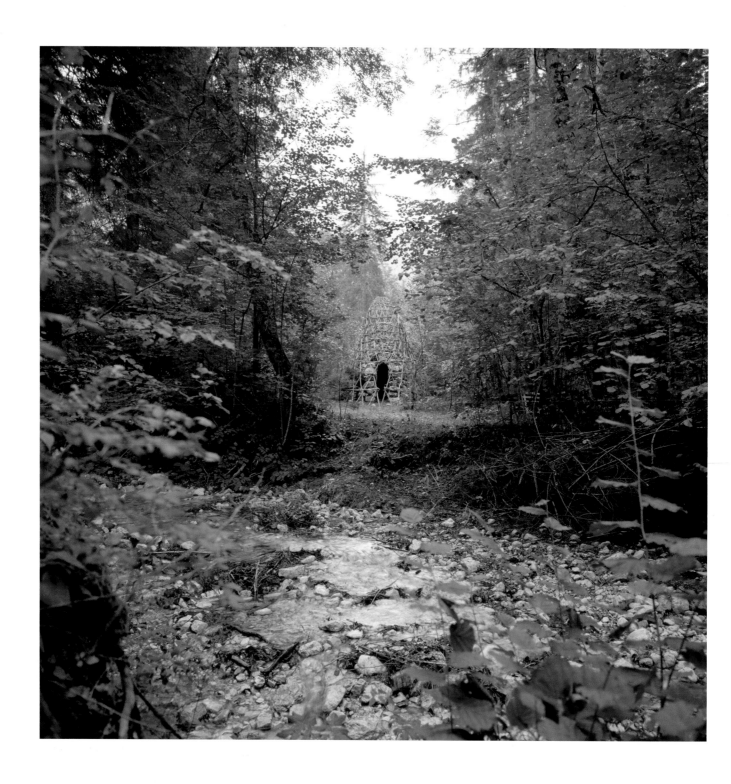

fig.39
Chris Drury
Tree Mountain Shelter
1994
Casa Strobele, Sella
Valley, Italy

culture. You look out through wood, through stone, through wood again, past the lone standing pine to the mountain.[20]

More recently Drury has also built meditative 'cloud chambers' such as *Wave Chamber* 1996 at Kielder Resevoir, Northumberland, and *Hut of the Shadow/Both Nam Faileas* 1997, Lochmaddy, North Uist. These structures incorporate *camera obscuras*, or lenses, so that an aspect of the outside world – a faint and otherworldly image of the sky seen through a canopy of trees or a stretch of water near a chamber built on the shore of the lake – is projected inside, for contemplation. Exterior reality and interior reality are thus conjoined, imposed one upon each other; a form of insight.

Landscape Rituals

It is too easy to establish a simplistic polarity between American and European strategies. In fact, a number of artists based in the US and Canada have adopted strategies analogous to the ambitions of Art in Nature. Michael Singer is an American artist whose landscape-based practice of the 1970s offers a number of points of comparison with that of both Goldsworthy and Drury. Like Goldsworthy he is fascinated by, and committed to exploring the physical nature of his materials. Like Drury, his landscape works offered the possibility of a transformative experience of place, a process he has characterised as 'ritual'.

In the late 1960s Singer was based in New York and making work using balanced groupings of wood, steel and bricks. In 1971 he moved out of the city to Vermont, where the siting of a steel sculpture in fields near his home offered an important revelation:

> I found myself making changes and then looking at the work through a camera. It dawned on me that I needed a camera to re-create the framework of the walls of my city studio and that I was being strongly influenced by the urban vision and experience I had just left. It was an important lesson for me to realise that in this different natural environment vision isn't always blocked, there are no grids. In the pastoral and wooded landscape of Vermont, vistas open to valleys and mountains, and it's the atmosphere that veils and reveals the hills over great distances. It was this natural environment that I wanted to understand.[21]

Between 1971 and 1973 Singer embarked upon a series of works at the Beaver Bogs, Marlborough, Vermont, and at Saltwater Marshes on Long Island. Works such as *Situation Balance Series Beaver Bog* 1971–3 were made by cutting trees and balancing them, attempting to create stacked configurations that would look 'natural', as if they had been created by windfall.

These works led Singer to explore the properties of insubstantial materials such as phragmites, grasses and bamboo (see fig.40). Works such as the *Marsh Ritual Series* 1973, Long Island, and the *Glades Ritual Series* 1975, Everglades National Park, Florida, were composed of sculptural constructions spread across large areas of landscape, each barely visible but gradually revealed, through the ongoing engagement of the viewer, as part of a complex whole. Singer's intention was to

address the formal properties of the materials with which he was working, as well as sculptural notions of balance, form, light and space, but he was also concerned with the experience of landscape as revealed by the work; a notion of sculpture 'interdependent with place'. Diane Waldman noted that 'only after prolonged viewing is the spectator able to isolate the delicate tracery of the structure from its surroundings.'[22]

Singer said of the *Glades Ritual Series*:

> I built a structure using materials indigenous to the area. It was to become the symbol for a ritual. The ritual took place throughout the day at different moments – once when the structure seemed to catch the low clouds as they passed through it; once when the light silhouetted the piece against the pineland forest illuminating it intensely for a moment; and again, when the full moon on the eastern horizon coincided with the setting sun, causing the piece to shine with the colours of the reflected light. The piece provided the apparatus for the rituals of any given day to take place.

It is apparent that for Singer these natural 'rituals' had magical significance. He has spoken of 'building an apparatus to see more of what I am, where I am'.[23] Like Goldsworthy and Drury, Mauri, Nils-Udo and others, his work represents a dialogue with nature and materials, creating a situation in which it reveals the experience of place and the particular conditions at a certain moment in time.

Growing Art

A different kind of dialogue with nature is created in the planted projects of David Nash, herman de vries, Nils-Udo and Sjoerd Buisman. Nash moved to Blaenau Ffestiniiog in the mountains of North Wales in 1967. Shortly afterwards he explained the ambition behind his rejection of urban life and art:

> I want a simple approach to living and doing. I want a life and work that reflects the balance and continuity of nature. Identifying with the time and energy of the tree and with its mortality, I find myself drawn deeper into the joys and blows of nature. Worn down and regenerated; broken off and reunited; a dormant faith revived in the new growth of old wood.[24]

Nash's language, his desire to be 'worn down and regenerated' is strikingly reminiscent of both Fulton and Drury's ambition to use their art to 'break down' physical and psychological barriers and 'weave into' nature, and reveals an intense desire for transformation which is a central concern of his art.

Since the late 1960s Nash has worked exclusively in wood, treating wind-fallen, dead or dying trees as 'wood quarries' from which to draw the material for sculptures ranging from table forms, abstract shapes – pyramids, cubes and spheres – and anthropomorphic frames and standing structures. An entire Nash exhibition might be drawn from a single large tree. Typically, Nash has worked in the landscape, alongside the source of his material, responding not just to the wood available, but also to the local cultural conditions in Wales, Japan, California and

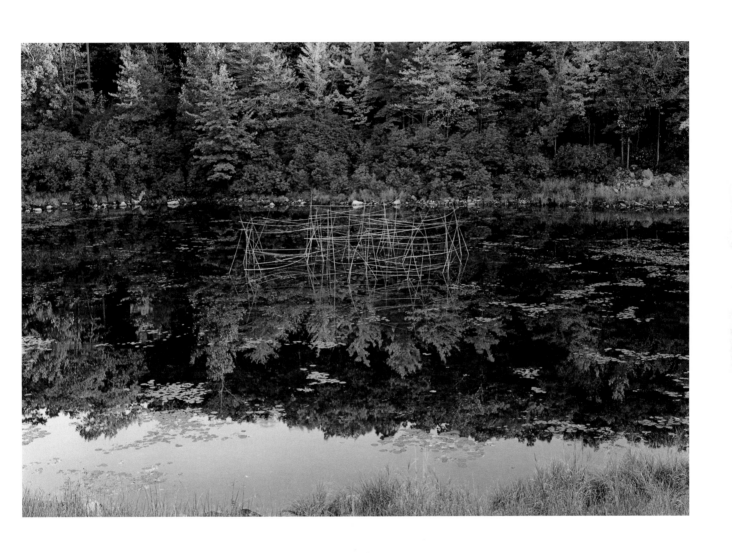

fig.40
Michael Singer
Lily Pond Ritual Series
1975
Bamboo and jute rope
Harriman State Park,
Harriman, New York

elsewhere. Nash originally worked only with hand tools, but since 1977 he has used chainsaws. Like Goldsworthy, he does not want to limit his art to make an ecological point; it is more a question of using the right means to create the right work. Also like Goldsworthy, Nash has sought to counter romantic readings of his work by positioning it within a formalist discourse, emphasising attention to form and properties of materials over symbolic readings. However, his choice of wood as a material, his selection of a small community in North Wales as his base, and indeed the forms of his sculptures, speak of a philosophy of life and an attitude towards nature that is deeply spiritual.[25]

Nash is best known for his sculptures in wood, but since the mid-1970s he has also produced a series of planted projects. While a number of these have been realised in sculpture gardens, such as *Divided Oaks* 1985 at the Kroller-Muller Museum in Otterlo, Holland, most of these pieces have been carried out close to home, on a hillside at Cae'n-y-Coed in the Vale of Ffestiniog. There are over twenty works here, of which the best known is the *Ash Dome* (fig.41), begun in 1977. The *Ash Dome* is a ring of twenty-two ash trees, guided and fletched using traditional husbandry techniques, so as to grow into a dome, a sculptural form that symbolises the interaction of nature and culture as well as creating a meditative chamber. Visiting the work is an extraordinary experience; the trees are clearly natural, yet their twisting, arching growth is intensely surreal, and the space they create feels peculiarly formal.

Nash's intention in making the dome was as an explicitly symbolic response

fig.41
David Nash
Ash Dome 1977–2006
photographed in 1999
Cae'n-y-Coed, Blaenau
Ffestiniog, North Wales

to a specific social context:

> When I first planted a ring of twenty-two ash trees for the *Ash Dome* in 1977, the Cold War was still a threat. There was serious economic gloom – very high unemployment in our country – and nuclear war was a real possibility. We were killing the planet, which we still are because of greed. In Britain our governments were changing very quickly so we had very short-term political and economic policies. To make a gesture by planting something for the twenty-first century, which was what the *Ash Dome* was really about, was like a long-term commitment, an act of faith.[26]

The commitment was an extended duty of care, a constant need for tending. While the dome represents a collaboration with nature, Nash has gently forced the trees to do something that they are not naturally inclined to do. Nonetheless, the *Ash Dome* has endured into the twenty-first century and is now reaching maturity.

Less intervention into natural processes can be seen in herman de vries's *die wiese* (*the meadow*), which was established in 1986. Like Nash, de vries has consciously sought to distance himself from the art world, and since the early 1970s has lived in the small village of Eschenau in Bavaria. Like a readymade, *die wiese* is simply a field, a space set aside and allowed to develop naturally, and is now dense with apple trees, wild cherries, roses, and home to a wide variety of wildlife. All de vries has done is designate the space a work of art. He has said, 'it will go completely back to nature. This not doing anything any more will be the art'.[27]

die wiese has its urban equivalent in de vries's *sanctuarium* 1997 in Munster

(fig.42). The *sanctuarium* is a walled and inaccessible garden that has not been planted but colonised by plants from wind-blown seeds. de vries has thus established a 'natural' space within the constructed and artificial space of the city. Feeling that people have lost their relationships with the natural world, but that art can restore them, he sees the artist's role as inherently social and political. One of the things that he does in order to achieve this is the simple act of *showing*: 'I have to make visible what people don't see anymore.' His work is thus a 'a social contribution to a general consciousness'.[28]

Art in Nature and Politics

Nash's relocation to North Wales, and de vries's to Eschenau, came at a time when there was renewed interest in pastoral living. In Britain this was manifested in two ways. Firstly it was reflected in the explosion of published memoirs and histories of traditional rural life, and compendiums of 'old wisdom' – something that was perceived as being under threat from modernisation and agri-business – such as George Ewart Evans's *The Pattern Under the Plough* (1966), Ronald Blythe's *Akenfield* (1969) and John Stewart Collis's *The Worm Forgives the Plough* (1973). Secondly it

fig.43
Andy Goldsworthy
Midsummer Snowball,
London 2000

was visible in the back-to-the-land movement, which was popularised by books such as John Seymour's *The Fat of the Land* (1961) and *Self-Sufficiency* (1973) and magazines such as *Practical Self-Sufficiency*. While such publications focused on the practicalities of change, the subtext was that something had gone wrong with contemporary life, but that one might still return to a kind of pre-lapsarian Eden by revising the way in which life was lived. In the 1970s, with growing awareness of the degradation of the environment by industry through books such as Charles Reich's *The Greening of America* (1971) and Edward Goldsmith's *Blueprint for Survival* (1972), such ideas and attitudes became increasingly politicised. An awareness of these issues runs deeply through much of the work discussed in this chapter.

Michael Singer's landscape work of 1970s exemplifies a tension between formal means – the sculptural language of the work – and a desire to articulate an idea or an attitude towards the environment. While the success of the sculptures was determined by Singer's sensitive deployment of material and his articulation of space and light, he has also said:

> Part of my obsession about the absence of humans in these works came from the shame I felt about being part of a culture that has systematically destroyed the natural environment. In order to experience and learn from the natural environment I felt the need to yield to it, respect it, to observe, learn and then work with it.[29]

This is an attitude that many of these artists have attempted to negotiate. However, as with earthworks, those artists 'working with nature' have found that their aims and intentions have been consistently misunderstood as being 'about' green issues, and even appropriated to political ends. While many are sympathetic to these causes, such readings have deflected attention from the formal innovations of the work itself and their actual concerns with materials, time and place. One artist in particular whose work has served as a focus for such debates is Goldsworthy:

> It's not the intention of my work, but it does prime people towards environmental issues. I don't know how it does that, or why, but it does. I'm happy for that to happen. But if that became the intention of the work then the work would be weakened. If the message my work was putting out was that people felt they needed to take up the cause, the work would wither.[30]

He was forced to confront this possibility in 2000. One of his *Midsummer Snowballs* was positioned close to the London Headquarters of BP. When the environmental pressure group Greenpeace learned of this they issued a press release – including a quote from Goldsworthy taken from another context – suggesting that the work was about climate change and specifically a protest against BP's role in the creation of global warming. Goldsworthy was shocked to have his work used in this way, which, as he saw it, reduced its content to a specific issue. As a result of this incident – which revealed to him the extent to which his art might be limited by association – he has been forced to reassess the ways in which his work has been used to promote a number of environmental causes.

REGENERATION
ART, ECOLOGY AND THE ENVIRONMENT

fig.44
Hamish Fulton
*No Talking for 14 Days,
Montana* 1997

'Making art today is synonymous with assuming responsibility for our fellow human beings.'[1]

While a political intention or, perhaps more precisely, a moral position, is *implicit* in the work of many of the artists discussed in the previous chapter, a number of Land artists have made work that has addressed environmental issues in a direct and overt manner. The development of environmental awareness since the 1960s has stimulated an extraordinary range of work that registers what is widely perceived as a developing ecological crisis, that proposes solutions to specific problems, or that aims to raise awareness and politicise thinking about man's relationship with the landscape.

This period has seen a paradigm shift in our understanding of the world around us as a result of scientific advances. The physicist Fritjof Capra characterises this as a change from viewing the universe as 'a mechanical system composed of elementary building blocks' in which society is 'a competitive struggle for existence' (where success is achieved through uninhibited technological and economic growth), to what might be called a holistic conception of the world. In this new view, the world is understood as 'an integrated whole rather than a dissociated collection of parts'. In Capra's analysis, 'it may be called an ecological view, if the term "ecological" is used in a much broader and deeper sense than usual. Deep ecological awareness recognises the fundamental interdependence of all phenomena and the fact that, as individuals and societies, we are all embedded in (and ultimately dependent on) the cyclical processes of Nature.'[2]

This vision of the world offers a new framework for thinking about the relationship between art, society and the environment. In 1980 Agnes Denes suggested that the 'new role of the artist is to create an art that is more than decoration, commodity or political tool – an art that questions the status quo and the direction life has taken'.[3] In the 1970s and after the remedial possibilities of earthworks and other practices, and the consciousness-raising potential of art, have become increasingly important and have inspired major projects by artists as diverse as Robert Morris, Agnes Denes, Buster Simpson, Betty Beaumont, Mel Chin and Helen Mayer Harrison and Newton Harrison. This aspect of Land art has been widely characterised as 'Ecological' or 'Environmental' art, and within the genre it is perhaps possible to identify three principle creative strategies.

The first is a kind of practice that offers both a commentary upon environmental issues and 'creative solutions' to the problems perceived there. Such work includes land-reclamation projects that attempt the recovery of 'abused' land. It positions art as a resource, a means of 'healing' or 'making better'. The second kind of work offers symbolic warnings and poetic meditations on the present state of affairs. It aspires to restore lost connections with nature. It too aspires to a process of healing, but one that is more shamanistic than practical in character. The third strategy is one we might characterise as that of simply bearing witness. All three strategies articulate an ethical position in relation to the land and nature.[4]

NO TALKING FOR 14 DAYS

A 21 DAY WANDERING WALK

20 NIGHTS CAMPING

IN THE BEARTOOTH MOUNTAINS OF MONTANA

ENDING WITH THE SEPTEMBER FULL MOON 1997

It is interesting to note that while the earthworks artists were all male and such work was frequently interpreted as archetypically masculine (Heizer's comment about his search for an 'unraped' landscape in which to work is explicitly gendered and violently sexual), a high proportion of the artists working in the field of environmental activism are female. These include Betty Beaumont , Betsy Damon, Agnes Denes, Harriet Feigenbaum, Nancy Holt, Patricia Johanson, Christy Rupp and Mierle Laderman Ukeles. In the 1970s, ideas about ecology and feminism were brought together and gave rise to a way of thinking and working sometimes labelled Eco-feminism. A healing role is an archetypically feminine one and in the early 1970s Laderman Ukeles defined women's social role as 'unification ... the perpetuation and maintenance of the species, survival systems, equilibrium'.[5] Many of these artists have made work addressing these ideas. This Eco-feminist conception of art is epitomised by Dominique Mazeaud's ongoing project, *The Great Cleansing of the Rio Grande*, Santa Fe, Mexico, an annual ritual carried out since 1987 in which the artist walks the banks of the river enacting a process stereotypically associated with women: cleaning. She gathers, bags up and carries off the accumulated rubbish found there.

Land Reclamation

Robert Smithson's first major earthwork, the *Spiral Jetty*, was made in a remote landscape that was inaccessible, inhospitable and degraded by industrial activity. Indeed, the presence of industrial remains at the lake edge was an important consideration in his selection of the site. Yet while his work gained added complexity and richness of meaning through its association with this historical activity, it was in no sense intended to redeem it. However, Smithson's second earthwork, *Broken Circle/Spiral Hill*, was constructed in an abandoned and flooded quarry near Emmen, Holland, and thus did have an explicitly remedial function: reclaiming an exhausted site and giving it a social function. The work consists of a curving jetty and channel forming an almost complete circle on the water's edge, overseen by a constructed mound that can be ascended by means of a spiralling path. At the centre of the work lies a huge glacial boulder – discovered during the excavations and too large to move – that Smithson described as 'a dark spot of exasperation, a geological gangrene ... a kind of glacial "heart of darkness" – *a warning from the Ice Age*'.[6] The work was originally intended to be temporary, but Smithson was gratified when local residents voted to maintain it, and it still exists today. For Smithson this seems to have prompted a re-assessment of the social and environmental possibilities of earthworks, and he went on to produce a number of proposals for mining companies, including a series for the huge Bingham Copper Mine in Utah, then famous as the 'biggest hole in the world' (fig.45).[7]

However, Smithson's approach to the issue of land reclamation and its use and relationship to art was paradoxical. Part of the problem was that he *liked* degraded sites; he was fascinated by the derelict and the ruined. At such places his

BINGHAM COPPER MINING PIT – UTAH *73*
RECLAMATION PROJECT *Robert Smithson*

fig.45
Robert Smithson
*Proposal for Bingham
Copper Mining Pit* 1973

preoccupations – time, history, human activity and entropy – were laid out on the surface of the land. The Sonsbeek project was originally to have been located in a park, but Smithson instead sought out a site that was 'raw', that he would be able to 'mould'.[8] Thus his original inclination was aesthetic, not environmental. He was drawn to 'abused' sites not through a desire to redeem them but because he found them philosophically interesting. The notion of using art to alter aesthetically, to *revise* such sites, was therefore fundamentally problematic for him. With time, however, he saw that he could exploit these characteristics in large-scale earthwork projects, whilst also allowing art to perform a social function.

Smithson therefore sought to effect a paradigm shift in thinking about sites such as mines and quarries, whereby the processes that had led to their current states would be understood as fundamentally natural. He argued that: 'A dialectic between land reclamation and mining usage must be established. The artist and the miner must become conscious of themselves as natural agents.'[9] Smithson was eventually to propose that the artist might function as a mediator with regards such sites. 'Art can become a resource that mediates between the ecologist and the industrialist. Ecology and industry are not one-way streets, rather they should be crossroads.'[10]

However, we have to question the extent to which Smithson's promotion of land reclamation was genuine, or simply an expedient measure, a means by which expensive large-scale earthwork projects might get made. As Robert Morris noted, art functioning as land reclamation has 'a potential sponsorship in millions of dollars and a possible location over hundreds of thousands of acres throughout the country'.[11] In short, it was a viable possibility. In fact, Smithson and a number of his contemporaries demonstrated highly ambivalent (if not actively indifferent) attitudes towards notions of environmental responsibility. Heizer has been vocal in his contempt for the idea of land reclamation, although he too made a number of proposals for industry in the 1970s, specifically the Anaconda Mining Company, seeing it as an opportunity to get funding and a site in which to work on a very large scale. In the 1980s he embarked on a controversial reclamation project in Ottowa, Illinois, the *Effigy Tumuli* 1983–5, while denying that the project was about reclamation at all, but 'strictly art'.[12] Dennis Oppenheim made proposals for spreading rat poison and iron filings onto marsh land, and controversy surrounded Smithson's own proposal for the *Island of Broken Glass* in Vancouver, which was halted due to local protests about the possible negative environmental impact of the work.

A further paradox is suggested by Elizabeth Baker's argument that the ecological impact of individual earthworks is in most cases in fact negligible, and that their status as art may actually in some cases lead to the landscapes in which they are sited being more actively protected and preserved.[13] This argument is supported by the example of James Turrell's Roden Crater project in the Painted Desert, Arizona (discussed in chapter 7). Craig Adcock has observed that the area is being actively

mined for cinder and that a number of extinct volcanic cones near to Roden Crater have been completely flattened. Roden Crater's status as an art project on privately owned land means that it will remain intact.

However, we should note, in considering this issue, that for many critics it is not the actual environmental impact of works such as *Double Negative* that is so troubling, but the attitude that they embody.

In 1979, Robert Morris and seven other artists, Herbert Bayer, Iain Baxter, Richard Fleischner, Lawrence Hanson, Mary Miss, Dennis Oppenheim and Beverly Pepper, took part in an ambitious project in King County, Seattle. The project *Earthworks, Land Reclamation as Sculpture* aimed to initiate a debate about the relationship between art and reclamation, and to facilitate a series of works that would 'reclaim abused parcels of land'.[14] Each artist was offered a site and invited to make proposals. The sites varied enormously. Oppenheim was given an abandoned naval airstrip, Bayer and Fleischner huge sites of 100 and 200 acres respectively. Morris's site, Johnson Pit No.30 in Kent Valley, some ten miles south of Seattle, was just four acres, and in the event his project was the only one that was realised (fig.46). His proposal was to reshape the site with descending concentric terraces that would then be seeded with grass. The forms of the excavation and the construction of a hill would be abstract while referencing classic landscape forms – hills and valleys – and thus aesthetically pleasing, but would carry a reminder of the open-cast mining operations that had been executed there previously. The terraces

fig.46
Robert Morris
*Untitled (Earthwork
to Reclaim Johnson
Gravel Pit)* 1979
King County, Washington

would also introduce cross-cultural and historical echoes, for example to 'Persian and Mogul gardens' and 'the vast amphitheatres of Mugu-uray in Peru'.[15] Morris's work thus negotiated a contemporary situation whilst bringing in to play a wide range of associative meanings. The blasted stumps of trees were allowed to remain at the perimeter of the site as a stark reminder of the pre-industrial past of the landscape. Their forms recall the pioneering environmentalist Aldo Leopold's contention that for America, progress 'has been to conquer the wilderness and convert it to economic use ... a stump was our symbol of progress'.[16]

In his 'Notes on Art as/and Land Reclamation' (1980) Morris expressed his concern that by participating in the reclamation process, the artist inevitably endorses the original abuse of the environment, also warning against expectations for artistic reclamation projects to beautify:

> It would seem then that artists participating in art as land reclamation will be forced to make moral as well as aesthetic choices ... But it would perhaps be a misguided assumption to suppose that artists hired to work in industrially blasted landscapes would necessarily and invariably choose to convert such sites into idyllic and reassuring places, thereby socially redeeming those who wasted the landscape in the first place.[17]

More recently the French artists Gilles Bruni & Marc Babarit have been involved in reclamation projects in France and Germany such as *Treppe Nach Oben* (Steps Leading Up) 1993, at Griefenhain, Pritzen, Germany. This work is a structure of steps leading up the wall of a disused, open-cast, brown coal mine, linking a small grove of trees at the bottom with a mound of coal at the top, thus evoking the process by which organic matter is transformed into coal, and the method by which it is extracted from the earth. But Bruni & Babarit have also cautioned against the use of art to alleviate the burden of responsibility on the miners specifically and society generally. As they have stressed: 'a cosmetic approach doesn't cure the wounds, it only hides them'.[18] Morris's King County project attempted to negotiate this dilemma through the creation of something patently artificial that made no attempt to return the site to an ideal past and thus erase recent events, but which did make explicit reference to its industrial history.

Changing Landscapes

The development of Land art in the US might be said to mirror the development of American attitudes towards the landscape. In his seminal account, *Wilderness and the American Mind*, Roderick Nash suggests that the American engagement with wilderness has shifted from aggression – the drive to conquer and to tame – to one of reverence and preservationism. He proposes that the idea of wilderness defines America, yet notes that in the twentieth century this defining concept became increasingly distant from the daily experience of life.[19] The artist Alan Sonfist has sought to address this situation. His *Time Landscape* project draws attention to change – specifically the change wrought upon the landscape by the development

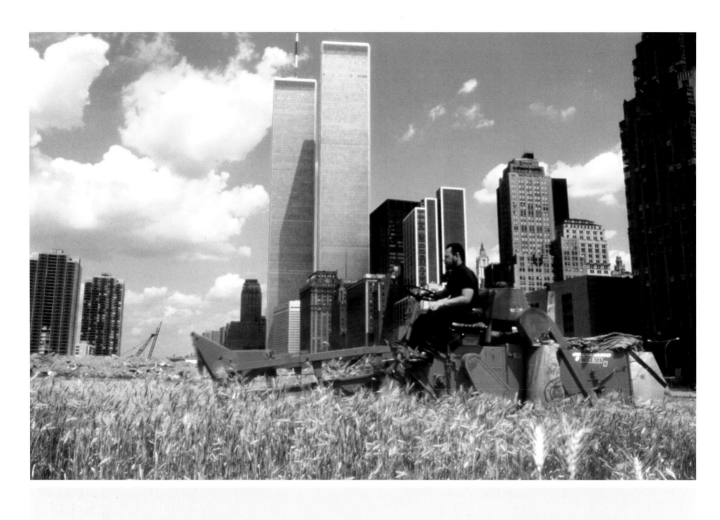

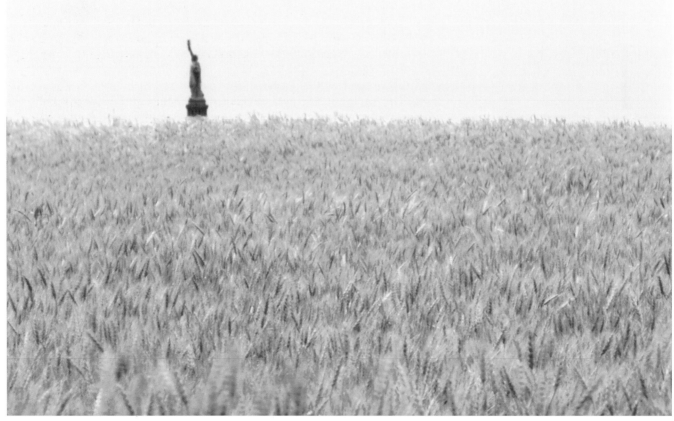

of the urban environment – and to the contrasting timescales of natural and human history.

In 1968 Sonfist proposed a revision of thinking about civic monuments and the parameters that define them. He suggested a new approach, with monuments that would celebrate the 'human ecosystem, including natural phenomena', and which would 'recapture and revitalise the history of the natural environment at that [particular] location'.[20] He proposed a series of *Time Landscapes* in New York, a 'restoration of the natural environment before Colonial settlement'; lakes, grassland, marsh and forest. These pocket landscapes within the city would make the geological, biological and cultural history of that given place visible to the contemporary world.

Sonfist's *Time Landscape* 1965–2005 on the corner of La Guardia Place and Houston Street, just north of Soho in New York, is a permanent installation, an 8,000 square foot area of native forest, the elevations of the land restored to what they would have been in the seventeenth century, viewable through a chain-link fence. The juxtaposition of natural and artificial, nature and culture, organic life and inorganic technology within this urban context raises awareness of the profound disjunction between these different conditions and through this, the present social and ecological situation. In addition, the work brings the city dweller back into contact with nature, restoring lost connections with natural history in contemporary life.

In 1982 Agnes Denes was invited by the US Public Art Fund to create an outdoor sculpture. She chose to work with the Battery Park landfill in downtown Manhattan, and the PAF secured permission for her to use the site prior to development. Denes created *Wheatfield: A Confrontation* (fig.47), an extraordinary work that from the beginning was conceived as a political statement. She explained that her decision to plant a wheat field in Manhattan instead of designing 'just another public sculpture' came out of 'a long-standing concern and need to call attention to our misplaced priorities and deteriorating human values'.[21]

Work on the two-acre site began in March, with the dumping of 200 truckloads of garbage landfill, followed by a further eighty truckloads of dirt, enough to create a one-inch layer of topsoil. In May, the land, which is just two blocks from Wall Street and the site of the World Trade Center, and faces the Statue of Liberty, was cleared of rocks and garbage and 285 furrows were hand dug. Wheat seeds were planted by hand. The artist and a small team of volunteers carefully tended the crop and by late summer it had grown into a beautiful field of wheat, slowly changing from green to gold, nestling surrealistically amongst the skyscrapers of the financial district. This was the intense paradox she had sought in creating the work, 'a powerful paradox … for the calling to account'.[22]

In this context the wheat field was a potent political symbol. Denes had intended it to be so but she was also interested in how it might embody a poetic

fig.47
Agnes Denes
Wheatfield: A Confrontation,
1982
Battery Park Landfill,
New York

moment, and appeal to the memories (perhaps of better times) of its viewers:

> *Wheatfield* was a symbol, a universal concept. It represented food, energy, commerce, world trade, economics. It referred to mismanagement, waste, world hunger and ecological concerns. It was an intrusion into the Citadel, a confrontation of High Civilisation. Then again, it was also Shangri-La, a small paradise, one's childhood, a hot summer afternoon in the country, peace, forgotten values, simple pleasures.[23]

When the crop was harvested in mid-August the work became the focus of global press attention. The yield was almost 1,000 lbs of 'healthy, golden wheat'. Denes's paradox, the 'calling to account', was embodied by the fact that she had used land valued at $4.5 billion to produce a wheat crop worth just £158.[24]

Art and Science

Robert Smithson proposed that art might function as mediator between ecology and industry. However, a further possible model might position art as a mediator between science, ecology and society.[25] An example of this approach is Mel Chin's series of *Revival Fields*, made since 1990 in collaboration with Dr Rufus Chaney, a heavy-metals specialist in the US Department of Agriculture. The project is an exploration of the use of hyperabsorbent plants – which can leach toxins from contaminated soil – to 'revive' polluted landscapes. The project was, for Chin, 'driven by a desire to find solutions for problems, rather than express problems metaphorically'.[26] Interestingly, from Chin's point of view it was a sculpture project, but from Chaney's it was a scientific research project.[27] While the enactment of the experiments was ordered aesthetically by the artist, the project yielded hard scientific data. The discursive status of the work is indicated by the controversy that surrounded its funding. Chin's initial grant from the National Endowment to the Arts was awarded, rescinded and then reinstated after concerns that the project was not, in fact, art.

Newton and Helen Mayer Harrison work in an similar way. In order to address specific problems such as the erosion and pollution of crucial watersheds – for example, in ambitious projects such as *Breathing Space for the Sava River, Yugosalavia 1988–90* or *The Serpentine Lattice* – the Harrisons undertake a wide-ranging analysis of the situation, discussing the issues with experts in different fields of activity – biology, chemistry, forestry, ecology, climatology – before devising and proposing a solution. The process is recorded in maps and photographs and the presentation of the proposals – which are always realistic, practical and possible – are frequently intensely poetic and evocative.

In Germany, Hermann Prigann has adopted a similar approach with his Terra Nova project, which through a wide-ranging series of collaborations – with scientists, ecologists, and politicians – aims to achieve the 'aesthetic and ecological recreation of destroyed landscapes'. Prigann's works in this mode include a series of large-scale earthworks made with industrial spoil such as *Gelbe Ramp (Yellow Ramp)*

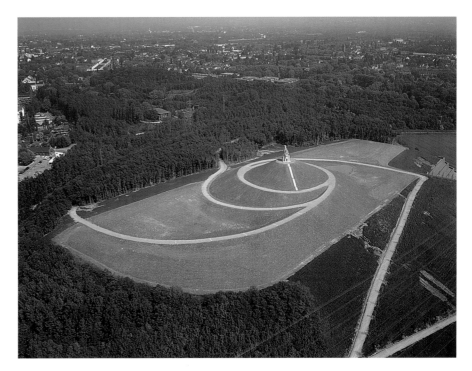

fig.48
Herman Prigann
Spiral Hill – Skystair
1998–2005
Ruhrgebiet, Germany

1993 at the Griefenhain mine, Pritzen, and *Spiral Hill – Skystair* 1998–2005 in Ruhrgebiet, a 1220m high artificial hill, with a tower constructed from reclaimed concrete blocks (fig.48).[28]

Symbolic Growth

It is striking how many works in this area of activity revolve around the planting and husbandry of trees or plants. In part, this is down to the practicalities of reclamation activity, the need to 'dress' the earth. But it is also about the symbolism of renewal through fresh growth.

Another major project by Denes, *Tree Mountain*, was conceived in the same year as *Wheatfield*, but was not realised until 1995 (fig.50). At the Earth Summit in Rio de Janiero on Earth Environment Day, 5 June 1992, the Finnish Government announced that they would undertake the work's construction as Finland's contribution to help alleviate the world's ecological stress. Sponsored by the United Nations Environmental Programme and the Finnish Ministry of the Environment, *Tree Mountain* was created on huge reclaimed gravel pits near Ylojarvi, Finland. Covering over 100,000 square metres it is the world's largest international monument.

While *Wheatfield* addressed the absurdities of the contemporary economic structure, *Tree Mountain* symbolises the need for collaboration to ensure survival.

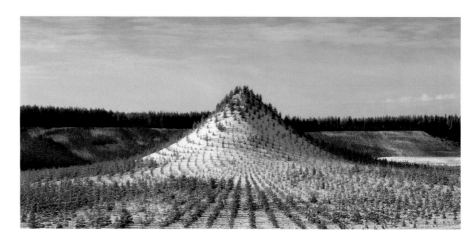

Denes brought together 10,000 people to each plant a tree that would then bear their name. The trees might change ownership through succeeding generations but could never leave the forest. *Tree Mountain* itself 'can never be owned or sold'.[29] Here is a different kind of 'calling to account', but which also expresses a need for responsibility, for husbandry. *Tree Mountain* is, for Denes: 'a collaborative, environmental artwork that touches on global, ecological, social and cultural issues. It is a massive earthwork and land reclamation project that tests our finitude and transcendence, individuality versus teamwork, and measures the value and evolution of a work of art after it has entered the environment.'[30] The plantings on *Tree Mountain* are laid out in a curving rhythmic pattern, according to an intricate mathematical formula, which will prevent erosion of the site, enhance oxygen production and provide a living environment for wildlife, eventually transforming the site into virgin forest. Denes stressed that the trees used would need to have a life span of at least 400 years in order to 'carry our concepts into an unknown time in the future'.[31]

Everything under the Sun

While many artists have sought to create concrete solutions to environmental or ecological problems, or to generate awareness of alternative ways of addressing these issues, others have sought a more poetic engagement. Implicit in such work is the notion that healing must not be just physical but philosophical, cultural and spiritual. This ambition is perhaps best exemplified by Joseph Beuys, arguably the most important German artist of the post-war period. Beuys's conception of art was revolutionary. He believed that it is inseparable from everyday life and that 'everyone is an artist'. A frustrated questioner once shouted at him 'You talk about everything under the sun, except art!' to which Beuys replied, 'Everything under the sun is art!'[32]

Beuys's thinking was grounded in the art and literature of German Romanticism, which posits a world in which man and nature, spirit and matter are interdependent and indivisible. Following a breakdown in 1957, which was resolved by 'work in the fields', he developed a theory of sculpture. To him, sculpture describes 'the passage of everything in the world, physical or psychological, from a chaotic, undetermined state to a determined or ordered state'; it is thus the opposite of entropy.[33] His work took the form of actions, environments, performances, lectures, sculptures, prints and installations.

In 1979 Beuys ran for the German parliament as a member of the Green Party. Three years later, he expressed his desire 'to go more and more outside, to be among the problems of nature and problems of human beings in their working places', signalling his desire to stop making 'sculptures' or 'environments' but instead to undertake 'regenerative activity'.[34] When Rudi Fuchs invited him to take part in *Documenta VII* in Kassel that year, he responded with his proposal for a monumental project, *Eichnen 7,000 (7,000 Oaks)* (fig.49), which would represent

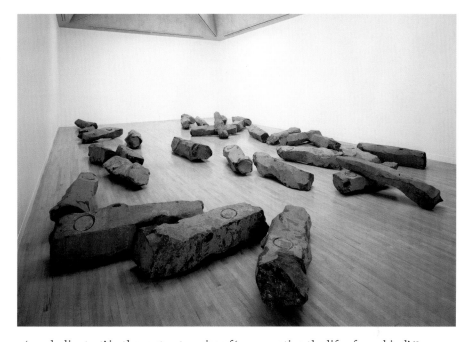

a 'symbolic start' in the vast enterprise of 'regenerating the life of mankind'.[35]

Beuys proposed to plant 7,000 young oak trees within the city of Kassel. The project would begin in the centre of the city, where the earth is covered with 'asphalt and paving slabs and electrical installations', and expand outwards, re-greening the urban environment. Each tree was to be paired with a basalt column set vertically into the ground, which would thus establish a coupling of the organic and inorganic, old and new, the static and the growing. The stones could be quarried close to the city. Beuys's decision to use oaks was heavily loaded: the oak was a powerful national symbol in Germany but had been associated with nationalism under the Nazis. Beuys aimed to restore it to its original value.

The monumentality of the task that Beuys had set himself and the city was made visible by the huge pile of 7,000 basalt stones that was heaped up prior to installation in the Friedrichsplatz, in front of the museum where the *Documenta* exhibitions are held. The municipality did not initially want to engage with Beuys's proposal, but could hardly refuse the offer of the trees. In this sense, the forging of political will to accommodate the trees was one of the points of the work. Beuys planted the first tree and stone in the Friedrichsplatz at the opening of *Documenta VII*. As the project advanced, the mound of stones slowly diminished. After his death in 1986 the final tree was planted there by his widow and son during *Documenta VIII*.

Beuy's explicit purpose was 'regeneration', but one might suggest that there is another aspect to his work – a counterpoint to the healing embodied by *Eichnen*

WARM

A 21 DAY ROAD WALKING JOURNEY FROM THE NORTH COAST TO THE SOUTH COAST OF SPAIN RIBADESELLA TO MALAGA WINTER 1999

DEAD

BIRD

WALKING AGAINST THE ONCOMING TRAFFIC

fig.52
Hamish Fulton
Warm Dead Bird, Spain
1999

7,000 – which needs to be considered in this context: the task of mourning. *The End of the Twentieth Century* 1983–5 (fig.51) is a gallery installation of unrefined basalt blocks – natural objects brought into the artificial environment of the gallery from each of which a cone had been cut, the cavity lined with felt and clay, and the cone replaced. This work can be considered a kind of adjunct or companion piece to the Kassel work, echoing the 7,000 stones, but scattered across the floor and deprived of their organic counterparts the blocks resemble a field of felled headstones. A recent commentator has compared the installation to a *Massacre of the Innocents*, composed of one-eyed torsos lying on the floor in 'the haphazard aftermath of a calamity'.[36] According to this reading, *The End of the Twentieth Century* is a sculpture redolent of 'disaster' and apocalypse, both a warning and an act of mourning for the victims of a disaster – for humans or perhaps for nature – that has already happened, or which is still happening around us. However, Beuys's basalt is also a symbol of potential growth. The lined cavities in the stones suggest wounds that have been dressed or, alternatively, intimate the possibility of new life emerging after a dark century. The work thus becomes, like *Eichnen 7,000*, a redemptive one.

Walking against the Traffic

To this partial examination of environmental strategies in recent art one might add one final, simple tactic: that of bearing witness. Hamish Fulton has produced a series of works that in themselves are no more then the clear presentation of a location through which the artist has passed, but which clearly articulate a moral position. He has highlighted global warming and climate change in numerous text works, but has also drawn attention to injustice in Tibet and the plight of Native American Indians. The photograph *When Sitting Bull Crossed the Milk River, Alberta* 1999 shows us nothing more than a river winding through an empty landscape, yet Fulton's text informs our reading of the meaning and significance of that landscape. The same is true of *Tibetan Escape Route from Imprisonment and Torture, Tibet* 2000, which shows an empty road in the Himalayas. The decision to walk through landscapes and photograph such sites is a conscious and deliberate one. Fulton's presence there is an act of bearing witness.

In other recent works, Fulton makes his position clear. The title *To Build is to Destroy. No Man-Made Obstacles for the Winter Winds. 14 Seven Day Walks, Cairngorms, Scotland 1985–1999* is printed over an image of a snowy mountain plateau scoured by powerful winds. The work highlights a specific controversy about the building of ski lifts in one of Britain's last remaining wild areas, but also addresses a more general ethical question about human impact on the environment. In another work, a black and white image of an empty road through rural countryside is overprinted with the text *Warm Dead Bird, Walking Against the Oncoming Traffic, a 21 Day Road Walking Journey from the North Coast to the South Coast of Spain, Ribadesella to Malaga, Winter 1999* (fig.52).

COSMIC CYCLES, PRIVATE RITUALS

7

Many recent artists working in the landscape have sought inspiration in the ritual structures of ancient cultures, and the essentially mysterious forms and sites of prehistory. The critic Lucy Lippard characterises such practice as an 'overlay', a layering of form and meaning in which the contemporary and the ancient each enrich the other. Her speculative survey of this ongoing fascination, *Overlay: Contemporary Art and the Art of Prehistory* (1983), focuses on 'what we have forgotten about art', and represents an attempt to 'recall the function of art by looking back times and places where art was inseparable from life', as so many of the artists she discusses have done.[1] In explaining the allure of the past she quotes Anton Ehrenzweig:

> It is perhaps due to the fact that our own modern art is often content to work from low irrational levels of the mind alone, that our civilisation has become so receptive to the art of other civilisations, prehistoric, historic, primitive and exotic. What alone seems to matter to us is the complex diffuse substructure of all art. It has its source in the unconscious and our own unconscious still reacts readily to it, preparing the way for ever new reinterpretations.[2]

Lippard's thesis is that the artists who have explored this 'overlay' of contemporary and ancient have pioneered 'the restoration of symbolic possibility in contemporary art'.[3]

Layers of Time

The motivations for seeking inspiration in ancient forms and practices are numerous and complex. In some instances the inspiration has been purely formal. On one level, sites such as Stonehenge, Avebury, Carnac, New Grange and Nazca are models of formal simplicity and bear a distinct resemblance to the reductive abstract motifs of much modernist sculpture and painting. Thus to the eye conditioned by developments in post-war art they can appear surprisingly contemporary.[4] Lippard compares the 'hermetic quality of the awesome stones' at sites such as Stonehenge and Avebury with the 'obdurate silence' of Minimalism.[5] Both emphasise regularity and geometric simplicity.

In other cases artists have sought to enrich the content of their own work, to evoke a sense of mystery, by referencing these older works of art and architecture. Lippard argues that overlay allows the artist to tap into a vital seam of meaning that is powerful precisely because it defies categorisation. Such forms also allow direct communication. She suggests that artists overlaying contemporary scientific understanding of human experience and our place within the universe with formally simple (but conceptually complex) ancient forms are 'repossessing the means of communication by going directly to their audiences'. She argues that in doing so

> they become not only decorators and object makers but image makers, shamans, interpreters and teachers. At its most effective, their art helps us to understand how the

fig.53
James Turrell
Roden Crater
1972–present
Flagstaff, Arizona

108

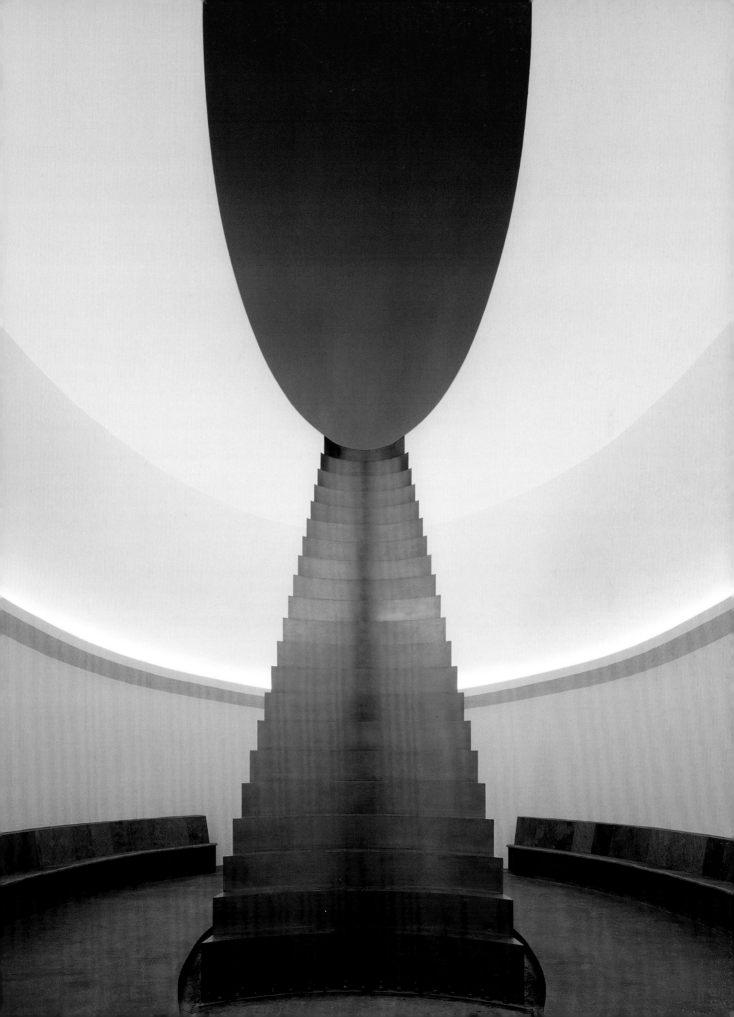

ancient patterns apply to our own, to move towards a reintegration of the political and the cultural, the personal and the natural, and all the permutations thereof.[6]

At its most effective, such work also offers a means of ordering human experience and addressing seemingly incomprehensible concepts: the vastness of space, cosmological time, the cyclical movements of the stars in relation to our planet, and thus the insignificance of human life. It can be a means of making comprehensible complex theories, of making astrological time and distance visible in terms of human scale. A number of artists – including Robert Morris, Michelle Stuart, Hans-Jorg Voth, Nancy Holt, Charles Ross, and James Turrell – have explored this territory, constructing works such as huge calendars, clocks and naked-eye observatories. Their work constitutes a distinct subgenre of Land art. These are participatory artworks realised through a complex matrix of modern technology and ancient wisdom. They are functional in the sense that they respond to external stimuli – the sun and the stars – and by doing so enhance our comprehension of the present.

Observatories

One of the key ways in which artists have used prehistoric systems of knowledge is by employing solstitial and equinoctial alignments and the timings of sunrise, moonrise and eclipses. Strategies for doing so have varied from the construction of complex, observatory-like structures, simpler arrangements of stones in the landscape – such as Michelle Stuart's *Stone Arrangements/Solstice Cairns* 1979, Rowena Plateau, Oregon – to Long and Fulton's use of such events as structuring devices for their walks.[7]

One of the first artists to explore this territory was Robert Morris. Running through his varied oeuvre is an abiding interest in man's relationship to nature, in ways of seeing and states of perception. Much of his work involves the creation of sculptural structures that order and define the bodily experience of – and the related mental and visual perception of – space. Direct experience of Morris's sculptures is required in order to clarify one's perception and/or understanding of them. As Marcia Tucker has suggested: 'Morris's work *shows* us, rather than *tells* us, about ourselves and the world.'[8]

Morris had first conceived of and made drawings for a sculpture as 'observatory', inspired by Stonehenge, as early as 1965.[9] His *Ottowa Project*, a concrete and earth spiral mound with cuts aligned with solstices, equinoxes and moonrises, was planned in 1970 but not built. However, an opportunity to realise such a structure arose with the invitation to take part in the *Sonsbeek '71* outdoor sculpture exhibition in Holland and Morris's *Observatory* 1971 (fig.54) – in many ways a simpler structure than that proposed for Ottowa, consisting of two circular mounds – was constructed at Ijmuiden. The sculpture was destroyed later that year but was eventually rebuilt as a permanent structure in 1977 at Oostelijk, Flevoland,

fig.54
Robert Morris
Observatory 1971
Lelystad, Netherlands

in Holland. It was one of the earliest contemporary earthworks to be completed in Europe, and can still be visited.

The sculpture is large – 330 feet in diameter – and is constructed from earth, timber and granite. The outer ring has two notches, which are aligned to the winter and summer solstice sunrises, and the inner has four; two aligned with the outer and two more aligned with the equinoxes. Aerial photography of *Observatory* is misleading and cannot give a true impression of what it is like to experience it on the ground. Inside the sculpture it is not possible to see the complete layout; the viewer discovers its structure gradually by moving around and through it. It is revealed and activated by participation. The implications of its temporal and cosmic alignments would only be discovered – by an unprimed visitor – through a prolonged exploration over time.

Formally, *Observatory* directly recalls stone circles such as Stonehenge. However, Morris's intention in making it is very different. In this work, human behaviour and perception are connected to cosmic cycles, but Morris is also concerned with layers or different categories of time: the experiential time of the visitor to the sculpture and time as a 'concretized abstraction' revealed by the alignments of the site.[10]

The Physical Presence of Time

Like Morris, Nancy Holt is fascinated by time and perceptual systems. Early works such as *Missoula Ranch Locators* 1972, eight viewing stations in a landscape, each aligned to cardinal points of the compass, were structures – what might be termed frameworks for viewing – that would direct the viewer's gaze either inwards (towards the other stations) or outwards (towards the landscape), and thus order their experience of place.

Her best known work, however, is the iconic *Sun Tunnels* 1973–6 (fig.55). In common with two other major American astronomical artworks discussed in this chapter – Charles Ross's *Star Axis* (fig.56) and James Turrell's Roden Crater project (fig.53) – the *Sun Tunnels* are situated in a remote desert location, in Utah's Great Basin Desert. The desert is traditionally a site of revelation and transcendence, the openness and immensity of the landscape offering a vision of the insignificance of man. In the desert, one's sense of scale is stretched. As in the mountains, Robert Macfarlane's notion of 'deep time' comes into play. This was certainly a factor in the decision of these artists to site their works in such places – alongside practical considerations such as atmospheric clarity and the absence of light pollution in the night skies – and all three artists embrace this notion of relativity and revelation. These works engage with the immensity of cosmological space and the relentless cyclical nature of time.

Holt's *Sun Tunnels* are small in scale compared to *Star Axis* and Roden Crater. Four concrete tubes, each 18 feet long and 9 feet wide, are laid out in a cross format, their openings oriented to the summer and winter solstices. This means that the

fig.55
Nancy Holt
Sun Tunnels 1973–6
Concrete
Great Basin Desert, Utah

solstitial sunrises can be viewed across the axis of the structure, revealing the importance of the orientation. The views through the tubes also frame and focus the surrounding landscape. In addition, holes are drilled into the skin of the pipes in the form of the constellations of Capricorn, Draco, Perseus and Columbia, so that the bright desert sun projects them as points of light into the cool, shadowed interiors.

The *Sun Tunnels* offer a paradoxical experience. They are scaled to accommodate the human body, but are set within a vast, open and empty landscape. They are remote and difficult to reach. They offer some kind of shelter, yet are open. They engage with annual cycles of time, and star constellations that are light years distant, yet the positioning of the projected constellations within the tunnels changes from moment to moment as the sun moves across the sky. They are both timeless and time-specific.

Time is the central theme of the *Sun Tunnels*. Holt was concerned to create a situation in which it was both physically present and intellectually palpable:

> *Time* is not just a mental concept or a mathematic concept in the desert. The rocks in the distance are ageless; they have been deposited in layers over hundreds of thousands of years. *Time* takes on a physical presence. Only 10 miles south of the *Sun Tunnels* are the Bonneville Salt Flats, one of the few areas in the world where you can actually see the curvature of the earth. Being part of that kind of landscape and walking on earth that has surely never been walked on before evokes a sense of being on this planet, rotating in space, in universal time.[11]

Yet, paradoxically, the experience of the *Sun Tunnels* returns us forcefully to the present, to the landscape that surrounds us. It is through the shocking contrast between what we see and the knowledge that the sculpture's structure reveals, and its implication, that we have an opportunity to sense the immensity of cosmic time.

Points of Contact

The predominant ordering framework for the *Sun Tunnels* is provided by the annual cycles of sun and moon, although a wider frame of reference is introduced through the constellations of light. Charles Ross's major work *Star Axis* also evokes cyclical time, but on a vastly enlarged scale. Ross's affirmation that 'There is a need for art and architecture to speak more of our cosmic connection'[12] recalls the title of a 1973 collection of essays by the astronomist Carl Sagan.[13] It also bespeaks a widely felt need in the late 1960s and 1970s for art to take account of the huge advances in scientific understanding of our place in, and relation to, the universe, as well as the spiritual implications of such knowledge. Sagan wrote that 'Space exploration provides a calibration of the significance of our tiny planet, lost in a vast and unknown universe.'[14] Throughout the 1960s, and especially after the moon landing in 1969, the space race created massive curiosity about 'what lies out there'.

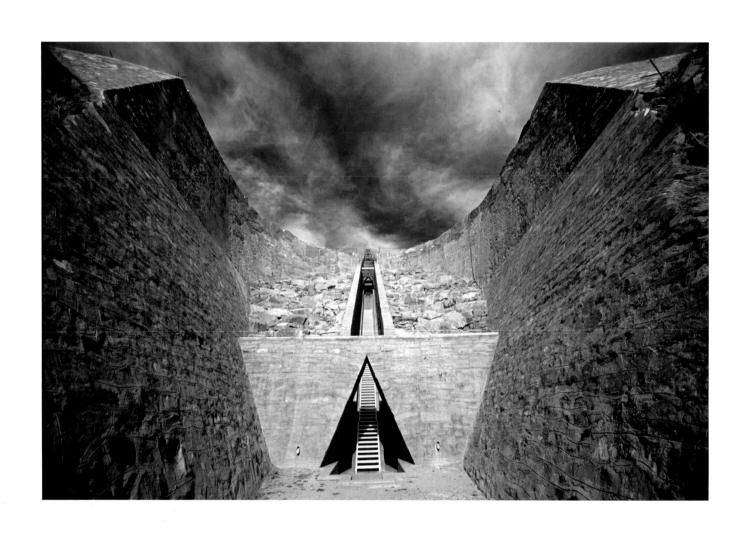

fig.56
Charles Ross
Star Axis 1971–present
Looking north at the
Star Tunnel, 2005
Santa Fe, New Mexico

As a consequence, the 1960s and 70s saw an extraordinary boom in science fiction, both in literature and at the cinema. Films such as *2001: A Space Odyssey* (1968) were massively popular, and influential magazines like *New Worlds*, under Michael Moorcock's editorship, showcased a 'New Wave' of science-fiction writing by authors including Brian Aldiss and J.G. Ballard. Novels such as Aldiss's *Earthworks* (1965) and Ballard's *The Crystal World* (1966) explore a contradictory mixture of apocalyptic and utopian ideas and as such reflect the tenor of the times, with its strange combination of trauma and idealism. [15]

This was also a time when 'new age' thinking was becoming increasingly popular, resulting in renewed interest in esoteric wisdom like astrology. Offbeat theorising, such as the speculative writings of Erich Von Daniken (who argued in *Chariots of the Gods* (1968) that the Nazca line drawings were evidence of alien visitations) also reached wide audiences. Such developments point to a fascinating context for the work of Ross, Holt and others, with its interest in establishing connections with the visible universe. Of course, it is not suggested here that artists such as Ross and Holt subscribed to such thinking or were directly responding to these theories, but that their work is very much of the time in which it originated, with its desire to connect everyday life, the human present, with the cosmic and the infinite.

Ross's work is fundamentally an exploration of the physical properties of light. In 1965 he began to work with prisms, creating minimal structures with lenses to fragment and scatter light and thus interact with their surroundings. That he termed his prisms 'cracks in the world' indicates something of his desire to reach beyond everyday reality in his work. In 1972 he extended his practice with a series of solar burns made onto wooden panels on the roof of his New York apartment, using a large, fixed lens. The burns created a record of the light conditions throughout each day of the year, and when placed end to end formed a double spiral. Ross saw *Sunlight Convergence/Solar Burn: The Year Shape* 1972 as looking 'beyond the notion of art as a closed system to propose art as a point of contact with the universe energy matrix'. In his conception, the solar burns are 'not information *about* but are rather a point of contact with their source'.[16]

In 1971 Ross had begun a four-year search for a site for a major earthwork, a naked-eye observatory that would make visible the relationship between Earth and the Pole Star. Construction of *Star Axis* began in 1974 on a mesa at the edge of the Sangre de Cristo Mountains, eighty miles from Santa Fe, New Mexico, and is now nearing completion. *Star Axis* is a hugely ambitious work and an exemplary example of Lippard's concept of overlay. It is enabled by modern technology and indebted to the earthworks of artists such as Heizer as well as contemporary architecture, but also recalls ancient earthworks and comparatively recent structures such as the naked-eye observatories of Jai Singh, constructed in the Indian cities of Delhi, Jaipur, Ujjain and Varanasi in the eighteenth century. In the artist's words, *Star Axis* provides 'a place of heightened focus where an individual

can experience the movement of the Universe in relation to his or herself.'[17]

The structure enables us to see a 26,000 year cosmic cycle with the naked eye. In 1995 Ross explained:

> At the centre of the *Star Axis* site, an inverted cone has been carved deep into the capstone and lined with rock masonry. Within this cone a stainless steel tunnel will rise eleven stories and be placed exactly parallel to the Earth's axis. The tunnel focuses on the celestial pole in order to sight and frame the motions of Polaris [the Pole Star]. Inside the tunnel, stairs rise to the top of the sculpture, emerging above the mesa through a granite pyramid whose shape is derived from the seasonal angles of the sun. Visitors will enter the tunnel from the bottom of the cone and walk up the stairs in perfect alignment with the Earth's axis and its outward extension to the stars. Wherever one stands within the tunnel, the circle of the sky framed by the opening represents Polaris's precise orbit for a particular period of history. Dates engraved on each stair identify the years. Thus, the visitor can stand in the orbit of Polaris as it existed for the pyramid builders, Leonardo da Vinci, or as it was in the Stone Age and will be again 13,000 years in the future.[18]

Ross's ambition is to create a way of making contemporary scientific knowledge about the Universe both personal and intimate, to bring it into a human scale. For him, sculpture is a tool for making complex concepts visible: 'I think of the Earth-to-star axis as an energy matrix that can be experienced in sculptural form ... larger orders of reality become visible by "earthing" them in form. *Star Axis* distils the geometry of time into a physical environment'.[19]

In works such as *Sun Tunnels*, *Observatory* and *Star Axis*, time is the dominant theme. They tap into and are structured by systems of knowledge that are ancient and – to all intents and purposes – timeless. Yet they are of the contemporary world, constructed from contemporary materials (Holt's concrete pipes could come from no other time than the late twentieth century). These structures are carefully calibrated in order to make time visible. Yet they locate and return the viewer to a specific point in time, the present – positioning it within greatly expanded temporal frameworks – albeit with a vertiginous sense of relativity.

The Perception of Light

> In working with light, what is really important to me is to create an experience of wordless thought, to make the quality and sensation of light itself something really quite tactile. It has a quality seemingly intangible, yet it is physically felt. Often people reach out and try to touch it.[20]

The artist whose work perhaps best exemplifies this area of activity is the American, James Turrell. Like Ross, Turrell works with light. However, his intention is different. There are two distinct areas of his art: interior pieces and works in the landscape. His gallery installations are characterised by his use of light to create intense perceptual experiences. Shaped white light is projected powerfully into the corner of a gallery in order to give the appearance of a bright, solid object floating in space. What at first appears to be a flat monochrome

painting on a wall turns out to be an opening onto an empty space filled with diffuse coloured light. Spaces are shaped and finished so that there is no detail for the eye to fix on, and then filled with carefully controlled light – both natural and artificial – to create Ganzfelds effects. While at first Turrell's installations are baffling and magical, it is always (with time) readily apparent how the effect has been achieved. But far from negating the magic of the experience this only intensifies it, as we are made aware of our own visual responses to the situation that Turrell has created for us:

> The work I do is with light itself and perception. It is not about those issues; it deals with them directly in a nonvicarious manner so that it is about your seeing, about your perceiving. It is about light being present in a situation where you are, rather than a record of light or an experience of seeing from another situation.[21]

Turrell's landscape works include *skyspaces*, in which an opening into the ceiling of a chamber isolates a patch of sky, making us perceive it as a solid object (see fig.57). This allows us to see the subtle colour changes that occur throughout the day. Other constructions reveal a phenomenon known as 'celestial vaulting' – the impression that the sky forms a vast dome above the earth, the altitude of the vault being less than the distance between the viewer and the horizon – and are archetypal Land art. They offer a direct experience of the environment: nature, light, atmosphere and place, the conditions at a specific and particular moment in time.

Turrell studied psychology before beginning art studies at the University of California in 1965–6. He was one of a number of American artists (many working in California in the late 1960s/early 1970s) making post-Minimalist work with and about light, including Dan Flavin, Robert Irwin, Doug Wheeler and Larry Bell. However, Turrell's work was distinctive, being as much, if not more, informed by his interest in Japanese and Asian philosophies and the discipline of meditation as by the theoretical concerns of the contemporary art world. Of paramount importance was Turrell's parallel career as a pilot of small planes, and the spectacular phenomena of light and space – such as cloud inversions and Ganzfeld effects – that he was able to see whilst flying.

Turrell's major work, a hugely ambitious and complex project on which he has been working for over thirty years, is the Roden Crater, an extinct volcano in the Painted Desert, Arizona. Turrell is engaged in reshaping the crater bowl and excavating tunnels and chambers within the structure of the volcano. Using the crater and the spaces within the mountain itself, he will create a range of perceptual experiences. He conceived of the project in 1972. In 1974, funded by a Guggenheim Fellowship, he spent 500 hours flying a 1967 single-engine Helio Courier in the area between the Rockies and the Pacific, from Canada down to Mexico, sleeping under the plane at night, searching for a site that would meet his requirements. He identified the Roden Crater as a potential location on that trip,

fig.57
James Turrell
Deer Shelter 2006
Yorkshire Sculpture
Park, Leeds

but was unable to purchase the land until 1977. In 1979 he moved to Flagstaff, near the site, and began the re-shaping of the crater rim. This in itself has required the excavation and repositioning of around 438,000 cubic yards of earth, rock and cinder using cut and fill, which gives some sense of the immense scale of the undertaking.

The Roden Crater project consists of three principle elements. The first is the approach to the site. Turrell is intensely aware that perception is dependent not only on the physical state of the environment – the external stimuli – but also on the internal physiological and psychological states of the perceiver. To this effect he hopes to position the experiences found within the volcano within a geographical and geological context. The approach thus takes the visitor through the Painted Desert to the volcano via sites of 'exposed geology', which gives a powerful sense of 'geologic time' and 'a strong feeling of standing on the surface of the planet'.[22]

Secondly, there is a series of passages, stairways and chambers through which one moves up and into the volcano itself.[23] The different chambers contain light let into the interiors by various means, and they reiterate key aspects of Turrell's oeuvre. These works will respond to and make tangible ambient light, sunlight, moonlight, as well as – extraordinarily – celestial light. Turrell explains: 'Several spaces will be sensitive to starlight and will be literally empowered by the light of stars millions of light years away. The gathered starlight will inhabit that space, and you will be able to feel the physical presence of that light.'[24]

Finally, there is the Crater bowl itself. This huge, open, amphitheatre-like space has been shaped into an even ellipsoid so as to maximise the effect of celestial vaulting. Craig Adcock has commented:

> Along with manipulating light, Roden Crater will manipulate space. One of the most important instances of its power to alter the quality of spatial perception will occur in the bowl of the crater. When we come up into the skyspace chamber at the end of the Tunnel, the sky will seem to be stretched across its opening. It will look like a surface, but it will have a ponderance, a kind of three-dimensionality, as if the sky had come right down to the edge of the space. As we make out way up out of the chamber by means of a staircase, the upper margin of the crater will suddenly appear. When this happens, our sense of a blue 'surface' immediately above out heads will change radically. The sky will expand outward and upward, changing from a small ceiling into a huge vault of space seeming to rest on the rim of the crater.[25]

In addition, from the rim of the crater the viewer will experience the 'concave earth illusion', whereby as one looks down onto the surrounding landscape of the Painted Desert, one perceives that rather than dropping away at the edges it curls up around the viewpoint, like a shallow bowl.

Turrell's work is architectural in its realisation and in this sense engages with Lippard's notion of overlay: the forms of his spaces, the passages, seating, stairways, doorways and viewing platforms, all recall aspects of different kinds of ancient

structures, temples, civic spaces, cathedrals. However, importantly, Turrell's work is about perception, and thus the architectural references and inspirations he employs are removed from their functionality. Adcock has suggested that Turrell 'enjoys spaces that have lost their civic or religious intent and recalls finding that quality at archaeological sites in Mexico and Central America.' When Turrell first visited Palenque, Uxmal, Chichen Itza, Copan and Tikal, 'the structures there were for him dissociated from their original purpose. The Mayan buildings had been, in his words, "emptied of their use"'. This interested Turrell; he felt that the ruins created a powerful sense of presence and formed space with light. In his own work, he has sought to create spaces comparable to what he found at such sites, but 'to manipulate light in ways that were uncontaminated by any given symbolism'. His designs for the Roden Crater thus emulate past architecture but do not reference any specific cultural iconography. 'He wants the light without the messages the light was originally intended to illuminate.'[26]

The Roden Crater project is hugely ambitious and promises to offer an extraordinary, transcendent experience of light and space. Whether Turrell is successful or not remains to be seen. If he is, this work will place the viewer in what Bachelard poetically calls the experience of 'intimate immensity'.[27] At the time of writing, the project is supposedly nearing completion, but no opening date has yet been announced.

Private Rituals

In contrast with the monumental constructions of Ross and Turrell, the British artist Roger Ackling's work is small scale, humble and modest (see fig.58). It is also made using natural light, but it exists on an intimate, human scale. It is handmade and handheld and constitutes a form of private meditative ritual.

Ackling works with driftwood gathered on walking journeys around the world or on the North Sea beaches near his home in Norfolk, England, always selecting wood that carries some trace of human use. Using a small lens he burns the wood with sunlight, creating a series of tiny dots or points, which form lines, abstract motifs: squares, grids, circles, chevrons. Sometimes these seem to respond to the traces of use on the wood – a rusted nail head or a patch of flaking paint – and sometimes they appear to overwrite such marks, as if cauterizing memory. Ackling always works from left to right – like writing – the lens held in his right hand, the sun over his right shoulder. While his technique recalls Ross's *Solar Burns*, Ackling's work is not intended to reveal anything other than the simple activity of the artist; it does not track sun or star positions in the sky (although it does record the passage of time and the conditions of light during that passage). His is an art of small, repetitive acts, seemingly pointless and containing the possibility of meaninglessness. In making this work, Ackling is engaged in the moment, at one with his surroundings, sitting in the landscape, on a beach in Japan, the Outer Hebrides or in his garden in Norfolk. The form of the burns is planned in advance,

so that he can empty his mind, 'freeing it from any logical thought process so he can be wholly receptive to the air around him'.[28] His actions thus represent a form of meditation.

Through his intervention, time and place are encoded into the objects with which Ackling works. The burns are what Chris Yetton has called 'an imprint of real time'.[29] In this sense they have a photographic aspect, each individual burn recording the quality of light in that place, at that time. Sylvia Ackling has argued:

> The lines are photographic in the truest sense. Each mark or dot is a small black sun. Each line is a repeat pattern of burnt sun images, scaled down many million times. Images of the sun, that is, minus any object which intervenes between the glass in his hand and the sun one hundred and fifty million miles away; when a bird passes overhead, its shadow is captured within the burnt sunspot.[30]

Ackling's work constitutes a private ritual, at once seemingly empty and at the same time magically rich and moving. In his words:

> rituals performed in private
> change the face of the world.[31]

fig.58
Roger Ackling
Weybourne 1997
Sunlight on wood
34.5 × 25.3 × 1.7 cm

ANOTHER PLACE
THE EXPANDED FIELD OF LAND ART

Land art is not only a historic phenomenon; it represents an emphatically vital and continuing narrative. We might map the development of the genre by identifying three distinct phases of activity.

The first, covering a period approximately 1967 to 1977 – from Richard Long's groundbreaking *A Line Made by Walking* to Walter De Maria's *The Lightning Field* – represents a time of extraordinary innovation and sees the creation of what are, literally, new forms of landscape art, as well as the re-assessment of long-established ways of thinking about landscape, nature and art, and the opening up of a whole new field of activity for art.

The second phase was from the late 1970s to the end of the 1980s, when the social and political possibilities of this new mode of engagement with landscape and nature were revealed, and the emphasis shifted from the predominantly formal and conceptual concerns of the first generation to the articulation of environmental frameworks. The emblematic works of this phase are Robert Morris's untitled earthwork for the 1979 King County symposium on land reclamation, Agnes Denes's *Wheatfield: A Confrontation*, and Beuys's *7,000 Oaks* in Kassel.

The last fifteen years have produced a third phase, one of reassessment and re-engagement, various, diverse and ongoing. A younger generation of artists, many of whom would have been at art school during the 1980s and early 1990s – when the art world was dominated on the one hand by figurative painters such as Francesco Clemente, Julian Schnabel, Sandro Chia, Anselm Keifer and the so-called School of London, and on the other by the postmodern appropriationist strategies of Jeff Koons and Richard Prince – had begun to look back at their precursors working in the landscape and with nature, and to explore new possibilities and contexts. In the 1990s and the first decade of the new millennium, artists as varied as Francis Alÿs, Lothar Baumgarten, Adam Chodzko, Susan Derges, Mark Dion, Simon Faithfull, Anya Gallaccio, Wolfgang Laib, Lars Vilks, Kate Whiteford and Andrea Zittel have expanded the field of Land art still further, and continue to do so.

New Contexts

The 1980s constituted a decade distinguished by extremes: on the one hand the fall of Communism and dismantling of the Soviet Union, and on the other the seeming triumph of rampant capitalism. It was the 'me' decade, a time epitomised by the words of Gordon Gekko, a character played by Michael Douglas in Oliver Stone's film, *Wall Street* (1987): 'Greed is good.' Yet the 1980s also saw the publication of a series of important books that refocused attention on the fragile state of the natural environment, and the damaging effects of unchecked technological and industrial development. James Lovelock's *Gaia: A New Look at Life on Earth* first appeared in 1979 and stimulated a heated debate in the ensuing decade about the ecological balancing act that nature maintains, and the way that mankind affects that tenuous balance. At the end of the decade, in 1990, Bill McKibben published *The*

fig.59
Anthony Gormley
*A Room for the Great
Australian Desert* 1989
New South Wales,
Australia

122

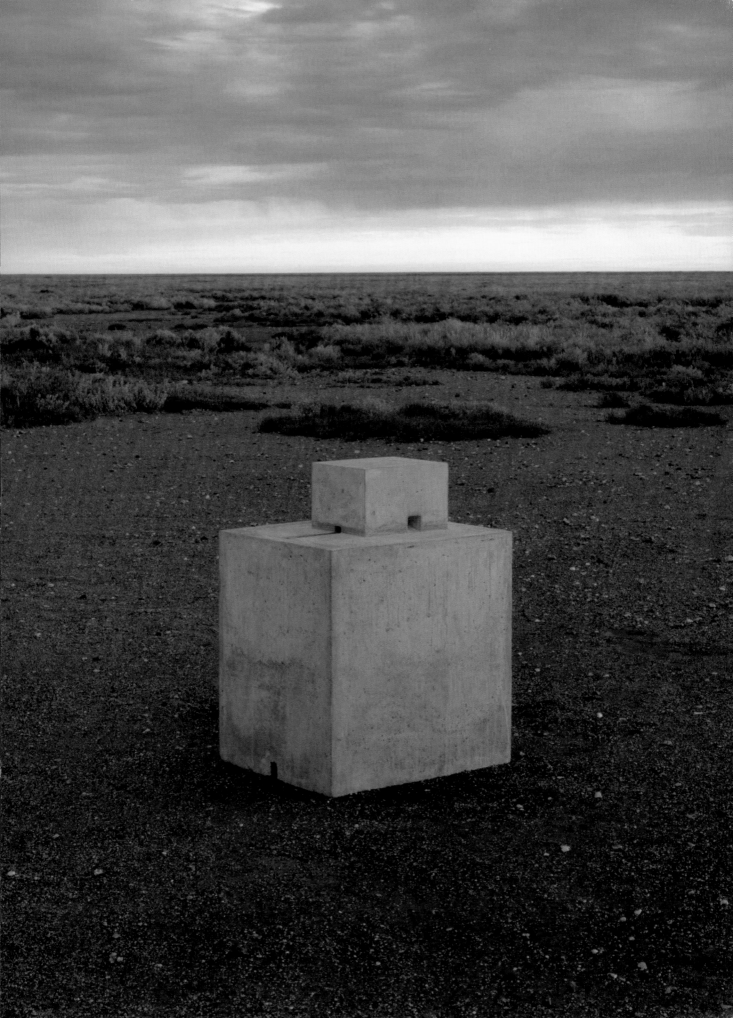

End of Nature, a seminal examination of the phenomenon of global warming.

Lovelock's Gaia hypothesis has continued to be extremely influential, provoking a widespread re-assessment of our relationship with the planet. Gaia is a complex entity or system involving the Earth's biosphere, atmosphere, oceans and soil. Lovelock suggested that life on Earth constitutes a cybernetic, homeostatic feedback system, which seeks an optimal physical and chemical environment for life on this planet, thus leading to broad stabilisation of global temperature and chemical composition. Despite initial scepticism from the scientific community, the basic tenets of the Gaia hypothesis have come to be widely accepted.[1]

In *The End of Nature* McKibben predicted that global warming would have disastrous consequences for life on earth, and in particular for mankind. He suggested that a crisis point had already been reached, and perhaps even passed:

> Our comforting sense then, of the permanence of our natural world, and our confidence that it will change gradually and imperceptibly, if at all, is the result of a subtly warped perspective. Changes in our world can happen in our lifetime – not just changes like wars, but bigger and more total events. I believe that, without recognising it, we have already stepped over the threshold of such a change.[2]

In the 1990s, resurgent environmental concerns provoked by such publications created a situation that was strikingly reminiscent of the 1960s, when the environment and the landscape were first radicalised as a locus of political and artistic debate. Once again, the relationship between man and nature was a key concern for young artists. As in the 1960s, much of the work produced betrayed deeply conflicted attitudes towards the environment.

Modern Nature

A work by the Scottish artists Dalziel + Scullion, *Modern Nature* 2000 (fig.60), dramatises two aspects of these conflicted views. It highlights a sense of threat, of loss, whereby species and habitats are gradually and irrevocably destroyed or disabled, and suggests an increasing sense of alienation. Yet it also embraces technology, and appears to embody a seemingly utopian view of future possibilities. The artists have sited six tall futuristic aluminium structures – such as one might see in a science-fiction film – on Elrick Hill, north of Aberdeen. The structures house solar panels that power a sound system. Speakers are buried in the surrounding landscape and periodically broadcast the call of the male Capercaille. The Capercaille is one of Scotland's largest and most impressive birds, but is no longer found on Elrick Hill; indeed, the Capercaille has died out in Scotland once already (in 1784; it was reintroduced from Scandinavia in 1830) and is about to do so again, its numbers being once more in decline. Curator Keith Hartley has observed that 'JG Ballard once ironically suggested that if we knew the DNA details of endangered species we could in the future resurrect them through modern technology. The mournful truth is that all we can do now is to recall memories of

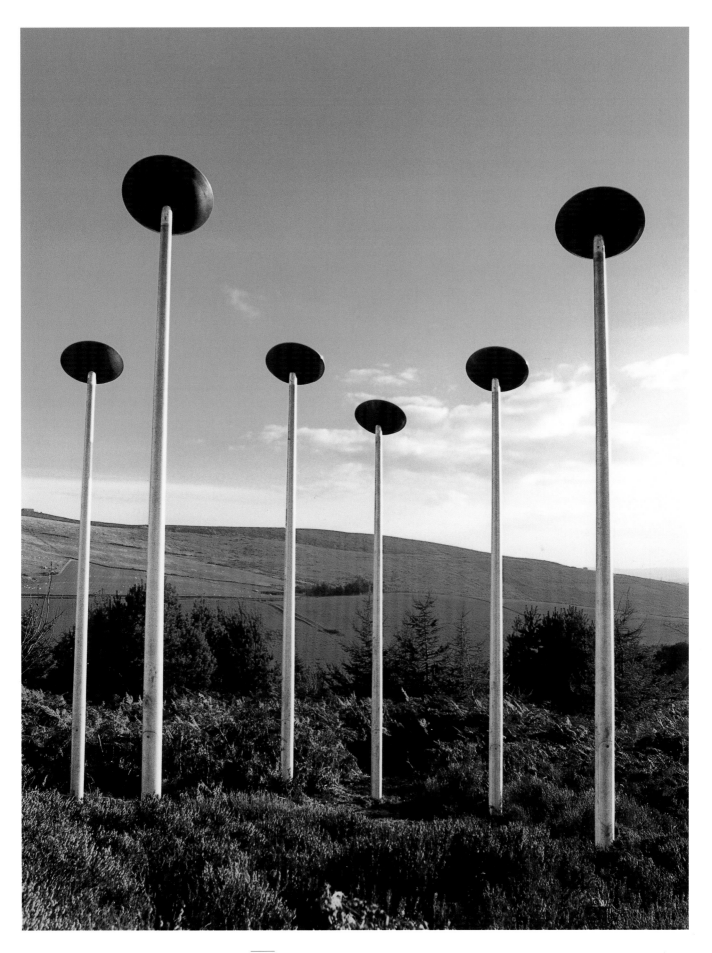

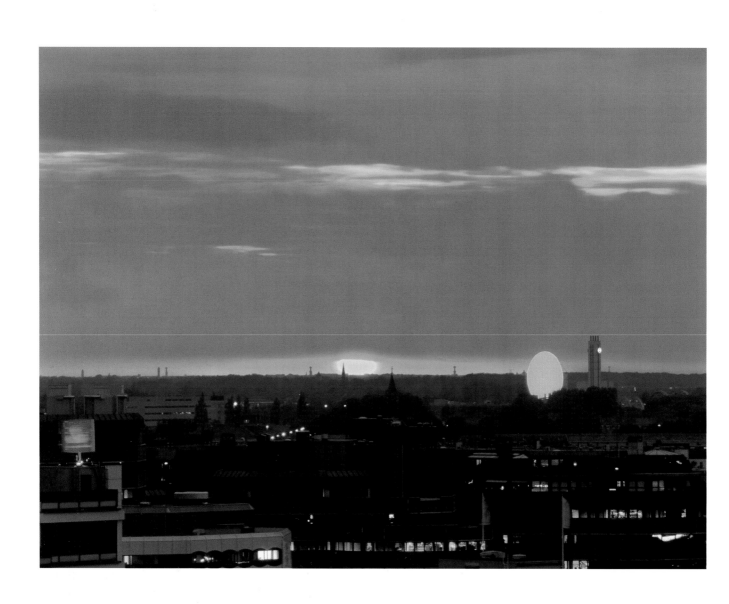

fig.61
Olafur Eliasson
Double Sunset 1999
Utrecht, Netherlands

their presence.'[3] Thus it is technology, itself the agency of environmental change, that allows the unmistakable call of the bird to be heard. A paradox is illuminated. Sited in a landscape that appears at first to be natural and rural but which is in fact highly historically determined and furthermore hedged in on all sides by urban and industrial development, the work becomes a point of focus for the consideration of the impact of man on the landscape. It evokes and reflects, and mourns, change. Yet it also stimulates a kind of bitter hope for the future.

The complexity of the relationship between man and nature is similarly evoked by the Danish artist Olafur Eliasson. His projects have included dyeing an entire river green (*Green River*, Stockholm, 1998) and inserting a second, false, sunset into a real (urban) landscape (*Double Sunset*, Utrecht, 1999; fig.61). Eliasson's aim in creating such surreal interventions is not to highlight an environmental agenda per se (although, like many of the artists examined in this book, this is an undeniable result of his work), but rather to make us aware of our own perception of our surroundings; in his formulation, to be 'seeing oneself seeing'.[4] Nonetheless, by shocking us into such a state of awareness by his surprising (if patently and very obviously artificial) effects, he lets us see afresh the natural phenomena we take for granted; the daily spectacle of the sunset, or a river running though the city that we pass every day.

A similar sense of re-engagement is created by John Frankland's *Untitled (Boulder)* 2001 (fig.62), an ambitious project at Compton Verney, Warwickshire, England. Frankland's project carries echoes of epic works by Michael Heizer such as *Displaced/Replaced Mass* 1969 – in which three massive boulders were dynamited from the Sierra in Nevada, and then taken down to the Great Basin Desert, where they were deposited into cement-lined holes dug into the earth. Yet it transposes such strategies into a radically different context. Instead of the desert, Frankland's work engages with a landscape that is overwhelmingly constructed and formed by man. Quarried on Portland Isle and weighing over eighty tonnes, the boulder, the largest ever to leave the island, was transported 150 miles to be placed within the elegant grounds – designed by Capability Brown – of Compton Verney, an eighteenth-century Robert Adam house that is itself dressed with Portland Stone. Object and context thus create an extraordinary and surreal confrontation. Imposed upon a highly ordered and cultured landscape the boulder seems at first to be an intrusion of raw elemental nature. Yet, as Frankland points out, it is itself a cultural object; it has been quarried, blasted, cleaned, selected, lifted and transported. Frankland further complicates the situation by designating the boulder a site for the activities of rock climbers, encouraging the creation of 'routes' up and around the mass of rock, so bringing a different kind of cultural process into play. Climbing has many parallels with sculpture; tactility, attention to the material properties of rock, visuality, physical engagement, spatial awareness, and the boulder thus becomes a site for another kind of cultural confrontation or exchange.

Legacies of Conceptualism

Today's art world is extraordinarily pluralistic. Yet it is interesting to note that while it is predominantly urban both in location and outlook, landscape and the environment remain central concerns for a wide range of younger artists. And in addition to the similarities between now and the 1960s in terms of socio-political thinking and attitudes, there are also striking parallels in terms of artistic thinking, indicated in particular by the re-emergence of conceptual strategies in the last fifteen years. Conceptualism re-emerged in the early 1990s – after a period of neglect – as a reaction to (itself resurgent) figurative art, but has persisted as the dominant modus operandi of contemporary art, helped perhaps by a series of recent important exhibitions and publications.[5]

Many of the artists re-engaging with the legacies of Conceptualism and earlier phases of Land art have sought to create an active dialogue with the past. Tacita Dean's sound and text work, *Search for the Spiral Jetty* 1997, details the artist's failed attempts to reach Smithson's iconic earthwork using the artist's directions. It speaks of the complex relationship that exists between the art of the past and the present. That Dean wanted to attempt the arduous and difficult journey to Rozel Point at all is a mark of respect (and curiosity) towards the earlier artist (whose reputation in the mid-1990s was not as prominent as it is now). Yet in Dean's present the original work is lost; she does not find it. Nonetheless, the process of searching originates something new. In Dean's work, Smithson's site is revealed as an actual nonsite (i.e. absent). In this curious matrix of fact and fiction one questions the information with which we are presented. It can seem like a figment of the imagination, evocative of mental journeys through imagined landscapes. Listening to Dean's sound recording we recreate the rocky roads and obscure terrain of Utah in our minds, yet inevitably question the veracity of what we hear (and see); did she really travel all that way?

Journeys in Search of the Miraculous

Dean is one of a number of recent artists who have embraced the making of journeys as part of their practice. As such, they have been inspired by the way in which the siting of works by Smithson, De Maria and others in remote locations brought the journey to see them into the compass of the work. They have also been influenced by the wide-ranging travels of artists such as Long, Fulton and David Tremlett and actions by Chris Burden, Douglas Huebler and Stanley Brouwn. Bas Jan Ader is a further important precursor: a maker of pure journeys not as a means of getting to an artwork or site, but as artworks in their own right. As the central part of a proposed triptych of actions, *In Search of the Miraculous*, Ader set sail on 9 June 1975 from Cape Cod in his 13 ft cabin yacht, *Ocean Wave*, intending to sail to Amsterdam, where he was to make an exhibition about the journey at the Groninger Museum. He never arrived. 'Missing in action', Ader has become emblematic of the artist-as-traveller for a younger generation.

fig.63
Francis Alÿs
The Leak 1995
São Paulo, Brazil

Contemporary recapitulations of this theme have included Thomas Joshua Cooper's circumnavigation of the Atlantic for his massive ongoing photographic project, *The Atlantic Basin Project – The World's Edge*, Simon Starling's bicycle journey through the desert on an adapted bike, *Tabernas Desert Run*, 2004, and Pierre Huyghe's recent voyage to Antarctica for *The Journey that Never Was* 2005, supposedly in search of a mysterious and mythic creature. Two extremes of this kind of work – embracing the local and the global – are offered by Francis Alÿs, much of whose work comes out of a daily exploration of his immediate surroundings in Mexico City, and Ivan and Heather Morison, whose project *Global Survey* (2003–present) has the self-consciously absurd and grandiose aim of exploring and encompassing the everyday flow of life everywhere (or anywhere) around the world.

Belgian-born Alÿs has been based in Mexico City since the late 1980s and has taken the daily practice of walking the streets around his studio as the basis for his work, creating a kind of urban variation of Land art. His oeuvre includes photographs, films, books, texts, maps, paintings and actions. *El Collector* 1991–2 was a small metal dog, magnetised, that picked up all manner of small objects and debris as Alÿs walked it through the streets, thus wearing a record of its passage as a kind of coat. In a variation on the same theme, Alÿs had shoes made with magnetic soles (*Magnetic Shoes* 1993). He has also made walking works in other cities. For *The Doppelgänger* 1999, he followed his double around Istanbul. In São Paulo and Ghent in 1995 he made *The Leak* (fig.63), getting lost on purpose and then retracing his steps along a trail of paint tipped from a punctured can he had carried with him.

Alÿs's work takes its cue from and responds to the specific situations he provokes or discovers in the streets. It recalls Situationism in its engagement with the everyday realities of one's urban surroundings; the unexpected moments of insight or inspiration that may arise from the daily practice of what the Situationists called the *derive*, the purposeless but open-minded metropolitan amble.

The work of Ivan and Heather Morison also displays an extraordinary openness to the world. It has involved 'allotment gardening, floristry, fruit and vegetable vending, dendrology and forestry, ice fishing, bird watching and traveling', and since 2003 an ongoing investigation into 'the lives of everyday folk' around the world. Their *Global Survey* has taken them to Finland, Russia, China, New Zealand and South America, and has produced mailing cards, photographs, science-fiction novels, actions, LED displays. During their travels in China, the Morisons photographed trees, creating virtual arboretum which they have subsequently presented on billboards and as slide installations (fig.64). More recently, the Morisons have purchased a woodland in North Wales, which they intend to turn into an actual arboretum, thus adding landscape management, botany and conservation to their extraordinarily diverse portfolio of activities-as-art.

fig.64
Ivan and Heather Morison
From *Chinese Arboretum*
2003

Archaeology and Anthropogeomorphology

A journey can be understood as a kind of research into the world, and indeed the primary legacy of Conceptualism – which was about rethinking art so that it may be understood as much in terms of a process as of finished works – is perhaps the freedom that artists now feel to explore other disciplines, especially those that are research-based, and designate both process and result as artwork. Thus the process – of research, of the making of a journey – becomes the work, and is made available through documentation.

The American artist Mark Dion has explored and utilised the practices and conventions of archaeology, geography, anthropology and natural history, and allied them to classical museological display tactics. *A Meter of Jungle* 1992, was created during the Rio Earth Summit. Using anthropological field-work techniques, soil and debris were removed from a square metre of ground in the rainforest at Belem, at the mouth of the Amazon, and displayed in Rio, where their extraordinary biodiversity could be witnessed. The work thus engaged with notions of displacement, change, scientific process and knowledge; issues that were key considerations for the Summit itself.

Archaeological digs demonstrate another way of understanding the landscape. For his *Tate Thames Dig* in 1999 (fig.65), Dion set up tents at the Tate Gallery (now Tate Britain), which stands on the north bank of the Thames at Millbank, and at the site of Tate Modern, which stands on the south bank at Bankside. Volunteers worked alongside professional archaeologists and conservators to trawl the foreshore of the river, collecting items of interest – shoes, coins, bones, bottles, credit cards, toys – and these were then examined, classified, labelled, conserved and finally exhibited in special display cases (which themselves reference the

130

fig.65
Mark Dion
Tate Thames Dig 1999

specimen cabinets of Victorian museums) at Tate Britain. As such, the history and meaning of the river at those sites was evoked and explored. Yet by designating the process as art and displaying the results in the gallery, Dion also placed the practice of archaeology itself under scrutiny.

For the archaeologist Colin Renfrew, Dion's project blurred boundaries. He suggested that 'the process of the work often seems more important than the end product, the artefact display'. For Renfrew:

> Dion is to a significant extent an archaeologist because he does archeology, not because he puts Roman potshards in glass cases. He is a naturalist because he does botany or zoology, not because he exhibits butterflies. It is not really the end product which counts. The heart of the *Tate Thames Dig* is not really the display at the end of it. It is the work of the volunteers on the foreshore, and all the labour of conservation and classification in the tents. It is because they are doing archaeology, or at least what looks like archaeology, that the enterprise has a special fascination.[6]

Yet while one aspect of Dion's project was the exploration of the archaeological process, the recovery of items lost in time and the interpretation of their meaning, another is the engagement with the landscape at a visceral and physical level; not for nothing was the Tate project called a 'dig'.

The activities of the Center for Land Use Interpretation are also focused on research. Its own mission statement explains that it is 'a research organization involved in exploring, examining, and understanding land and landscape issues'. The CLUI employs a variety of methods to pursue this mission, 'engaging in research, classification, extrapolation, and exhibition'.[7] Run by Matthew Coolidge, the CLUI is based in Los Angeles and has developed a discipline he calls 'anthropogeomorphology', a fusion of overlapping, complementary but distinct disciplines, which when combined or examined together offer a new understanding of (primarily the American) landscape and its use.[8] The CLUI's practice is fact-based, rather than speculative. One of the organisation's ongoing projects is the compilation of a database of all the 'unusual and exemplary' sites or examples of land-usage in the United States. In making this information publicly accessible through its website, exhibitions, talks, publications and even bus tours, the CLUI hopes to initiate enquiry, discussion, debate, and thus insight into the way the landscape reflects and informs society.

> The entire landscape is an inscription of our culture on the ground, a mix of intentional and incidental markings, and that inscription can be read in many different ways ... The whole world is scripted in many different languages. Sometimes it is literary, using text; sometimes it uses postmodern chunks of ideas in the form of architecture, and sometimes it employs aqueducts, open-pit mines and dumping grounds; all of these are scripts, and these are the hieroglyphs that we interpret by means of the CLUI's programming.[9]

Another Place

> My body contains all possibilities. What I'm working towards is a total identification of all existence with my point of contact with the material world: my body.[10]

In the 1960s, Land art was one aspect of a sea change in art that signalled a decisive break with traditional forms. Its manifestations over the intervening forty years have been many and varied, but have been dominated by abstract and Conceptual practices. It is therefore interesting to note that one of the most vital contributions to landscape art in recent years has been that of the British sculptor Antony Gormley, the only figurative artist discussed in this book.

Gormley's own body and his own bodily experience is at the heart of both making and meaning in his work. Since the early 1980s, his sculpture has been dominated by the human form; almost exclusively the cast form of his own body:

> You are aware that there is a transition, that something that is happening within you is gradually registering externally. But for accuracy it must be a moment of stillness, of concentration. I am trying to make sculpture from the inside, by using my body as the instrument and the material. I concentrate very hard on maintaining my position and the form comes from this concentration.[11]

Gormley's forms were initially cast in plaster and then encased in sheets of beaten lead, but have more recently been made in bronze and iron or used as templates for fragmented structures of filaments, cubes or balls. In contrast to the meditative stillness of his earlier solid body forms – still, unseeing, silent – these latter works seem to give visible form to fields of energy, or suggest maps of sensation contained within the human form. A further group of works create hollow forms – blocks of concrete – to enclose and contain the human body. These are box-like structures, rooms for the body to occupy, with holes corresponding to the bodily orifices: mouth, ears, penis, anus.

Gormley's casts originate with the artist himself holding a particular position – itself an expression or equivalent for a mental state – but they then become anonymous everyman figures through the purging of facial and other features (although it is interesting to note that for all their generalisation the figures are often recognisable as Gormley himself). In this way, they proceed from the very specific to the universal. This process towards the universal and transcendent is emphasised by his tendency to use the landscape as setting for his figures. From quite an early stage he demonstrated an interest in seeing his works activate a landscape, often photographing them in open spaces (for example *Land, Sea and Air* 1982, three figures standing kneeling and crouching, which was photographed on a bleak and empty windswept beach).

From using landscapes as settings for sculpture, Gormley has proceeded to make works for specific locations that bring the landscape within the compass of the artwork, achieving an integration. A *Room for the Great Australian Desert* 1989 (fig.59) is set within a truly vast and empty landscape in Western Australia. It is a

concrete 'room' for a single seated figure. Resembling a piece of Minimalist sculpture or a fragment of Brutalist architecture, it is nonetheless obviously a correspondent to the body. As a container, it becomes a surrogate for the figure: absence is transformed into presence; or rather, the emptiness waits to be filled by the projection of our presence. It is empty (but for the insects and vegetation that may have colonised its interior), yet seems to serve as a repository for the sensation of being in the landscape. Its smallness, its emptiness, paradoxically create an extraordinary sense of expansion into the surroundings. In a genre with a history of siting monumental structures in remote spaces, Gormley's room is a modest but powerful statement. It also recalls earlier strategies that play with notions of birth and burial.

Early in his career, Gormley met Walter De Maria and made a visit to *The Lightning Field*. It was, for him, 'a seminal experience'.[12] There were important formal lessons learnt, not least the notion of the field as a structure for an installation, and the idea of 'art as place'. Like De Maria's iconic work, many of Gormley's landscape pieces are characterised by open, permeable structures. Like *The Lightning Field* they also punctuate the landscape and the sky with their repetitive verticality, a process that Gormley describes as a form of acupuncture. For the artist they are 'meditation gardens'.

In the 1990s, Gormley made a series of works using dispersed groups of cast figures. *Total Strangers* 1996, six figures in and around the Kunstverein in Cologne, was followed by *Stand* 1997, nine figures in a forest at Hanaskog, Sweden. *Another Place* 1997, created for the shore at Cuxhaven, Germany, and subsequently installed at Stavanger, Norway, in 1998 and Crosby, Liverpool, in 2005, is perhaps the culmination of this group of works (fig.66). It is an installation of 100 cast-iron figures spread out across the shallow beach, washed by the retreating and advancing tide. The figures seem to bear witness to the ebb and flow of the world, the advance and retreat of the sea, the changing weather, the passage of shipping and visitors to the coasts. Gormley has suggested that older landscape artists like Richard Long in fact affirm the separation of human experience and the land. He wants to 'reconnect the two; forge a recognition that we are with nature, in nature, part of nature'. Works such as *Another Place* underline this sense of connection. Inevitably, we identify with and project ourselves into these figures who maintain a stoic vigil in the landscape.

Overleaf:
fig.66
Antony Gormley
Another Place 1997
Installation at Stavanger,
Norway, 1998

NOTES

Introduction

1 Michael Heizer, 'The Art of Michael Heizer' in *Artforum*, vol.8, no.4, Dec. 1969, pp.32–9.
2 Heizer later said that he was interested in 'taking Pollock a step further'. Quoted in Michael Kimmelman, 'Michael Heizer: A Sculptor's Colossus in the Desert', *New York Times*, 12 Dec. 1999.
3 Quoted in Suzaan Boettger, *Earthworks: Art and the Landscape of the Sixties*, Berkeley 2002, p.116.
4 Quoted in Germano Celant, *Giuseppe Penone*, exh. cat., Arnolfini Gallery, Bristol 1989, p.34.
5 Ibid., pp.17–8.
6 Richard Long, 'Words after the Fact' (1982), reprinted in Rudi Fuchs, *Richard Long*, London 1986, p.236.
7 Long's early works included *A Snowball Drawing* 1964 and *A Sculpture in Bristol* 1965; De Maria's unrealised proposal was *Walls in the Desert* 1964.
8 *Richard Long* at Konrad Fischer, Düsseldorf; *Giuseppe Penone* at Deposito d'Arte Presente, Turin.
9 The phrase is taken from the title of Mark Kurlansky's useful overview of the events of that year, *1968: The Year that Rocked the World*, London 2004.
10 Kurlansky 2004, p.375.
11 Anna Bramwell, in her account of the decline of the Green Party, has noted of *Easy Rider*: 'Something significant about the 1960s experience lies behind this, once the Rousseauist trappings have been stripped off. It embodies several of the themes that were to dominate fully fledged American environmentalism during the 1970s and 1980s. There is the dream of the innocent wilderness with free and healthy sex thrown in; the self-pitying identification with apocalypse; the anarchic undertones; and finally the sense of death and regeneration that has characterised the radical movements of our century.' Anna Bramwell, *The Fading of the Greens: The Decline of Environmental Politics in the West*, New Haven 1994, pp.41–2.
12 Alanna Heiss, *And the Mind Grew Fingers: Dennis Oppenheim, Selected Works 1967–90*, New York 1992, p.5.
13 Michael Heizer said: 'I started making this stuff in the middle of the Vietnam War. It looked like the world was coming to an end, at least for me. That's why I went out in the desert and started making things in dirt.' *Michael Heizer: Effigy Tumuli*, New York 1990, p.11.
14 Quoted in Bertram Gabriel, 'Works of Earth' in *Horizon*, Jan.–Feb. 1982, p.48.
15 Quoted in Malcolm Andrews, *Landscape and Western Art*, Oxford 1999, p.215. See also Boettger 2002, p.172. Boettger quotes an interview with Long: 'I never identify myself as a "land artist". To me, this was a term coined by American curators or critics to define an American movement which, for me as an English artist in the 60s, I saw as American artists working in their own backyards, using their deserts to make monumental work, and only in America. They needed a lot of money to make art as they had to buy land, or hire bulldozers, so it was about ownership, real estate, machinery, American attitudes. It was a very different philosophy from my own work, which was almost invisible, or made only by walking, or used the land in a free way, without the need for possession or permanence. Especially with hindsight, I see my work as having as much to do with conceptual art, de-materialization, or even *Arte Povera*, closer in spirit. You can think of *A Line Made by Walking* as a classic *Arte Povera* work, sort of simple and artless and made out of nothing.'
16 Richard Long, 'Words after the Fact' (1982), reprinted in Fuchs 1986, p.236.
17 Jack Flam (ed.), *Robert Smithson: The Collected Writings*, Berkeley 1996, pp.110–11.
18 Ibid.

19 Rosalind Krauss, 'Sculpture in the Expanded Field' in *October*, no.8, Spring 1979, pp.38–41; Lucy R. Lippard, *Six Years: The Dematerialization of the Art Object*, New York 1973.
20 See for example Nicolas Bourriaud, *Postproduction*, New York 2002, which examines the implications of work by artists including Rikrit Tiravanija, Pierre Huyghe, Jorge Pardo and Liam Gillick.
21 See for example, *Forms in Nature*, exh. cat., The Hakone Open-Air Museum, Japan 1999.

1 Simple, Practical, Emotional, Quiet, Vigorous

1 Richard Long, *Five, Six, Pick Up Sticks, Seven, Eight, Lay Them Straight*, Anthony d'Offay Gallery, London 1980, unpag.
2 Richard Long, 'Fragments of a Conversation' in *Richard Long: Walking in Circles*, exh. cat., Hayward Gallery, London 1991, p.45.
3 Long, *Five, Six, Pick Up Sticks* 1980.
4 Ibid.
5 See *Crossing Stones* 1987 ('A stone from Aldburgh Beach on the East coast carried to Aberystwyth Beach on the West coast/A Stone from Aberystwyth Beach on the West coast carried to Aldburgh Beach on the East Coast/A 626 Mile Walk in 20 Days/England/Wales/England/1987').
6 Anne Seymour, 'Walking in Circles' in *Richard Long: Walking in Circles*, p.12.
7 Statement, 1971, quoted in ibid., p.20.
8 Quoted in *David Nash: Making and Placing: Abstract Sculpture 1978–2004*, exh. cat., Tate St Ives 2004, p.44.
9 *Artforum* was available in London from c.1965 and was an important source of information about developments in the US, but nothing by Judd, Andre, Morris or LeWitt was shown in London until 1969. See Charles Harrison, 'The Late Sixties in London and Elsewhere' in *1965–1972: When Attitudes Become Form*, exh. cat., Kettle's Yard, Cambridge 1984.
10 Rachel Tant, 'Sculpture at St Martin's' in Chris Stephens and Katharine Stout (eds.), *Art & the 60s: This Was Tomorrow*, exh. cat., Tate Britain, London 2004, p.88.
11 Atkins 'defined his attitudes as being those which were not "self-confirming", to question rather than to confirm. His emphasis on the analysis of the creative process rather than the form of the finished object, and in particular on this process as something shared, rising out of relations within groups of people rather than necessarily private and individual, was stimulating and productive.' Hilary Gresty, 'Introduction' in *1965–1972: When Attitudes Become Form*.
12 Interview with Colin Kirkpatrick, in *Richard Long: No Where*, exh. cat., Pier Arts Centre, Orkney 1994.
13 Long, *Five, Six, Pick Up Sticks*, 1980.
14 Rudi Fuchs, *Richard Long*, London 1986, p.44.
15 Ibid., pp.46–7.
16 Alternatively titled *Sculpture 1–3 December 1967*. 'Starting from the entrance of my art school in London, and carrying the components of the sculpture strapped to my bicycle, I commenced a more-or-less continuous day-night-day-night cycle ride around the counties to the north of London, ending back at my flat in the East End. At random places and times along the way I left one part of the work in each place. Each consisted of a yellow-painted vertical piece of wood stuck into the ground, with a blue horizontal cross-piece at the top. They were left in gardens, on verges or village greens, in fields etc. Near each was a white notice stating that this was one of 15 similar parts of a sculpture surrounding an area of approximately 2,400 square miles, and giving my name and address for any comments. I later received two replies.' Quoted in Suzaan Boettger, *Earthworks: Art and the Landscape of the Sixties*, Berkeley 2002, p.171.
17 Long, *Five, Six, Pick Up Sticks*, 1980.
18 Long has said that he was, to a certain extent, working in isolation in London: 'The whole artworld at that time was dominated by the aesthetics of Anthony Caro and the new generation sculpture. So, what I was doing was completely unconsidered. And then in 1968 I stepped out of that English artworld and into the more international stream and realised there was a whole new world of ideas going on from many different places. The Arte Povera in Italy, Minimalist and Conceptual Art in America, it was attitudes and not aesthetics. There was an immediate interest and understanding of my work

'as soon as I stepped outside England ... My work was known and supported at once by fellow artists ... although not necessarily by the media or the general public.' Martina Giezen, *Richard Long In Conversation Bristol 19.11.1985, Part 1*, MW Press, Holland 1985, p.17.

19 Carl Andre was to prove one of Long's most important contacts. Not only did he help Long in New York – his recommendation resulted in the invitation to show at the Dwan Gallery in 1970 – but his work demonstrated a 'non-theoretical, pragmatic, hands-on' approach that Long clearly sought to bring to his own practice. While there are superficial similarities between Andre's work and Long's floor-based sculptures Long has denied that Andre was a formal influence. Rather he was impressed and inspired by what he described as Andre's 'spirit' and his 'honesty'. Author's conversation with Richard Long, November 2004.

20 Quoted in Tony Godfrey, *Conceptual Art*, London 1998, p.178.

21 Interview with Colin Kirkpatrick, in *Richard Long: No Where*, exh. cat, Pier Arts Centre, Orkney 1994.

22 Long, *Five, Six, Pick Up Sticks*, 1980.

23 Paul Toner, 'Interview with Robert Smithson' (1970) in *Robert Smithson: The Collected Writings*, Berkeley 1996, p.235.

24 Robert MacFarlane, *Mountains of the Mind: A History of a Fascination*, London 2003, p.43.

25 Ibid., p.44.

26 Long, 'Fragments of a Conversation', p.92.

27 Hamish Fulton, 'Old Muddy' in *Richard Long: Walking in Circles*, p.242: 'Why make walks? To clear the mind, thoughts drifting effortlessly to the surface like tea leaves. Why walk? To make sculpture. Why walk in nature? To attempt a balance of influences. (Quantities of time.) Why walk? Partly to live in "real time".'

28 Long, p.236.

2 Entropy and the New Monuments

1 Until 1980 Long gave no interviews and offered no explanations, preferring to let his work speak for itself. In 1985 he said: 'I would never have done interviews ten years ago because there was nothing to talk about. Which is the opposite to Smithson. He could dream ideas and talk very well about things he had not done.' Martina Giezen, *Richard Long in Conversation Bristol 19.11.1985, Part II*, MW Press, Holland 1985, p.10.

2 Entropy is a concept drawn from physics which describes the inevitable loss of energy in any given system, or the 'degradation or disorganisation of the universe' (Oxford English Dictionary); it is typical of Smithson that he took such a scientific principle and transformed it into a poetic framework for visualising the world.

3 See for example Richard Brettell's essay in *Richard Long: Circles, Cycles, Mud, Stones*, exh. cat., Contemporary Arts Museum, Houston 1996.

4 Jack Flam (ed.), *Robert Smithson: The Collected Writings*, Berkeley 1996.

5 Robert A. Sobieszek, 'Robert Smithson's Proposal for A Monument at Anartica' in *Robert Smithson*, exh. cat., Museum of Contemporary Art, Los Angeles 2004, p.143.

6 See for example 'Entropy and the New Monuments', published in *Artforum*, June 1966.

7 John Coplans, 'Robert Smithson, The *Amarillo Ramp*' in Robert Hobbs, *Robert Smithson: Sculpture*, New York 1981.

8 Alloway observed that: 'Although some of Smithson's pieces employ an extendable module of fixed dimension like LeWitt's or Judd's, the direction of this development is towards progressions and expanding sequences.' He thus suggested that Smithson's pieces rejected seriality – a key characteristic of Minimalist work by Judd, Flavin and LeWitt – for progression. Laurence Alloway, 'Robert Smithson's Development' in Alan Sonfist (ed.), *Art in the Land: A Critical Anthology of Environmental Art*, New York 1983, p.126.

9 'The Crystal Land' (1966) in Flam 1996, pp.7–9.

10 Lucy Lippard, 'Breaking Circles: The Politics of Prehistory' in Hobbs 1981, p.31.

11 Implicit in the notion of the *Nonsite*, and extending one of Smithson's early preoccupations, is a questioning of a fundamental ability to see, ie. 'non-sight'. The site, in Smithson's formulation, is something beyond vision.

12 Smithson later wrote: 'The range of convergence between Site and Nonsite consists of a course of hazards, a double path made up of signs, photographs, and maps that belong to both sides of the dialectic at once. Both sides are present and absent at the same time. The land or ground from the Site is placed *in* the art (Nonsite) rather than the art placed *on* the ground. The Nonsite is a container within another container – the room. The plot or yard outside is yet another container. Two-dimensional and three-dimensional things trade places with each other in the range of convergence. Large scale becomes small. Small becomes large. A point on the map expands to the size of the landmass. A landmass contracts into a point. Is the Site a reflection of the Nonsite (mirror), or is it the other way around? The rules of this network of signs are discovered as you go along uncertain trails both mental and physical.' 'The Spiral Jetty' (1972) in Flam 1996, p.153.

13 Laurence Alloway, in Hobbs 1981, p.88.

14 Arthur C. Danto has suggested that 'An argument could be made that Robert Smithson is at least as important as a thinker and critic as he is as an artist' (quoted on the back cover of Flam 1996) although John Beardsley's judgement is that he was 'prolific if occasionally confused': *Earthworks and Beyond*, 3rd ed., New York 1998, p.20.

15 Eugenie Tsai, 'Robert Smithson: Plotting a Line from Passaic, New Jersey, to Amarillo, Texas' in *Robert Smithson*, exh. cat., Museum of Contemporary Art, Los Angeles 2004, p.21.

16 Hobbs 1981, p.88.

17 'Quasi-Infinities and the Waning of Space', *Arts Magazine*, November 1966, in Flam 1996, p.34.

18 Lawrence Alloway has described the construction of the Jetty: 'The working procedure on what was called Job No 73 was as follows. Front end loaders (Michigan Model 175) were used to dig out rocks and to collect sand on the shore. Ten-wheeler dump trucks carried the load to the lake, backed out along the coil, and tipped it off the ends. Here track loaders (Caterpillar Model 955) placed the dumped rocks and tamped them down within the narrow limits set up by the guidelines placed by Smithson. The technical difficulties were considerable and called upon all the skills of the drivers, including the operational hunch that tells when the ground is too soft and therefore likely to subside. The drivers, far from being ironic about a non-utilitarian project, appreciated the task as a challenge and brought their families out to the site for picnics at which they were able to demonstrate their virtuosity. The machines tipped and jostled their way along the spiral as the new embankments grew. A crucial figure in the work was the foreman, Grant Boosenbarck, who responded to the problems of the unprecedented structure with canny skill and maintained the concentration of the workmen by his leadership.' Lawrence Alloway, 'Robert Smithson's Development' in Sonfist 1983, p.137.

19 Ibid., p.146.

20 Robert Smithson, 'The Spiral Jetty' (1972) in Flam 1996, p.148.

21 Ibid., p.147.

22 Quoted in Jennifer L. Roberts, 'The Taste of Time: Salt and Spiral Jetty' in *Robert Smithson*, exh. cat., Museum of Contemporary Art, Los Angeles 2004, p.98.

23 Robert Smithson, 'The Spiral Jetty' (1972) in Flam 1996, p.145.

24 Ibid., p.146.

25 Lawrence Alloway, 'Robert Smithson's Development' in Sonfist 1983, pp.138–9.

26 John Coplans, 'Robert Smithson, The *Amarillo Ramp*' in Hobbs 1981, p.54.

27 Ibid., p.47.

28 Ric Collier and Jim Edwards, 'Spiral Jetty: The Re-Emergence' in *Sculpture*, July/Aug. 2004, p.33.

29 Ibid.

30 Stuart Husband, 'Ever Decreasing Circles' in *Observer*, 25 April 2004, p.28.

31 Ibid.

32 Ibid., p.29.

33 See for example Gary Shapiro, *Earthwards: Robert Smithson and Art after Babel*, Berkeley 1995; Suzaan Boettger, *Earthworks: Art and the Landscape of the Sixties*, Berkeley 2002; Ann Reynolds, *Robert Smithson: Learning from New Jersey and Elsewhere*, Cambridge, Mass. 2003; Jennifer L. Roberts, *Mirror Travels: Robert Smithson and History*, New Haven 2004; Ronald Graziani, *Robert Smithson and the American Landscape*, Cambridge 2004; Eugenie Tsai and Cornelia Butler (eds.), *Robert Smithson*, exh. cat., Museum of Contemporary Art, Los Angeles and tour 2004–5.

34 Robert Smithson, 'The Spiral Jetty' (1972) in Flam 1996, p.150.

3 Construction and Experience

1 Robert Smithson, 'Towards the Development of an Air Terminal Site' (1967) in Flam 1996, p.56.
2 Joshua C. Taylor, 'A Land for Landscape' in Sonfist 1983, p.4.
3 Alan Sonfist, 'Introduction' in Sonfist 1983.
4 We should note that important works were also completed in Germany – for example, Heizer's *Munich Depression* 1969 in Munich and De Maria's *Vertical Kilometre* 1977 in Kassel – and Holland, where both Robert Morris's *Observatory* 1971 and Smithson's *Broken Circle/Spiral Hill* 1971 were also commissioned as part of the *Sonsbeek '71* outdoor sculpture exhibition.
5 When Walter De Maria's *Vertical Earth Kilometre* was installed in Kassel in 1977, at a supposed cost of $250,000 (provided by an American oil company) the British artist Stuart Brisley's response was to dig a hole nearby and live in it for two weeks. For the historian Bryan Appleyard, 'The extremity, visibility and the primitive overtones of his condition represented a calculated insult to the over-refined and expensive elaborations of the American.' Bryan Appleyard, *The Pleasures of Peace: Art and Imagination in Post-war Britain*, London 1989, p.271.
6 Edward Buscombe, 'The Western' in Geoffrey Newell-Smith (ed.), *The Oxford History of World Cinema*, Oxford, 1996, p.286.
7 Michael Heizer interviewed by Julia Brown in Julia Brown (ed.), *Michael Heizer: Sculpture in Reverse*, exh. cat., Museum of Contemporary Art, Los Angeles 1984, p.10–1.
8 Quoted in Douglas McGill, 'Illinois Project to Turn Mined Land into Sculpture', *New York Times*, 3 June 1985.
9 Ibid., p.38.
10 Quoted in B. Gabriel, 'Works of Earth' in *Horizon*, Jan.–Feb. 1982, p.xxxii.
11 *Earth Works* featured ten artists: Carl Andre, Herbert Bayer, Walter De Maria, Michael Heizer, Stephen Kaltenbach, Sol LeWitt, Robert Morris, Claes Oldenburg, Dennis Oppenheim and Robert Smithson.
12 'A Sedimentation of the Mind: Earth Projects' is a manifesto only in the loosest sense imaginable. It is rather a marking out of a territory that in a typically Smithsonian manner encompasses landscape, geology, technology, aesthetic history and theory, gardens, the properties of steel and rust, Michael Fried and Clement Greenberg, entropy, Ehrenzweig and de-differentiation, Tony Smith, Robert Morris, Michael Heizer, the names of minerals, language, Jackson Pollock, Yves Klein, Walter De Maria, as well as a number of Smithson's own projects and proposals including the first *Nonsite*, his *Tar Pool and Gravel Pit* and *The Mud Pool Project*.
13 All are reprinted in Robert Morris, *Continuous Project Altered Daily: The Writings of Robert Morris*, Cambridge 1993.
14 'Notes on Sculpture part 2' in ibid., p.16.
15 *Grand Rapids Project: Robert Morris*, exh. cat., Grand Rapids Art Museum, Michigan 1975.
16 Heizer rejects the terms 'Land art' and 'earthworks' to describe his work, preferring 'sculptures'.
17 Michael Heizer, 'The Art of Michael Heizer', in *Artforum*, no.8, Dec 1969.
18 Quoted in John Beardsley, *Earthworks and Beyond*, 3rd ed., New York 1989, p.13.
19 Michael Govan has suggested that it would 'roughly absorb the Empire State Building lying on its side'. Lynne Cooke and Michael Govan, *DIA: Beacon*, New York 2003, p.147.
20 Quoted in Mark C. Taylor, 'Rend(er)ing' in *Double Negative*, New York, 1991, p.16.
21 Beardsley 1989, p.17.
22 Germano Celant, *Michael Heizer*, Milan, 1996, pp.xxviii-xxix.
23 Diane Waldman, 'Holes without History' in *ARTnews*, no.70,

May 1971, pp.44–8, 66–7.
24 Ibid.
25 For an account of a recent visit to *City* see Michael Kimmelman, 'Michael Heizer: A Sculptor's Colussus in the Desert', *New York Times*, 12 December 1999.
26 Robert Hughes, *American Visions* London 1997.
27 Quoted in B. Gabriel, 'Works of Earth' in *Horizon*, Jan-Feb 1982, p.xxxii.
28 Michael Auping, 'Michael Heizer: The Ecology and Economics of "Earth Art"' in *Art Week*, 18 June 1977, p.1.
29 Joseph Mashek, 'The Panama Canal and Some Other Works of Art', *Artforum* 9, May 1971, pp.136–50.
30 Elizabeth Baker, 'Artworks on the Land' in Sonfist 1983, p.74–5.
31 Dave Hickey, 'Eathworks, Landworks and Oz' in Jeffrey Kastner (ed.), *Land and Environmental Art*, London 1998.
32 Flam 1996, pp.41–2.
33 Boettger, *Earthworks: Art and the Landscape of the Sixties*, Berkeley 2002, p.245.
34 '*Las Vegas Piece*: two 1-mile lines, one north-south and one east-west, perpendicular to each other and meeting at the north end of the north-south line and the west end of the east-west line. The north-south line is intersected at the $^1/_2$ mile point by a perpendicular $^1/_2$ mile line going east-west. The east-west line is intersected at the $^1/_2$ mile point by a perpendicular line going north to south. The two $^1/_2$ mile lines meet.' *Walter De Maria: Seen/Unseen Known/Unknown*, exh. cat., Naoshima Contemporary Art Museum, Japan 2002, p.89.
35 Beardsley 1989, p.19.
36 Elizabeth C. Baker, 'Artworks on the Land' in Sonfist 1983, p.80.
37 Beardsley 1989, p.19.
38 Walter De Maria, 'The Lightning Field' in *Artforum*, April 1977.
39 Ibid.
40 Ibid.
41 Baker, 'Artworks on the Land', p.82.
42 Lawrence Alloway, 'Site Inspection', *Artforum*, Oct 1976, pp.49–52.
43 *Union Station* was made for *Projects in Nature* at Merrieworld West, Fall Hills, New Jersey.
44 Quoted in David Bourdon, 'The Razed Sites of Carl Andre', *Artforum*, Oct 1966.
45 Quoted in Boettger, *Earthworks*, p.165.

4 Body and Landscape

1 See also Graham Metson, *Rebirth* 1969, an attempt to create 'meaningful ritual', reproduced in Lippard, *Overlay: Contemporary Art and The Art of Prehistory*, New York 1983, p.55.
2 www.tate.org.uk
3 Charles Simonds, 'Microcosm to Macrocosm, Fantasy World to Real World: Interview with Lucy Lippard', *Artforum*, Feb. 1974, pp.36–9.
4 Ibid.
5 Ibid.
6 John Beardsley, 'On the Loose with the Little People: A Geography of Simond's Art' in *Charles Simonds*, exh. cat., Museum of Contemporary Art, Chicago 1981.
7 Amelia Jones, 'Survey' in Tracey Warr (ed.), *The Artist's Body*, London 2000, p.32.
8 Ronald J. Onorato, 'Real Time – Actual Space' in *Sitings: Alice Aycock/Richard Fleischner/Mary Miss/George Trakas*, exh. cat., La Jolla Museum of Contemporary Art, 1986, p.25.
9 Quoted in *Sitings: Alice Aycock/Richard Fleischner/Mary Miss/George Trakas. Perimeters/Pavilions/Decoys* was constructed at Nassau County, Long Island, New York.
10 "*after years of ruminating on the events that led up to this misfortune ...*": *Alice Aycock: Projects and Proposals 1971–78*, Center for the Arts, Muhlenberg College, Allentown, Pennsylvania, 1978.
11 Ibid.
12 Alice Aycock, 'Project for a Simple Network of Underground Wells and Tunnels' in *Projects in Nature: Eleven Environmental Works Executed at Merriewold West, Far Hills, New Jersey*, Merriewold West Inc., New Jersey 1975, unpag.
13 The work had additional powerful contemporary relevance in being constructed so soon after the end of the conflict in Vietnam, where fierce fighting had taken place in Vietcong tunnel systems.
14 "*after years of ruminating ...*"
15 Olga M. Viso, *Ana Mendieta: Earth Body: Sculpture and Performance 1972–1985*, exh. cat., Hirschhorn Museum and Sculpture Garden and tour 2004, p.35.
16 Ibid., p.227.
17 Ibid., p.230.
18 Unpublished artist's statement, quoted in ibid., p.47.
19 The text reads: 'In the Spring of 1970 I visited the Isle of Arran off the west coast of Scotland. One day I decided to swim the half mile stretch of sea between Kingscross on Arran and the lighthouse on Holy Island. I had never been to Holy Island. As I was swimming close to the rocks by the Lighthouse I saw a man and woman walking over the rocks towards me. They gave me a hand out onto the land. The man was my geography teacher from school whom I had not seen for six years. He is now the Lighthouse Keeper on the Island.'
20 Quoted in Michael Auping, 'Notes from the Land of the Electric Light' in *Hamish Fulton: Campfire*, exh. cat., 1985, unpag.
21 Hamish Fulton, 'Into a Walk into Nature' in *Hamish Fulton: Thirty One Horizons*, exh. cat., Lenbachhaus, Munich 1995.
22 '7 one day walks on country roads and paths out and back 44 miles each day Monday to Sunday by the same route ending on the Solstice Kent England 15–21 June 1998' and 'A guided and sherpa assisted climb to the summit plateau of Cho Oyu at 8175 metres via the classic route without supplementary oxygen Tibet Autumn 2000'. Cho Oyu is the fourteenth highest mountain in the world.
23 Hamish Fulton, 'Into a Walk into Nature' in *Hamish Fulton: Thirty One Horizons*, exh. cat., Lenbachhaus, Munich 1995.
24 Hamish Fulton, *Walking Through*, Stour Valley Art Project, 1999, p.34; this statement recalls the pioneering

environmentalist John Muir's account of a 1,000 mile walk from Indiana to the Gulf of Mexico: 'Presently you lose consciousness of your separate existence: you blend with the landscape, and become part and parcel of nature.' *A Thousand-Mile Walk to the Gulf* 1916 quoted in Roderick Nash, *Wilderness and the American Mind*, 3rd edition, New Haven 1982, p.126.

25 Fulton approvingly notes the fact that Haiku poets like Basho and Santoka Taneda were great walkers, Taneda reportedly walking 28,000 miles between 1926 and 1940.

26 *Touching One Hundred Rocks By Hand, Seven Days Walking Seven Nights Camping, Central Hokkaido, Japan, June Full Moon 1989.*

27 'If you take a photograph it gives you information about what a place looks like, but it doesn't tell you anything about the sounds, the smells, or indeed anything about the circumstances in the photograph – where it was, what day it was taken. The circumstances are important for me. Originally I made photoworks without any texts, but as my walks became clear – from A to B – I wanted to put that information in. I began to put words on top of the images in order to somehow challenge or attack the image. I wanted to attack the notion of beauty in the image, though at the same time you can make a beautiful image which combines words and photographs.' *Art Review*, March 2002, p.37.

5 Working with Nature

1 Quoted in Mel Gooding and William Furlong, *Song of the Earth*, London 2002, p.149.

2 Andy Goldsworthy, *Hand to Earth: Sculpture 1976–1990*, exh. cat., Leeds City Art Gallery 1990, p.161.

3 Maura Coughlin, 'Landed' in *Art Journal*, Summer 2005, pp.105–9. See also David Batchelor, *Chromophobia*, London 2000.

4 Oliver Lowenstein, 'Beauty and the Brand' in *Fourth Door Review* 7, 2005, p.16.

5 *Andy Goldsworthy, Rain sun snow hail mist calm*, exh. cat., The Henry Moore Centre for the Study of Sculpture, Leeds City Art Gallery, 1985, p.4.

6 *Andy Goldsworthy: Rivers and Tides: Working with Time*, Dir. Thomas Riedelsheimer, 2004.

7 For an account of Goldsworthy's early development see Miranda Strickland-Constable, 'Beginnings' in *Hand to Earth*, 1990.

8 *Andy Goldsworthy: Rivers and Tides*. op. cit., 2004.

9 Andy Goldsworthy, 'The Photograph' in *Hand to Earth*, 1990,p.9.

10 Vittorio Fagone (ed.), *Art in Nature*, Milan 1996, p.7.

11 Dieter Ronte, 'Art and Culture of the Environment: A Concrete Working Perspective' in ibid., p.26

12 Ibid.

13 Tihamer Novotny's account of the activities of the Mamu workshop artists in Transylvania in the 1980s vividly illustrates their concern with the symbolic properties of traditional practices: 'This kind of art discovers and resuscitates the mystic and religious elements of folklore: the tree of life, the corn doll, the shepherd's crook, the shroud, and revises the system of meanings attributed to fire, water, smoke, feathers, the sun, the moon, the bird, the snake, and the rabbit (fur). It has a constant love for the use of objects symbolising home ... It has an attraction towards certain agricultural relics like the dibble, the frames for drying shocks, the poles supporting the haystacks, the sheafs and the haystacks themselves. Its representatives turn their attention towards the landscape and nature: they collect driftwood, branches, feathers, grass, take snapshots of charcoal kilns, stacks of wood, scarecrows, nets for drying hemp, and embrace sheafs of maize. These rediscovered "lost properties", vehicles of universal concept, concrete qualities and certain emotional and moral characteristics and communicative roles are abstracted, transcribed, put into new contexts, taken apart, put together and reobjectivated.' Quoted in Laszlo Beke, 'Central-East Europe' in Fagone 1996, pp.109–16.

14 Chris Drury, *Chris Drury: Silent Spaces*, 2nd edition, London 2004, p.6.

15 Kay Syrad, 'Introduction' in *Silent Spaces*, p.6.

16 Drury, *Silent Spaces*, p.17.

17 Ibid., p.22.

18 Ibid., p.20.

19 'Sitting quietly, observing, watching. Small birds approach to feed on the crumbs of a meal, a lemming runs over my foot, an Arctic fox follows me to the tent, and we converse in short sharp barks. Over four days the tent is impregnated by soot from the fire. I collect simple objects which I attach to the canvas, and as the sun circles in the sky I mark off every hour with a star, 24 in all. The tent becomes a work, a talisman of the land.' Ibid., p.28.

20 Ibid., p.106–7.

21 Quoted in Diane Waldman, *Michael Singer*, exh. cat., Solomon R. Guggenheim Museum, New York 1984, p.16.

22 Ibid.

23 Quoted in Kate Linker, 'Michael Singer: A Position In, and On, Nature' in Sonfist 1983, p.188.

24 David Nash to Dore Ashton, 1970, quoted in *David Nash: Sixty Seasons*, exh. cat., Third Eye Centre, Glasgow, 1983. p.20.

25 Nash has said: 'There is no shamanism ... my concerns are fundamentally practical. The spiritual is absolutely dovetailed into the physical and the two are essentially linked with each other. To work the ground in a practical, basic commonsense way is a spiritual activity.' John K. Grande, 'Interview with David Nash' in *Art Nature Dialogues*, New York, 2004, p.6.

26 Ibid., p.3.

27 Gooding and Furlong, *Song of the Earth*, p.61.

28 Ibid., p.69.

29 Quoted in Waldman, *Michael Singer*, p.17.

30 Lowenstein, 'Beauty and the Brand', p.21.

6 Regeneration

1 Agnes Denes, 'The Dream' (1980) quoted in Robert Hobbs, 'Agnes Denes's Environmental Projects and Installations: Sowing New Concepts' in *Agnes Denes*, exh. cat., Herbert F Johnson Museum of Art, Cornell University, Ithaca, New York 1992, p.164.
2 Fritjof Capra, 'The New Vision of Reality' in Baile Oakes (ed.), *Sculpting with the Environment: A Natural Dialogue*, New York 1995, p.6.
3 Hobbs, 'Agnes Denes's Environmental Projects and Installations: Sowing New Concepts'.
4 'Ecological art does not isolate and interpret aspects of nature but integrates them into a total network of relationships. The subject of each work becomes the land or cityscape and its inhabitants – the plants, animals and human beings who live near or visit a site. This approach to art and nature is based on environmental ethics and the re-establishment of nature's equilibrium.' Barbara C. Matilisky, 'The Survival of Culture and Nature: Perspectives on the History of Environmental Art' in *Art and the Natural Environment*, London 1995, p.13.
5 Quoted in Lucy R. Lippard. 'The Garbage Girls' (1991) in *The Pink Glass Swan: Selected Essays on Feminist Art*, New York 1995.
6 'The Earth, Subject to Cataclysms, is a Cruel Master', Robert Smithson interviewed by Gregoire Muller, in Flam 1996, p.258.
7 The Bingham Copper Pit is in fact the second biggest open-cast copper mine in the world, being slightly smaller then the Chuquicamal pit in Chile. Currently half a mile deep and over two miles wide, the pit will continue to be enlarged until the ore runs out, which is not expected to occur until c.2020.
8 Flam 1996, p.253.
9 Robert Smithson, 'Untitled (1971)' in Flam 1996, p.376.
10 Ibid.
11 Robert Morris, 'Notes on Art as/and Land Reclamation' (1980) in Morris, *Continuous Project Altered Daily*.
12 'I'm not for hire to go patch up mining sites. The strip mine aspect of it is of no interest to me. I don't support reclamation art sculpture projects. This is strictly art. I love mining sites.' Quoted in David Bourdon, *Designing the Earth: The Human Impulse to Shape Nature*, New York 1995, p.226.
13 Elizabeth C. Baker, 'Artworks on the Land' in Sonfist 1983.
14 Yankee Johnson, 'Earthworks: Combining Environmental and Land Issues' in *Earthworks: Land Reclamation as Sculpture. Symposium*, King County Arts Commission, Seattle 1979.
15 'I have employed a method of terracing which has been used in ancient times as well as the present. Such a method has produced sites of such widely varying context and purpose as palaces and strip mines, highway embankments and mountain side cultivation. Persian and Mogul gardens were terraced as were the vast amphitheatres of Mugu-uray in Peru. Entire mountains in China have been terraced for erosion control and agriculture. [The process is] digging a hole and piling up the earth beside it. But such an innocent and practical act immediately reverberates to the point of excess with symbolic overtones, calling up sexual duality, funerary monuments, and the first temple hearths and altars. The act of digging and piling carried out in an organised way and at an intensified scale has produced sunken gardens and ziggurats on the one hand and gigantic geographical scars and ore tailings on the other. The forms are basically the same. The purposes and details vary, labelling one construction sublime, another absurd.' Robert Morris, Statement in *Earthworks: Land Reclamation as Sculpture. Symposium*, King County Arts Commission, Seattle 1979.
16 Quoted in Roderick Nash, *Wilderness and the American Mind*, 3rd ed., New Haven 1982, p.188.

17 Quoted in *Sitings: Alice Aycock/Richard Fleischner/Mary Miss/George Trakas*, exh. cat., La Jolla Museum of Contemporary Art 1986, pp.21–2.
18 'Eco-Habitat', interview with Gilles Bruni and Marc Babarit, in John K. Grande, *Art Nature Dialogues: Interviews with Environmental Artists*, New York 2004, p.27.
19 'Wilderness was the basic ingredient of American civilisation. From the raw materials of the physical wilderness Americans built a civilisation; with the idea or symbol of wilderness they sought to give that civilisation identity and meaning.' Roderick Nash, *Wilderness and the American Mind*, 3rd ed., New Haven 1982, p.xi.
20 Alan Sonfist, 'Natural Phenomena as Public Monuments', statement delivered at the Metropolitan Museum of Art, New York 1968, in Jeffrey Kastner (ed.), *Land and Environmental Art*, London 1998, pp.257–8.
21 *Agnes Denes*, Herbert F. Johnson Museum of Art, Cornell University, Ithaca, New York 1992, p.118.
22 Ibid.
23 Ibid.
24 Ibid., p.166.
25 Mel Gooding: 'We contemplate now a world in which the very elements upon which life depends – air, water and earth – are polluted, and the canopy of our biosphere is pierced. Never has there been a time in all human history when the quality of our understanding of our condition in nature – the nature of our historical being in the world – has been more crucial to our survival as a species, and to the survival of all the species of the animal and vegetable world in the complex network of terrestrial interdependence.'
26 Baile Oakes (ed.), *Sculpting with the Environment: A Natural Dialogue*, New York 1995, p.177.
27 See Robin Combalest, 'The Ecological Art Explosion', *ARTnews*, Summer 1991, pp.100–1.
28 See www.terranova.ws.
29 Agnes Denes, 'Tree Mountain – A Living Time Capsule – 10,000 Trees, 10,000 People, 400 Years' in Kastner (ed.) 1998, p.262.
30 Ibid.
31 Ibid.
32 *Joseph Beuys: The Revolution Is Us*, exh. cat., Tate Liverpool 1993.
33 Quoted in Ann Temkin and Bernice Rose, *Thinking Is Form: The Drawings of Joseph Beuys*, exh. cat., Philadelphia Museum of Art/Museum of Modern Art, New York 1993–4, p.14.
34 Joseph Beuys, 'Interview with Richard Demarco, 1982' in Carin Kuoni (ed.), *Energy Plan for the Western Man, Joseph Beuys in America, Writings by and Interviews with the Artist*, New York 1990, pp.109–16.
35 Ibid.
36 Mark Rosenthal, *Joseph Beuys: Actions, Vitrines, Environments*, exh. cat., The Menil Collection, Houston, and Tate Modern, London 2004–5, p.84.

7 Cosmic Cycles, Private Rituals

1 Lucy R. Lippard, *Overlay: Contemporary Art and The Art of Prehistory*, New York 1983, p.4.
2 Ibid.
3 Ibid., p.8.
4 'Certain forms have survived the intervening millennia as the vehicles for ... vital expression. The concentric circle, the spiral, the meander, the zigzag, the lozenge or diamond shape, the line in the landscape, the passage and labyrinth and welcoming, terrifying shelter are still meaningful to us, even if we cannot cite their sources and symbolic intricacies. These forms seem to have some basic connection to human identity, confirming bonds we have almost lost with the land, its products and cycles, and with each other. Symbols are inherently abstract. Certain images, rooted then uprooted, can still carry seeds of meaning as effectively as the most detailed realism, even to our own individualist society, estranged as it is from nature.' Ibid., pp.10–1.
5 Ibid., p.30.
6 Ibid., p.13.
7 See for example Long's *Walking to a Solar Eclipse* 1999 ('Walking to a Solar Eclipse/Starting from Stonehenge/A Walk of 235 Miles/Ending on a Cornish Hilltop/At a Total Eclipse of the Sun'), *and Midwinter Night's Walk* 1999 ('By the Light of a Full Moon on the Winter Solstice/A Walk of 16 Hours from Sunset to Sunrise/Somerset England 1999') and Fulton's *Counting 7 Barefoot Paces on Grass/Facing the Setting Sun, Spring Equinox* 1997.
8 Marcia Tucker, *Robert Morris*, exh. cat., Whitney Museum of American Art, New York 1970, p.55.
9 Kimberly Paice, 'Catalogue' in *Robert Morris: The Mind/Body Problem*, exh. cat., Guggenheim Museum, New York 1994, p.238.
10 Lippard 1983, p.110.
11 Nancy Holt, 'Sun Tunnels', *Artforum*, April 1977, pp.33–7.
12 Quoted in Oakes 1995, p.45.
13 Carl Sagan, *The Cosmic Connection: An Extraterrestrial Perspective*, London 1974 (pub. US 1973).
14 Ibid., p.66.
15 Both books feature prominently in essays by Smithson
16 Quoted in Lippard 1983, p.105.
17 Ibid., p.51.
18 Quoted in Oakes 1995, p.52.
19 Ibid. p.53.
20 Quoted in Ibid.
21 Julia Brown, 'Interview with James Turrell' in *James Turrell: Occluded Front*, exh. cat., Museum of Contemporary Art, Los Angeles 1985, p.23.
22 Ibid., p.31.
23 For a detailed account of the layout of the Roden Crater site and the various chambers that Turrell is building within it see Craig Adcock, *James Turrell: The Art of Light and Space*, University of California Press, Berkeley 1990.
24 Ibid.
25 Craig Adcock, 'Light, Space, Time: The Visual Parameters of Roden Crater' in *James Turrell: Occluded Front*, p.120.
26 Adcock 1990, p.196.
27 Quoted in Bright, 'When Light is Lost', p.21.
28 Sylvia Ackling, 'Lines of Latitude' in exh. cat., *Set Aside: Roger Ackling*, Annely Juda Fine Art, London 1998.
29 Chris Yetton, 'The Leap of a Man very Light in Body' in *Roger Ackling: Things of August*, exh. cat., Annely Juda Fine Art, London 2003.
30 Ackling, 'Lines of Latitude'.
31 *Roger Ackling: Works from Norfolk*, exh. cat., Annely Juda Fine Art, London 1990.

FURTHER READING

8 Another Place

1 A conference of the American Geophysical Union organised in 1988 by the climatologist Stephen Schneider, which was focused solely on Gaia, signalled the beginning of wider scientific acceptance of Lovelock's theory.
2 Bill McKibben, *The End of Nature*, New York 1990, p.7.
3 Keith Hartley in *Dalziel + Scullion: Home*, exh. cat., The Fruitmarket Gallery, Edinburgh 2001, p.12.
4 'Briefly summarised, "seeing oneself seeing" refers to: the observer's acknowledgement of the ocular act as one informed by manifold influences (memory, experience, ideology, context); the explosion of the individual viewing subject and its place in a multidimensional process that involves the viewer as both subject and object; and the suggestion that this awareness of both the construct of viewing, and the ability to view oneself in the third person, are crucial not only to appreciate the potential of art but, far more ambitiously, to manifest the type of criticality necessary in order to bring about social change.'
Jessica Morgan, 'Gartensozialismus' in *Parkett*, no.64, 2002, p.32.
5 Such as *Reconsidering the Object of Art 1965–75* (Museum of Contemporary Art, Los Angeles 1995); *Live in Your Head: Concept and Experiment in Britain 1965–75* (Whitechapel Art Gallery, London 2000); *Zero to Infinity: Arte Povera 1962–72* (Walker Art Center, Minneapolis and Tate Modern, London 2001); *Conception: Conceptual Documents 1968 to 1972* (Norwich Gallery and tour 2001); and *Open Systems: Rethinking Art c.1970* (Tate Modern, London 2005); Tony Godfrey's *Conceptual Art*, London 1999; *Rewriting Conceptual Art*, by Michael Newman and John Bird, London 1999.
6 Alex Coles (ed.), *Mark Dion: Archaeology*, Colin Renfrew, 'It may be Art but is it Archaeology? Science as Art and Art as Science' in Alex Coles (ed.) *Mark Dion: Archaeology*, London 1999.
7 See www.clui.org.
8 'True Beauty', Matthew Coolidge interviewed by Jeffrey Kastner, *Artforum*, Summer 2005, pp.286–7.
9 Matthew Coolidge, quoted in a press release for *The Center for Land Use Interpretation: Britain Bombs America, America Bombs Britain*, exhibition at the Royal College of Art, London, October 2003.
10 Quoted in Lewis Biggs, 'Learning to see: an introduction' in *Antony Gormley*, exh. cat., Malmö Konsthall and tour, 1993, p.22.
11 Interview with Roger Bevan in *Learning to See*, exh. cat., Galerie Thaddeus Ropac, Paris/Salzburg 1993, p.34.
12 Conversation with the artist, January 2006.

Surveys and group exhibition catalogues

Malcolm Andrews, *Landscape and Western Art*, Oxford 1999
Stephan Bann and William Allen (eds.), *Interpreting Contemporary Art*, London 1991
Daphne Beal (ed.), *Art in the Landscape*, Marfa, Texas 2000
Graham Beal et al., *A Quiet Revolution: British Sculpture since 1965*, exh. cat., Museum of Contemporary Art, Chicago 1987
John Beardsley, *Probing the Earth: Contemporary Land Projects*, exh. cat, Hirschhorn Museum and Sculpture Garden, Washington 1977
John Beardsley, *Earthworks and Beyond*, New York 1989
Suzaan Boettger, *Earthworks: Art and the Landscape of the Sixties*, Berkeley 2002
David Bourdon, *Designing the Earth: The Human Impulse to Shape Nature*, New York 1995
Germano Celant, *Arte Povera: Conceptual, Actual or Impossible Art?*, London 1969
Simon Cutts and David Reason, *The Unpainted Landscape*, exh. cat., Scottish Arts Council touring exhibition 1987
Vittorio Fagone (ed.), *Art in Nature*, Milan 1996
Tony Godfrey, *Conceptual Art*, London 1998
Mel Gooding and William Furlong, *Song of the Earth*, London 2002
John K. Grande, *Art Nature Dialogues*, *Interviews with Environmental Artists*, New York 2004
Hilary Gresty (ed.), *1965–1972: When Attitudes Became Form*, exh. cat., Kettle's Yard, Cambridge 1984
Nicola Hodges (ed.), *Art and the Natural Environment*, London 1995
Robert Hughes, *American Visions: The Epic History of Art in America*, New York 1997
Jeffrey Kastner (ed.), *Land and Environmental Art*, London 1998
Lucy R. Lippard, *Six Years: The Dematerialization of the Art Object*, New York 1973
Lucy R. Lippard, *Overlay: Contemporary Art and the Art of Prehistory*, New York 1983
Robert Lumley, *Arte Povera*, London 2004
Barbara C. Matilsky, *Fragile Ecologies: Artist's Interpretations and Solutions*, exh. cat., Queens Museum of Art, New York 1992
Kynaston McShine, *Information*, exh. cat., Museum of Modern Art, New York 1970
Robert C. Morgan, *Art into Ideas: Essays on Conceptual Art*, Cambridge 1996
Catherine Moseley (ed.), *Conception. Conceptual Art Documents 1968–1972*, exh. cat., Norwich Gallery and tour 2001
Roderick Nash, *Wilderness and the American Mind*, 3rd ed., New Haven 1982
Baile Oakes (ed.), *Sculpting with the Environment: A Natural Dialogue*, New York 1995
Jorn Ronneau, *Krakamarken : Land Art as Process*, Forlaget Djuri, Denmark 2001
Simon Schama, *Landscape and Memory*, London 1995
Ann Seymour, *The New Art*, exh. cat., Hayward Gallery, London 1972
Alan Sonfist (ed.), *Art in the Land: A Critical Anthology of Environmental Art*, New York 1983
Willoughby Sharp (ed.), *Earth Art*, exh. cat, Andrew Dickson White Museum, Cornell University, Ithaca 1970
Giles Tiberghien, *Land Art*, London 1995
Tracey Warr (ed.), *The Artist's Body*, London 2000
Udo Weilacher, *Between Landscape, Architecture and Land Art*, Basel 1996
Sally Yard (ed.), *Sitings: Alice Aycock/Richard Fleischner/Mary Miss/George Trakas*, exh. cat., La Jolla Museum of Contemporary Art 1986

Monographs and solo exhibition catalogues

Set Aside: Roger Ackling, exh. cat., Annely Juda Fine Art, London 1998
Francis Alÿs: Walking Distance from the Studio, exh. cat., Kunstmuseum Wolfsburg 2004
Carl Andre: Works on Land, exh. cat., Middelheimmuseum, Antwerp 2001
"after years of ruminating on the events that led up to this misfortune …": Alice Aycock: Projects and Proposals 1971–78, Center for the Arts, Muhlenberg College, Allentown, Pennsylvania 1978
Mark Rosenthal, *Joseph Beuys: Actions, Vitrines, Environments*, exh. cat., The Menil Collection, Houston, and Tate Modern, London 2005
Dalziel + Scullion: Home, exh. cat., The Fruitmarket Gallery, Edinburgh 2001
Walter De Maria: Seen/Unseen/ Known/Unknown, exh. cat., Naoshima Contemporary Art Museum 2002
Agnes Denes, Herbert F. Johnson Museum of Art, Cornell University, Ithaca, New York 1992
Alex Coles and Mark Dion (eds.), *Mark Dion: Archaeology*, London 1999
Kay Syrad, *Chris Drury: Silent Spaces*, London, 2nd ed., 2004
Susan May (ed.), *Olafur Eliasson: The Weather Project*, exh. cat., Tate Modern, London 2004
Hugh M. Davies, *Richard Fleischner*, exh. cat., University of Massachusetts, Amherst 1977
Michael Auping (ed.), *Hamish Fulton: Selected Walks 1969–89*, exh. cat., Albright-Knox Art Gallery, Buffalo, New York and tour 1990
Ben Tufnell and Andrew Wilson, *Hamish Fulton: Walking Journey*, exh. cat, Tate Britain, London 2002
Andy Goldsworthy: Hand to Earth: Sculpture 1976–1990, exh. cat., Leeds City Art Gallery 1990
Andy Goldsworthy: Time, London 2000
Antony Gormley, exh. cat, Malmö Konsthall and tour 1993
John Hutchinson et al., *Antony Gormley*, London 1995
Julia Brown, *Michael Heizer: Sculpture in Reverse*, exh. cat., Museum of Contemporary Art, Los Angeles 1984
Michael Heizer: Double Negative, Los Angeles 1991
Germano Celant, *Michael Heizer*, Milan 1996
Rudi Fuchs, *Richard Long*, London 1986
Richard Long: Walking in Circles, exh. cat., Hayward Gallery, London 1991
Richard Long: Walking the Line, London 2004
Vittorio Fagone, *Guiliano Mauri: Arte Nella Natura 1981–1993*, Milan 1993
Olga M. Viso (ed.), *Ana Mendieta: Earth Body: Sculpture and Performance 1972–1985*, exh. cat., Hirschhorn Museum and Sculpture Garden and tour 2004
Christian Zapatka, *Mary Miss: Making Place*, New York 1996
Marcia Tucker, *Robert Morris*, exh. cat., Whitney Museum of American Art, New York 1970
Robert Morris, *Continuous Project Altered Daily: The Writings of Robert Morris*, Cambridge 1993
Robert Morris: The Mind/Body Problem, exh. cat, Solomon R. Guggenheim Museum, New York 1994
Julian Andrews, *The Sculpture of David Nash*, London 1996
Hubert Besacier, *Nils-Udo: Art in Nature*, New York and Paris 2002
Alanna Heiss, *And the Mind Grew Fingers. Dennis Oppenheim, Selected Works 1967–90*, New York 1992
Germano Celant, *Giuseppe Penone*, exh. cat., Arnolfini Gallery, Bristol 1989
Charles Simonds, exh. cat., Museum of Contemporary Art, Chicago 1981
Charles Simonds, exh. cat., IVAM, Valencia 2003

CREDITS

Diane Waldman, *Michael Singer*, exh. cat., Solomon R.
 Guggenheim Museum, New York 1984
Robert Hobbs, *Robert Smithson: Sculpture*, New York 1981
Jack Flam (ed.), *Robert Smithson: The Collected Writings*, Berkeley
 1996
Eugenie Tsai and Cornelia Butler (eds.), *Robert Smithson*, exh. cat,
 Museum of Contemporary Art, Los Angeles and tour 2004–5
James Turrell: Occluded Front, exh. cat., Museum of Contemporary
 Art, Los Angeles 1985
Craig Adcock, *James Turrell: The Art of Light and Space*, Berkeley
 1990

INDEX